Britain's Oldest Art

The Ice Age cave art of Creswell Crags

Britain's Oldest Art

The Ice Age cave art of Creswell Crags

Paul Bahn and Paul Pettitt

with contributions by
Andrew Chamberlain, Mabs Gilmour, Roger Jacobi,
Michael Mawson and Alistair Pike

ENGLISH HERITAGE

Published by English Heritage, Kemble Drive, Swindon SN2 2GZ
www.english-heritage.org.uk
English Heritage is the Government's statutory adviser on all aspects of the historic environment.

© English Heritage 2009

Images (except as otherwise shown) © English Heritage

First published 2009

ISBN 978-1-84802-025-2

Product code PC 51449

British Library Cataloguing in Publication data
A CIP catalogue record for this book is available from the British Library.

The National Monuments Record is the public archive of English Heritage. For more information, contact NMR Enquiry and Research Services, National Monuments Record Centre, Kemble Drive, Swindon SN2 2GZ; telephone (01793) 414600.

All drawings in Chapter 4, unless otherwise stated: Paul Brown
All photographs in Chapter 4, unless otherwise stated: Alun Bull © English Heritage
Fig 2.2 redrawn and Figs 5.1–5.4, 5.6–5.7 reworked for this publication by Bookcraft Ltd

Brought to publication by Joan Hodsdon, Publishing, English Heritage.

Typeset in Charter 9.75/13pt

Edited by Merle Read
Indexed by Alan Rutter
Page layout by George Hammond Design
Front cover design by Simon Borrough

Printed in the UK by Severn

Front cover
The first engraved panel to be discovered in Church Hole,
comprising motifs interpreted as birds and/or stylised women.
[DP027434]

Back cover
The 'ibis' figure on the ceiling of Church Hole, a combination
of natural features, engraving and bas-relief.
[DP027476]

CONTENTS

ACKNOWLEDGEMENTS

The Creswell art was discovered in April 2003 by Paul Bahn, Paul Pettitt and Sergio Ripoll. Subsequent study of the art was undertaken by the three of us, with the assistance of Francisco Muñoz.

We are profoundly grateful to Ian Wall and his staff at the Creswell Heritage Trust, and to Jonathan Last and Jon Humble at English Heritage, for their unfailing support and help with this project. We would also like to acknowledge the fundamental contributions to this book which have been made by Alun Bull (photographs) and Paul Brown (tracings).

The authors are very grateful to Brian Chambers, Andrew Chamberlain, Roger Jacobi, Nigel Larkin and Gillian Varndell for help with the documentation for Chapter 1, and to Carole Watkin for the source of Gascoyne's phrase. The extracts from *Antiquity* in Chapter 1 are reproduced with the kind permission of Antiquity Publications Ltd.

We would like to thank James Krakker, Smithsonian Institution, Washington DC for assistance with Figs 2.9 and 2.14.

For Chapter 4, we would like to express our thanks to Yves Martin for documentation, and above all to Michel Lorblanchet for his expertise and wise judgement. As always, special thanks go to Ian Wall and his staff at Creswell; Brian Chambers; and Roger Jacobi at the British Museum, who spent hours examining the images with Paul Pettitt. Alun Bull provided the excellent photographs, and Paul Brown the line drawings which were produced independently of Alun's photographic record. Pedro Cantalejo Duarte kindly gave permission to reproduce the Ardales figure. None of the photographs published in this chapter has been digitally altered or enhanced in any way, with one exception (Fig 4.24, p 77, *bottom*).

A variant of Chapter 5 first appeared in the *Journal of Archaeological Science* (Pike *et al* 2005) and in *Palaeolithic Cave Art at Creswell Crags* (Pettitt *et al* 2007). The authors are grateful to the Creswell Heritage Trust for their kind assistance in providing access to the caves at Creswell Crags, to Jon Humble and Alex Bayliss of English Heritage for facilitating the scientific study of the Creswell art, and to the staff at the NERC U-series Facility at the Open University.

Michael Mawson, author of Chapter 6, would like to offer special thanks to Maurice Tucker.

With regard to Chapter 7, as well as thanking Andrew Chamberlain (University of Sheffield), whose help has been invaluable throughout, the authors wish to express their warmest thanks to Rob Dinnis (University of Sheffield), now an integral part of the exploration team. In addition, for help at various caves, they would like to acknowledge the help of Paul Mortimer, John Barnatt, Nick Powe, John Wright, Tim Taylor, Robert White, Tom Lord and Laura Basell.

We also extend our warmest thanks to Merle Read and Joan Hodsdon for their respective professionalism in editing the book and bringing it to publication.

FOREWORD

The discovery of parietal art in the cave of Church Hole on 14 April 2003 was a remarkable event for several reasons.

- This was a planned search, not caused by pure chance. It was based on progress in knowledge about the peopling of Great Britain during the final period of the last Ice Age. The persistence of parietal art during the entire time span of the Magdalenian made its expansion into England towards the end of the period quite plausible. The discovery in Church Hole confirmed these scientific facts, and both completed and extended them quite substantially.

- It was a collective discovery which involved academics from different countries: England and Spain.

- It was made in a particularly difficult geological context: in a cave entrance exposed to external atmospheric influences in which parietal works of art, often poorly preserved, have suffered from natural factors, especially as the supporting rock is a sandy limestone which disintegrates easily. Moreover, this discovery was made on a wall and ceiling far above the present floor, on surfaces which are riddled with fissures and full of highly uneven reliefs and exuberant and unusual natural forms – some of which (though not all) were used by the artists in their productions. Straightaway the discoverers undertook a decipherment of the walls which proved extremely difficult, especially as this was a new discovery, making any comparison with previously known works impossible: innovation was essential.

- The discovery brought to light some completely original figures – including a depiction of an 'ibis' – which made use of natural shapes with new techniques, intermediate between engraving and bas-relief.

The study of this discovery, as presented in this book, is also exemplary since the difficulties of decipherment gave rise to a debate on the scientific methods of reading parietal works in complex situations (poor conservation, irregular support and so on). It has also led to dating of parietal figures by multidisciplinary and complementary methods (stylistic comparisons, archaeological context and dating of calcite).

The presentation of the score of indisputable parietal works in this little cave thus constitutes a decisive turning point in the study of the earliest art: it marks England's definitive entry into the European club of Ice Age decorated caves, and at the same time opens up the prospect of future discoveries, not only in Britain but also in Belgium, Germany and Switzerland.

I hope that readers will appreciate the scientific mastery of this study, as they meditate in the cave itself and stroll through the romantic site of Creswell Crags, which is such a magnificent setting for dreams about reindeer hunters, the first animal artists in a very long history.

Michel Lorblanchet

Honorary Director of Research, Centre National de la Recherche Scientifique

CONTRIBUTORS

Paul Bahn 428 Anlaby Road, Hull HU3 6QP

Andrew Chamberlain Dept of Archaeology, University of Sheffield, Northgate House, West Street, Sheffield S1 4ET

Mabs Gilmour Planetary and Space Sciences Research Institute, Open University, Walton Hall, Milton Keynes MK7 6AA

Roger Jacobi Dept of Palaeontology, Natural History Museum, Cromwell Road, London SW7 5BD

Michel Lorblanchet Roc des Monges, 46200 St Sozy, France

Michael Mawson Dept of Earth Sciences, University of Durham, Durham DH1 3LE

Paul Pettitt Dept of Archaeology, University of Sheffield, Northgate House, West Street, Sheffield S1 4ET

Alistair Pike Dept of Archaeology, University of Bristol, 43 Woodland Road, Clifton, Bristol BS8 1UU

The discovery of cave art at Creswell Crags

PAUL BAHN AND PAUL PETTITT

On 14 April 2003, in collaboration with our colleague Sergio Ripoll, we made the first discovery of Ice Age cave art in Britain. Since portable art of the Palaeolithic period had long been known in this country (Sieveking 1972; Campbell 1977, vol 2, figs 102, 105, 143), it seemed probable to us that parietal art (images on walls or ceilings) must also have existed. It was fairly obvious that paintings were unlikely to be discovered – barring the finding of a totally unknown cave or a new chamber within a known cave – since paintings tend to be quite visible, and somebody (whether owner, speleologist or tourist) would probably have reported them by now. Engravings, in contrast, can be extraordinarily difficult to see without a practised eye, oblique lighting (that is, light directed at the surface of a cave wall at a raking angle) and, often, a great deal of luck. Such was the purpose of our initial survey and, sure enough, we rapidly encountered engraved marks in a number of caves. At the already well-known sites of Creswell Crags (Fig 1.1), on the Derbyshire/Nottinghamshire border, we found both figurative and non-figurative engravings of the period.

Early claims for British cave art

Bacon Hole

This was third time lucky for British cave art, following two false alarms. In the first case, in 1912 the French specialist abbé Henri Breuil and Oxford scholar W J Sollas claimed that ten wide red parallel horizontal painted stripes under calcite in the Welsh coastal cave of Bacon Hole (east of Paviland) were 'the first example in Great Britain of prehistoric cave painting' (see *The Times* 14 October 1912, 10; Sollas 1924, 530–1; Garrod 1926, 70; Grigson 1957, 43–4). Under the heading 'The Most Ancient

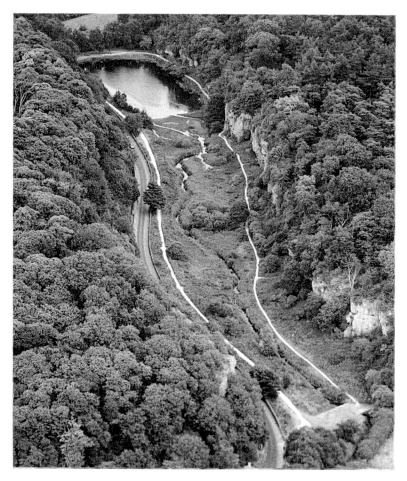

Painting in Britain: A Discovery in Wales', *The Times* (Fig 1.2) reported: 'The first example in Great Britain of prehistoric cave painting of the kind already familiar to palaeontologists from the caves of the Dordogne, the south of France, the Pyrenees and the peninsula of Spain, has recently been discovered on the walls of Bacon's Hole, near the Mumbles, by Professor Breuil and Professor Sollas.' The article explains how, after a survey of all the caves of Gower, Breuil and Sollas went into Bacon's Hole: 'On entering this, one of the investigators cried, "Les voilà" and the other "There they

Fig 1.1
Aerial view of Creswell Crags taken from over Creswell village and looking east. The lake at the eastern end of the gorge is the result of the damming of the stream that runs through it by the Duke of Portland in the 1860s to allow boating. The visible side of the gorge (at right) is the Nottinghamshire side. (Courtesy of Creswell Heritage Trust)

THE MOST ANCIENT PAINTING IN BRITAIN.

A DISCOVERY IN WALES.

The first example in Great Britain of prehistoric cave painting, of the kind already familiar to palæontologists from the caves of Dordogne, the South of France, the Pyrenees, and the peninsula of Spain, has recently been discovered on the walls of Bacon's Hole, near the Mumbles, by Professor Breuil and Professor Sollas. The discovery cannot fail to arouse much interest among students of the Stone Age in these islands, and should stimulate investigators to make a systematic search among the caves which the hunters of antiquity frequented. The polychrome representations of bisons, reindeer, mammoths, and other animals, both recent and extinct, already known to us in the Continental caves, reveal an artistic power which would not have discredited the ancient Greeks, and some of the caves in which they are found are veritable galleries of the fine arts.

The age of cave paintings began with the commencement of the Upper Palæolithic epoch, which includes three stages, known as the Aurignacian, the Solutrian, and the Magdalenian. The oldest of these, the Aurignacian, is well represented in France and Germany, but until lately had not been definitely identified in Britain, although a famous find, at Paviland, in Gower, South Wales. made by Dean Buckland as far back as 1823, had been tentatively assigned to it by Professor Sollas. The specimens found by Buckland, which are preserved in the University Museum of Oxford, include an imperfect skeleton of a man, often spoken of as "The Red Lady of Paviland," and associated implements in flint and ivory. The bones of the "Red Lady" are coloured by red ochre, in which they were immersed, according to a custom which is known to have prevailed in Aurignacian times, and the articles carved out of mammoth ivory—cylindrical rods and an annulus or bangle—are precisely similar to some which have been found in Aurignacian deposits abroad.

When Professor Breuil, without exception the most distinguished investigator of Aurignacian deposits, was visiting Oxford a short time ago his attention was directed to Buckland's specimens, and they proved so interesting to him that a joint expedition was planned with Professor Sollas to visit the cave in which they were found. On the way there the Museum of Swansea, which contains other objects found in Paviland Hole, was visited, and after an examination of these Professor Breuil was able to assign the "Red Lady" to the Aurignacian age, and even still more precisely to its closing days. It may be noted in passing that the classification of ancient cave deposits in France has been carried to such a degree of refinement that each of the major subdivisions of the Upper Palæolithic epoch has again been subdivided into three minor stages.

On visiting Paviland Hole itself Professor Breuil's determination was confirmed by finding Aurignacian implements, including the characteristic point of La Gravette, still embedded in the cave earth which forms the floor.

The presence of Aurignacian relics having thus been ascertained, the question naturally presents itself, "Are there any Aurignacian paintings on the walls?" A close search failed to reveal any; a number of other caves along the coast of Gower were then visited with equal want of success. Only one cave remained to investigate—the well-known and easily accessible Bacon's Hole, a few miles west of the Mumbles. On entering this one of the investigators cried, "Les voilà!" and the other, "There they are!" On the right hand wall, at about the level of the eyes, may be seen—not a picture, that would be too proud a beginning—but a number (ten) of horizontal bands, vivid red, arranged in a vertical series about one yard in height. A deposit of stalagmite has formed over them and sealed them up, so that none of the paint can be removed by rubbing. Similar bands have been described from the walls of Font de Gaume, in Dordogne. Thus the upper Palæolithic paintings have been found, and now that they are known to occur in our islands further discoveries may be expected. It is to be hoped that steps will be taken to preserve the paintings in Bacon's Hole, the most ancient so far known in Britain; at present they are at the mercy of the casual visitor, and no record has yet been taken of them by photography.

are".' The text goes on to describe them – a series of red bands – and to say:

a deposit of stalagmite has formed over them and sealed them up, so that none of the paint can be removed by rubbing Similar bands have been described from the walls of Font de Gaume in the Dordogne. Thus Upper Palaeolithic paintings have been found, and now that they are known to occur in our islands further discoveries may be expected.

Whereas Sollas clung to this belief for a long time, Breuil soon became more equivocal. By 1913 he was already stating that 'Il est fort possible que ces bandes rouges puissent remonter aux temps paléolithiques, comme elles peuvent être de date relativement récente' ('It is very possible that these red stripes could date back to Palaeolithic times, just as they could be of relatively recent date'; Breuil and Obermaier 1913, 160). Later he wrote that their age could not be fixed (Breuil 1952, 25).

As Glyn Daniel wrote long afterwards, in the editorial of the December 1961 issue of the journal *Antiquity* (Daniel 1961, 259–60):

how are we to explain the strange story of the alleged Palaeolithic paintings at Bacon's Hole, near the Mumbles in the Gower Peninsula? The facts about this discovery are not in dispute and we are grateful

to the present Lord Swansea for permission to quote from his father's notebook and press-cuttings. The painted bands in Bacon's Hole were made in 1894 by a man called Johnny Bale from Oystermouth, an interesting character who made a fine Gower rabbit soup. An old Norwegian barque, the *Althea*, outward bound from Swansea with a cargo of anthracite coal, was driven ashore. The salvage firm who bought the wreck of the *Althea* used Bacon's Hole to store their material. Lord Swansea, in his notebook for 17 October 1912, says 'Mr Hodgens … asserted before us that he himself had seen the marks made by a workman with a ship's paint brush about 17 years ago. His firm bought the wreck of the barque *Althea* close by the cave. They used the cave to store salvage and the men often sheltered there from the wet. There was ship's paint there and one man whose name he gave picked up a paint brush on the shore and took it with him, and when larking in the cave, splashed paint at his mates and daubed the wall.'

'The Palaeolithic paintings at Bacon's Hole are therefore without any doubt "Johnny Bale his marks"'. This fact was clearly apprehended by the first Lord Swansea, Colonel Morgan and others in October 1912, was widely known, and was well published in *The Cambrian Leader* of 19 and 21 October 1912. It is therefore saddening and surprising, but salutary, to note that in his Huxley Memorial Lecture for 1913 Professor Sollas still proclaimed their authenticity. Miles Burkitt in his *Prehistory* (1925) was, wisely, more cautious: they were 'of unknown age' or 'of any age'. But in 1957, Geoffrey Grigson, in his *Painted Caves*, is deliciously savouring the acrid smoke of the non-existent fire when he describes the cave as perhaps exhibiting 'a very few markings in red ochre which are perhaps Aurignacian … what may be, after all, the only cave painting of the Old Stone Age in Great Britain'. Grigson was impressed by the fact observed by Sollas and Breuil, namely that the marks were covered by a thin glaze of stalagmite. That glaze had formed between 1894 and 1912 and anyone who uses the stalagmite-cover arguments to authenticate Palaeolithic painting … should remember this, and should observe the thick stalagmite manifestations in many of our railway tunnels in western Europe.

Daniel later added (1961, 261) that Breuil and Sollas never seem to have taken into account the known facts about Bacon's Hole, which would have stopped them from the error of their pronouncements in lectures in Cardiff and London. Lord Swansea wrote in his notebook: 'If one desires to see similar marks there is no need to go down to Gower. There are plenty to be seen in the Swansea dry dock walls against the side of which brushes are cleaned every day of the week.' And Daniel's final comment (1981,

81) was that 'The Bacon Hole "palaeolithic" paintings were made in AD 1896 [*sic*]: it was sad that Breuil and Sollas fell for them in 1912. They were soon discredited and relegated to books on frauds, fakes, forgeries and follies in archaeology.'

At any rate, after their discovery in 1912 the Bacon Hole marks rapidly faded, and are now generally thought to have been either natural or the traces left by that 19th-century sailor cleaning his paintbrush (Morgan 1913; Garrod 1926, 70; Houlder 1974, 159; Daniel 1981, 81).

Symonds Yat

In 1981 the *Illustrated London News* rashly published, without verification, an 'exclusive' claiming the discovery of Palaeolithic animal engravings in the small cave of Symonds Yat in the Wye Valley (Rogers *et al* 1981; Rogers 1981) – two examples (a bison and a deer) of representational Stone Age cave art, the first to be found in Britain.

In his editorial for the July 1981 issue of *Antiquity*, Glyn Daniel (1981, 81) wrote that:

Mr Rogers is described as a 48-year-old archaeologist born in Canada: on his writing paper he lists himself as 'Thomas Rogers B. A., Ph. D. Director of the Stone Age Studies Research Association (Canada)', of which institution the Editor of *Antiquity*, in his abysmal ignorance, had been hitherto unaware. Martin Walker, of *The Guardian*, has been checking the bona fides of Rogers, who claims he was an undergraduate of Dalhousie in Canada and a Ph. D. of Pittsburgh University School of Anthropology. Walker discovered that Dalhousie did not award him a degree: Pittsburgh admitted that they did receive from Rogers 'a copy of his so-called thesis, which he had printed himself', and described it as 'a tissue of all kinds of strange things … We just discarded it.' The dissertation is apparently called *Moon, Magic and Megalith* … Rogers said that he believed Pittsburgh had accepted the Ph. D. thesis, but would now remove the title Dr from his notepaper and not refer to himself as Dr Rogers any more. 'They give away degrees as if they are confetti in the U.S.A.', he said. 'It will be quite a relief to be plain Mr again. But the important things are the finds themselves' (*The Guardian*, 24 January 1981).

All this, not unnaturally, predisposes one to regard the Symond's Yat finds with caution, and this cautious approach is strengthened by the fact that we cannot see any palaeolithic engravings in the exclusive pictures published by the *ILN*, while readily admitting that it is very difficult to photograph palaeolithic engravings. What is strange is that the

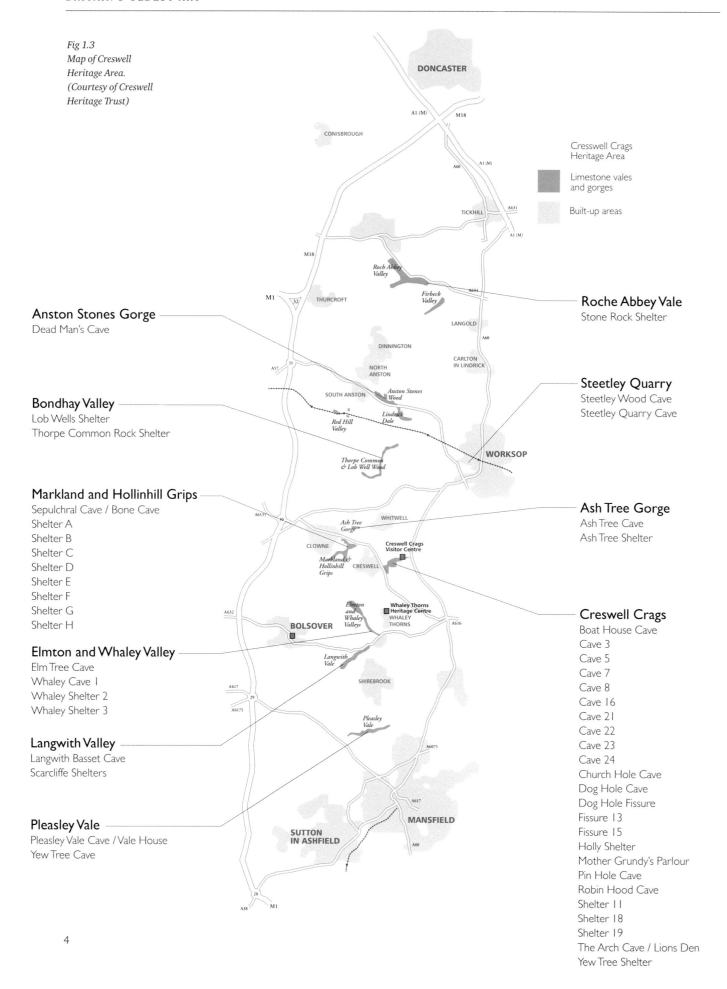

Fig 1.3
Map of Creswell
Heritage Area.
(Courtesy of Creswell
Heritage Trust)

DONCASTER

CONISBROUGH

Cresswell Crags
Heritage Area

Limestone vales
and gorges

Built-up areas

TICKHILL

Roch Abbey Valley

Firbeck Valley

Roche Abbey Vale
Stone Rock Shelter

LANGOLD

THURCROFT

Anston Stones Gorge
Dead Man's Cave

DINNINGTON

CARLTON
IN LINDRICK

NORTH
ANSTON

SOUTH ANSTON

Anston Stones Wood

Steetley Quarry
Steetley Wood Cave
Steetley Quarry Cave

Bondhay Valley
Lob Wells Shelter
Thorpe Common Rock Shelter

Red Hill Valley

Lindrick Dale

Thorpe Common & Lob Well Wood

WORKSOP

Markland and Hollinhill Grips
Sepulchral Cave / Bone Cave
Shelter A
Shelter B
Shelter C
Shelter D
Shelter E
Shelter F
Shelter G
Shelter H

WHITWELL

Ash Tree Gorge

CLOWNE

Creswell Crags
Visitor Centre

Markland & Hollinhill Grips

CRESWELL

Ash Tree Gorge
Ash Tree Cave
Ash Tree Shelter

Elmton and Whaley Valleys

Whaley Thorns
Heritage Centre

WHALEY
THORNS

BOLSOVER

Creswell Crags
Boat House Cave
Cave 3
Cave 5
Cave 7
Cave 8
Cave 16
Cave 21
Cave 22
Cave 23
Cave 24
Church Hole Cave
Dog Hole Cave
Dog Hole Fissure
Fissure 13
Fissure 15
Holly Shelter
Mother Grundy's Parlour
Pin Hole Cave
Robin Hood Cave
Shelter 11
Shelter 18
Shelter 19
The Arch Cave / Lions Den
Yew Tree Shelter

Elmton and Whaley Valley
Elm Tree Cave
Whaley Cave 1
Whaley Shelter 2
Whaley Shelter 3

Langwith Vale

SHIREBROOK

Langwith Valley
Langwith Basset Cave
Scarcliffe Shelters

Pleasley Vale

Pleasley Vale
Pleasley Vale Cave / Vale House
Yew Tree Cave

SUTTON
IN ASHFIELD

MANSFIELD

authors have resuscitated the sad affair of the Bacon Hole in the Gower peninsula, where they claim there is an abstract example of palaeolithic art! Don't they read the literature and study the history of their subject?

Subsequent investigation showed that the marks were entirely natural, and that the claim was utterly groundless (Daniel 1981, 81–2; Sieveking and Sieveking 1981; Sieveking 1982). Nothing was heard of Rogers afterwards. *The Illustrated London News* of May 1981 (p 24) published a retraction (and soon ceased its coverage of archaeology altogether). As Daniel wrote (1981, 89):

What an ungenerous piece of reporting, unworthy of the high traditions of the *ILN*'s archaeological writing! As the Editor and the Archaeology Editor of *The Illustrated London News* scrape the egg off their faces, we ask them why, when Rogers reported this alleged discovery to them, did they not invite a party of what they churlishly describe as 'archaeological heavyweights' to visit the site before rushing into publication?

Why indeed? As this 'discovery' had been reported throughout the British press, we were somewhat worried that, after our own discovery, someone would challenge us, claiming that we were not the first to find British cave art. But we need not have worried as, mercifully, the Symonds Yat affair had been forgotten.

The discovery

It had been a long-standing ambition of one of us (Paul Bahn) to seek Ice Age cave art in Britain; there was no reason at all why it should not exist, despite discouraging opinions throughout the literature on the subject – for example, 'to expect in English or Welsh caves … a rich cave art would be like expecting an art as accomplished and pure as Giotto's on the wall of an English medieval church or expecting a Picasso painting in a Canadian farmhouse' (Grigson 1957, 45).

The project gradually evolved from the dream of one person. Paul Bahn and Paul Pettitt discussed the possibility of searching for art at an Oxford dinner in late 2002. Sergio Ripoll was invited to join for his experience in detecting and recording Ice Age art, and organisation of the itinerary was undertaken by Paul Pettitt because of his expertise in the British Palaeolithic and familiarity with British caves.

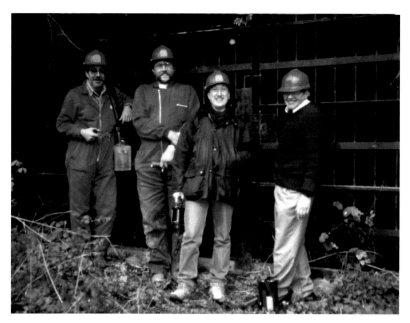

Fig 1.4
After the discovery in Mother Grundy's Parlour, 14 April 2003: from left to right, Sergio Ripoll, Paul Bahn, Paul Pettitt and Brian Chambers.
(Photo: Paul Bahn)

Transportation was provided by Gesine Reinert of Oxford University. We decided to carry out a very preliminary three-day survey in April 2003, visiting a number of the best-known caves in southern and central Britain. By pure chance – our first piece of luck – the team began at Creswell Crags (Fig 1.3) on 14 April, and through a mixture of luck and skill a number of engravings were discovered that first morning.

The first caves to be investigated were Robin Hood and Pin Hole, but nothing was found in them (though an engraved triangle was subsequently found in Robin Hood). But in Mother Grundy's Parlour, the third of the south-facing caves on the Derbyshire side, we found an engraved motif which, with our poor lighting, looked like a possible small horse-head: we now know that it is in fact a more complex and probably non-figurative design (*see* Fig 4.1), but it was a definite find, and led to the first 'photograph of triumph' in front of the site (Fig 1.4).

We were about to leave for the Gower Peninsula, thinking that we had done all we could at Creswell, when Brian Chambers, who was then Creswell head ranger, urged us to take a look in Church Hole, on the Nottinghamshire side of the valley. Although this cave was north-facing and therefore, in our estimation, less likely to contain art, it had at least contained evidence of Late Upper Palaeolithic occupation (*see* Chapter 2). And so, just to please Brian – our second piece of luck – we decided to have a quick look at this unpromising site.

Having seen nothing in the entrance chamber, we went down the long dark passage,

Fig 1.5
The exterior of Church Hole
during excavation in 1876.
Note the size of the spoil
heap.
(Photo: Robert Keene;
photographic copy: Tessa
Bunney. Derbyshire County
Council: Buxton Museum
and Art Gallery, (WBD
colln))

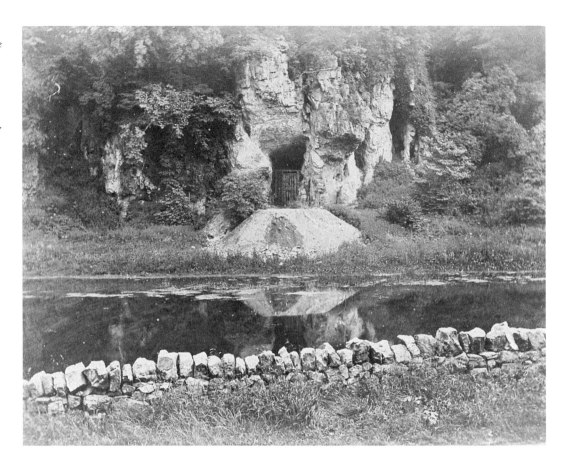

Fig 1.6
The exterior of Robin Hood
Cave during excavations in
the 1870s.
(Photo: Robert Keene;
photographic copy: Tessa
Bunney. Derbyshire County
Council: Buxton Museum
and Art Gallery, (WBD
colln))

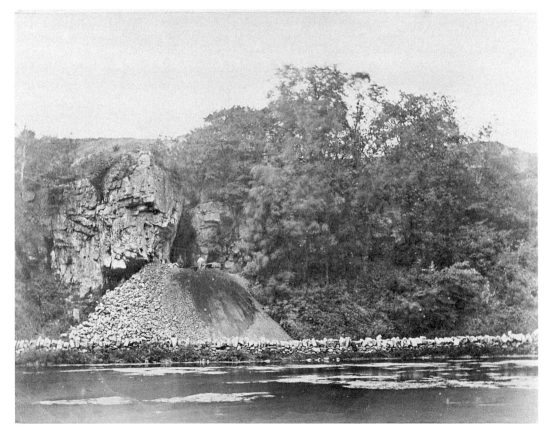

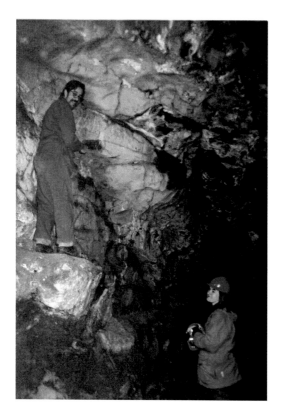

Fig 1.7
*The moment of discovery of
the stag: Sergio Ripoll and
Gesine Reinert.
(Photo: Paul Bahn)*

discovery, for without it Sergio Ripoll would not have been able to climb up to investigate the vertical line which he had glimpsed from below and which had struck him as interesting. By chance – our fourth piece of luck – Paul Bahn decided to take a photograph of Sergio perched precariously, clinging to the rock wall and the small ledge (Fig 1.7): the instant it had been taken he turned back to face the wall, and suddenly saw the big animal engraving which we now believe depicts a stag. Not only is it very unusual for cave art to be found by archaeologists (the vast majority is found by speleologists, or people blasting through rocks to build roads and suchlike), it is extraordinarily rare for a photograph to be taken at the very moment of such a historic and momentous discovery. As we emerged from Church Hole, the second 'photograph of triumph' of the day was taken, this time with Ian Wall, now director of the Creswell Museum and Education Centre (Fig 1.8).

The stag figure (originally interpreted as an ibex: *see* Fig 4.24, p 76, *top*) is only visible from the present floor level if one knows where to look and how to light it – otherwise it is quite undetectable, which of course explains why it had not been spotted before. Some people in the recent past, however, certainly saw it. Before the sediments of the cave mouth were excavated away in the 1870s, the image would have been just above head height to the average adult. At that time, when there were also no graffiti obscuring it, the figure must have been quite visible to those standing in its vicinity, even in natural daylight. Just opposite the stag is a fine graffito by J Gascoyne (a ubiquitous presence in the Creswell caves), marked 'April 12 1870. And of such is the Kingdom of God' (a quotation from Mark 10: 14). Visitors such as Gascoyne, and of course the excavators who removed the sediments in 1876, possibly saw the large stag at their eye level. If they did, they certainly did not record it or think it important. It is easy to see why. At that time cave art had not yet been discovered – the first strong claim for its existence came in 1880, with Altamira (*see* Bahn and Vertut 1997, 17), so a drawing of this kind in a cave had no significance whatsoever for anyone in the 1870s. If the excavators did see it, they probably thought it was modern.

The incised and scraped modern graffiti on the stag, although disfiguring and annoying, nevertheless played a useful role in that some

where we made our first major discovery – a panel of engravings (the 'bird panel') that are definitely human-made, although we still disagree as to what they depict. We found nothing else in the passage, and two of us returned to the entrance chamber, leaving Paul Pettitt searching the back of the cave.

Like the other inhabited caves of Creswell Crags, Church Hole had been crudely emptied of its sediments over the course of a month or so in the 1870s (Figs 1.5, 1.6). Hence the Upper Palaeolithic floor level in the entrance chamber was about 1.5m higher than the present floor. By chance – our third piece of luck – the Victorians had left a small ledge of the Palaeolithic floor sticking out on the left side as one enters. The Upper Palaeolithic floor was covered by a stalagmite layer which must have been difficult to cut through in order to expose the sediments below for excavation, and that is probably the reason why this section was left undisturbed. It is quite easy to climb up onto it. This explains why so many visitors over the next century (until the cave was closed in the 1970s) climbed onto this ledge and, in their flush of triumph at their 'achievement', felt the need to inscribe their names or the date on the rock in front of them, not realising that it bore ancient engravings. It was also the presence of this very ledge which enabled us to make our major

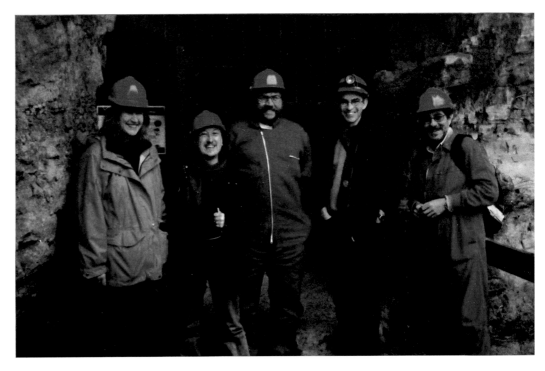

of them are dated (1948, 1957), and in the former case provided an immediate minimum age for the stag, as the graffiti overlie it. The brightness and sharpness of the graffiti form a complete contrast with the lines of the stag, which are worn and have the same patination as the natural rock walls, and hence, we inferred, must be very considerably older. However, it seems that one visitor at least did see and identify the figure as a male goat (as we ourselves did, initially), because at some point – we estimate between the 1940s and 1970s, going by the dated graffiti and the brightness and sharpness of the incisions – a 'beard', comprising a series of long parallel lines, was carefully engraved from its chin downwards. Had this person reported the figure, he or she could have made a great contribution to British archaeology, instead of simply vandalising a beautiful image.

These first figures to be detected were initially interpreted as two birds and a large ibex, and were published as such (Bahn 2003; Bahn *et al* 2003); however, these interpretations, as well as the initial sketches, were based on on-the-spot decisions and poor photos taken hurriedly and with inadequate lighting (Fig 1.9). It was always obvious that the situation would change with improved lighting and better access to the walls.

The next time in the year when all three team members were free to resume the work at Creswell was from June 25 onwards. Immediately before our arrival on that day – now with a fourth member of the team, Francisco Muñoz – English Heritage had installed scaffolding in Church Hole, with a platform at the Upper Palaeolithic floor level. This transformed the situation, since it not only allowed us to stand back from the stag panel and view it properly (instead of clinging to the rock while trying not to slip off the narrow ledge) but also gave us access to the rest of the walls and the ceiling. Immediately on arrival that day, our second major discovery was made – a bovid engraving to the right of the large stag. Today this stands over a void, but is so easily visible at head height that we would certainly have found it on 14 April had the ledge extended to it. From the present floor level, however, the bovid, like all the other images subsequently found in the entrance chamber, is virtually invisible

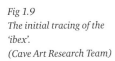

unless one knows it is there and can light it appropriately.

During the first search and the main search of June 2003 we found a total of 13 engravings, with more – most notably the 'ibis' on the ceiling – to follow in 2004. Wall figures come with an inbuilt orientation, but the problem with ceiling figures is that their correct orientation is unknown at first: although we had certainly noticed parts of the bird in 2003, we had been looking from the wrong side, so that its downward curving beak looked something like an upturned horn. In addition, in 2003 the weather was constantly dull and rainy, and we were working with generators and artificial light. In the spring of 2004 we had beautiful weather outside, and the good sunlight plus a chance glimpse from the correct angle enabled Paul Bahn to identify the 'ibis'. Once seen, it is hard to believe that we could have missed it until then.

Why Creswell?

One of the reasons why we included Creswell Crags on our list of caves to investigate was not only the presence there of several occupation sites of the Late Upper Palaeolithic, but also and especially the fact that Creswell caves had yielded the only known figurative portable art of the British Ice Age.

The first piece, the famous horse-head engraving (for example, Dawkins 1880, 185), was found by the Revd John Magens Mello in Robin Hood Cave in July 1876, and is now housed in the British Museum (Fig 1.10). William Boyd Dawkins (1877, 592) described it as:

the head and fore quarters of a horse incised on a smoothed and rounded fragment of rib, cut short off at one end and broken at the other. On the flat side the head is represented with the nostrils and mouth and neck carefully drawn. A series of fine oblique lines show that the animal was hog-maned. They stop at the bend of the back which is very correctly drawn.

He felt that comparison with the known portable Ice Age horse depictions from the caves of Perigord and Kesslerloch (Switzerland) made it 'tolerably certain' that the Creswell hunters were the same as those of the continent.

However, the piece's discovery and authenticity were seriously challenged at the time: in particular Thomas Heath, the curator of

Derby Museum, published a number of pamphlets (for example, 1880) in which he cast severe doubt on it as well as on a *Machairodus* (today classed as *Homotherium* – the sabre-toothed cat) tooth supposedly found by Dawkins in the same cave. A furious exchange of letters and articles in the press ensued. Heath had insinuated that the engraved bone was placed in the Creswell Crags cave by someone, having been brought from some other place. Dawkins (in Heath 1880, 5) stressed that he, unlike Heath, had been present in Robin Hood Cave when Mello made the discovery. In the course of a protracted discussion in the *Manchester City News*, a certain John Plant FGS of Manchester (who had visited the caves, but played no part in the excavations) stated the following:

We have now heard from both sides their versions of the incidents attending the finding of the incised 'bonelet' and of the Machairodus tooth. It appears these objects were found within four days of each other, in July, 1876. The incised bonelet was the first to be found; it was picked up in the dark Cave by Mr. Mello himself, Mr Tiddiman and Professor Dawkins being present. There is no dispute about this object on either side. It is admitted to be identical in colour, style, and feature with similar engraved pieces of bone common to Cave deposits in France and Italy, and is probably a contribution of an etching of a horse from a Palaeolithic School of Art in the Caves at Perigord, to the Pre-historic Exhibition at Creswell Caves. I have seen and studied this early artistic effort of Pre-historic man, and am satisfied that it comes from a French Cave. There is no such thing yet known as a piece of bone bearing marks of intelligible ideas or natural forms from any Pleistocene deposit in the isles of Britain. The broken Machairodus tooth was next to be found by Professor Dawkins, in the presence of Mr. Heath, Mr. Hartley, and a workman. One can gather from the several reports upon these Caves … that, from April, 1875, to the end of the Explorations, in 1878, not less than eight thousand separate bones and Pre-historic objects were dug out of the floor deposits by the workmen at Creswell Caves – an enormous quantity it will be admitted. Yet these two specimens – the bone and tooth – are more extraordinary in every point than the whole of the eight thousand other specimens put together. Yet it fell to the happy lot, during a cursory visit to the Caves, of the Rev. J. M. Mello and Professor Dawkins, to pick them up for themselves, almost in the same spot, and within so short a time of each other. The doctrine of chances is acknowledged to be inexplicable; but to my mind this is an instance of coincidences and lucky chances beyond all precedent. (Heath 1880, 22)

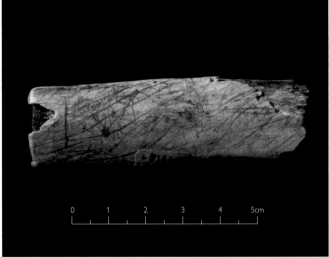

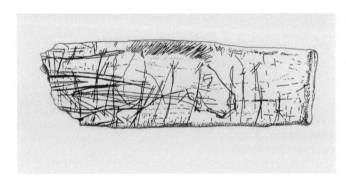

Fig 1.10
(above, left)
The horse-head engraving on bone from Robin Hood Cave: the rib is 7.3 × 2.3 × 0.8cm.
(© Trustees of the British Museum)

(left)
Drawing of the horse-head.
(Creswell Heritage Trust)

(above)
Engraved lines on the reverse of the rib decorated with the horse-head.
(© Trustees of The British Museum)

(below)
Detail of the horse-head engraving.
(© Trustees of The British Museum)

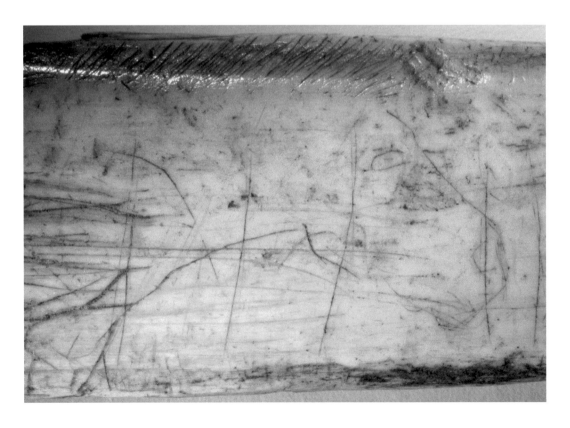

In short, the engraved horse came under suspicion firstly because no such object had been found in Britain before – but why should it not be the first? – and secondly because of its association in space and time with the even more suspicious tooth. Plant's conclusion (ibid, 24) was that 'both the tooth and the incised bone were buried in the Creswell Cave not very long before they were found, in 1876'.

In addition, Frederic Stubbs (who had worked in the cave), in a letter to the *Manchester Guardian* (Heath 1880, 33), wrote that:

Both Professor Dawkins and Mr Mello affirm that the *Machairodus* tooth, and the thin white bone with the scratched outline of the horse, came out of the dark cave earth, pretty near the modern surface of the Cave floor; and if so, like the other bones and objects obtained from the Cave, they ought to have been brown, much discoloured, and stained by ages of contact with the damp earth. Instead of this, the tooth and incised bone are very pallid, dry, and white – the two exceptions out of thousands of bones.

It should be noted, however, that a later analysis of the *Machairodus* tooth strongly supported its authenticity (Oakley 1969, 42–3) – its chemical composition agreed with that of local Upper Pleistocene cave mammals, while its tiny fluorine content was markedly different from that of specimens on the continent. It may simply have been a local fossil picked up by Palaeolithic people.

Subsequently, according to Dawkins (1925):

the Creswell horse was the first proof of the range into Britain of the wonderful art of the French Caves, and the discovery made in the seventies by myself [sic] was published, after a careful scrutiny by Sir John Evans, Sir Augustus Franks, Lord Avebury, General Pitt-Rivers and other leaders, in the quarterly *Journal of the Geological Society of London*. It has remained unchallenged for more than 40 years, and has passed into the literature of anthropology.

However, these words were prompted by the reappearance of the controversy when, in an edition of his famous book *Ancient Hunters*, W J Sollas (1924, 530) wrote that 'There is a singular absence of any attempt at art in all the paleolithic Stations of England. The horse figured here is, I am assured, a forgery introduced into the cave by a mischievous person.'

Dawkins's reaction was swift and severe, stressing that:

The charge of forgery is now to be made without clear evidence. In answer to a letter asking for this, Professor Sollas writes to me that it is based on what he was told 'some years ago, I think 1919' by a clergyman since dead, who declined to give names or other particulars. This means that the charge of forgery is founded on gossip without a shred of evidence and unworthy of further notice. (Dawkins 1925)

Sollas (1925) himself then explained that he obtained his information from a 'conversation with the Revd A A Mullins, Rector of Langwith-Basset, well known by his exploration of the Langwith Cavern, which is situated within easy reach of Creswell Crags'. Mullins had told him that the horse engraving had been surreptitiously introduced into the cave, with more than one person having been concerned in 'this nefarious proceeding'. He had refused to name names, but assured Sollas that he spoke of his own personal knowledge. However, in the light of Dawkins's response, Sollas withdrew the statement in his book, and said he would delete the footnote at the earliest opportunity.

One of the factors which seemed to add weight to the authenticity of the horse-head at this time, and which was cited by both Dawkins and Sollas in their exchange, was the new discovery by Leslie Armstrong and G A Garfitt of 'incised figures of bison and reindeer' (Dawkins 1925) at Creswell Crags, 'especially as they relieve the Aurignacian inhabitants of these islands from the unmerited reproach of an indifference to art' (Sollas 1925). The new finds (Fig 1.11), made during work carried out between June and October 1924 and first reported in *The Times* of December 22 that year, came from an excavation in front of Mother Grundy's Parlour: here, amid Palaeolithic stone and bone tools and numerous bones of Pleistocene animals, there had been found engraved bones bearing 'a spirited drawing of a reindeer, another a part of a bison with the head, and a third fragment too small for identification' (*see Nature* 115, no. 2879, 3 January 1925, 24).

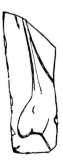

Fig 1.11
The supposed engravings on bones from Mother Grundy's Parlour. (From Armstrong 1925, 169)

The account of the excavation by Armstrong (1925) provided drawings and photographs of these three objects (p 169 and plate XXII). In the drawing the reindeer is clear enough, albeit badly drawn, with its outline highlighted in Chinese white for the photograph, an unfortunate and distracting habit of Armstrong's. The 'bison-head' looks extremely implausible. As for the lines on the third fragment, Armstrong has by now decided that they depict a rhinoceros-head, and he compares it with three known rhinoceros-heads from French caves. However, it looks far less plausible than even the highly dubious bison-head. Interestingly, an account in *Nature* (115, no. 2896, 2 May 1925, 658–9) revealed that, after Armstrong's paper was read to the Royal Anthropological Institute in April, a letter from Dawkins was read 'in which he entered a caveat against acceptance of the engravings on bone from Mother Grundy's Parlour as of human origin. In his opinion they were due to the action of roots.' In the ensuing discussion, Sollas had said that he had no doubt they were of human origin, while Garrod stated that 'she was authorised to say that the abbé Breuil, who had examined the fragments that day, was convinced that the reindeer, and some at least of the lines forming the figure which was thought to be a rhinoceros, had undoubtedly been engraved by man. The bison, however, was more doubtful and might possibly be due to root action.' In a later publication, Armstrong (1927, 11) notes that Burkitt agrees fully with his own judgement of the two doubtful pieces, while Dawkins considers that the bison and the rhinoceros muzzle are rootmarks (natural marks made by plant roots), while everyone admits the 'rhino horn' to be the work of man. Oddly, however, after Armstrong's death, Burkitt (1963, xii) wrote that at 'the Pin Hole, [Armstrong] found the only authentic palaeolithic engravings that are known in this country' (*see below*), so he seems to have changed his mind about the Mother Grundy pieces.

We must, at this point, state that some scholars viewed the reindeer as being of human origin, albeit extremely crude; Garrod (1926, 145) said of it: 'on one [fragment] the lines are undoubtedly made by man, and may represent a cervine animal, drawn on a very small scale, with a fine, rather uncertain line'. The photograph in the British Museum's catalogue (Sieveking 1987, pl. 129) is unclear, but in the description (ibid, 102) it is stated that the bone bears a 'group of lightly engraved lines that can

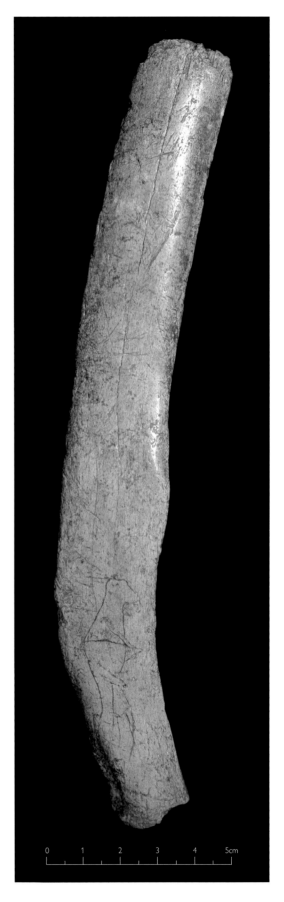

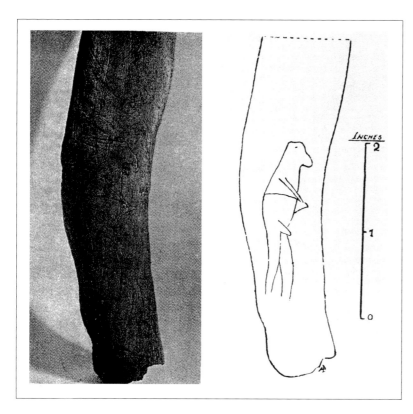

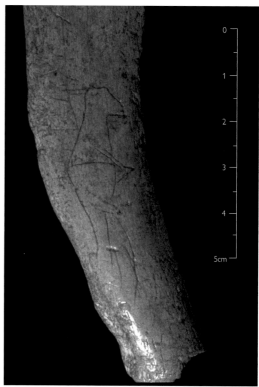

be interpreted as an animal figure (head, neck and trunk of a cervid?) facing left. The engraving is minimal, however, and the perceived animal may owe its existence to a fortuitous grouping of lines'. This is certainly the view of Paul Pettitt, who has viewed these pieces in person and is not convinced that they are anything but natural.

Even if the 'rhino' lines were of human origin, their interpretation by Armstrong seems highly tenuous. As Garrod said, 'Mr Armstrong has deciphered a rhinoceros, but although the lines of the supposed horn are clearly and deeply incised, the line which forms the muzzle is due to the action of roots on the bone' (Garrod 1926, 145). As for the 'bison', the opinions of both Dawkins and Breuil seem very sound, and are supported by Sandra Olsen (cited in Sieveking 1987, 102). Garrod says that 'the third engraving, interpreted by Mr Armstrong as the head of a bison, is so much mixed up with lines undoubtedly caused by roots that it is difficult to decide whether it is the work of man at all' (1926, 145).

In short, therefore, Armstrong appears to have been prone to wishful thinking and over-interpretation of largely natural marks, although his deer image may possibly be acceptable. Shortly afterwards, in 1928, during

excavations in Creswell's Pin Hole Cave, he discovered the famous 'Pin Hole Cave man', an engraving on a rib-bone (Fig 1.12) which he interpreted as 'a masked human figure in the act of dancing a ceremonial dance' (Armstrong 1928, 28). He stated that the image was discovered after the bone had its stalagmitic film removed with a solution.

At first sight, all seems well here – but, as an analysis by Jill Cook has shown, the Pin Hole man in fact belongs at least in part to the same category of wishful thinking, reinforced by excessive and inaccurate application of pigment. Exactly the same phenomenon had already occurred with other similar finds by Armstrong elsewhere in England before this period. The flint mines of Grimes Graves are now well established as being Neolithic, but in the 1920s and 1930s some researchers believed passionately – and tried to prove – that they dated back to the Palaeolithic. In 1915 an enigmatic piece of 'flint crust', with lines cut directly into the cortex, was found by Armstrong, who was a firm believer in the site's Palaeolithic age. Another such piece was

found, apparently by Peake, in 1920 ... Following this discovery Armstrong made sure that 'every fragment of flint crust' unearthed during the course of his excavations was duly carefully examined. Sure

Fig 1.12
(opposite)
The humanoid engraving on bone from Pin Hole Cave: the rib is 20.8 × 3 × 1.4cm.
(© Trustees of The British Museum)

(above, left)
Bone with engraved human figure and tracing of the engraving.
(From Armstrong 1928)

(above)
Close-up of human.
(© Trustees of The British Museum)

enough, in the days that followed, more startling discoveries were made … a second cortex engraving … portrayed the head and upper torso of a horse with an 'impaling arrow or lance' apparently penetrating its neck. The depictions were crude. (Russell 2000, 37–8; Armstrong 1922a; 1922b)

'Favourable comparisons were immediately made between the new discoveries and examples of Old Stone Age art from the south of France. Those who had long argued that the British flint mines predated the Neolithic now had just the evidence they needed' (Russell 2000, 38). In 1921 Armstrong, with his colleague Dr Favell, found four more blocks of floor-stone with incised representational depictions – two found by Armstrong himself featured an 'elk or hind' and 'three animal heads, two with horns, seen as deer or ox'. The other two, found by Favell, comprised an unidentified animal and three parallel lines. Armstrong, in his report, stressed that, since the art of engraving on bone and stone has long been looked upon as a distinctive feature of Late Palaeolithic times, then the finding of such items at Grimes Graves was 'of more than ordinary importance' (ibid).

The pieces of engraved cortex were shown to many eminent scholars: Smith believed in them and regarded them as Palaeolithic, Reinach saw the deer as a likely forgery, and the abbé Breuil ascribed them 'to the time of the dolmens of Portugal' (Varndell 2004). We can only assume that their examination was perfunctory, since the drawings as published bore scant resemblance to true prehistoric imagery. This is especially true of the very crude deer found by Armstrong (1922a; *see also* Russell 2000, 40). According to Armstrong (1922a), authorities at the Natural History Museum believed this to be an elk, but Breuil was 'equally satisfied' that it was a red deer.

It is also worth stressing that Armstrong (1922a; 1922b) apparently saw no problem or contradiction in the fact that his engravings were closely associated with what he considered to be Mousterian tools, in particular 'large Levallois flakes'.

Russell (2000) wonders who was responsible for these clumsily fabricated engravings, and he notes that only one person seems to have been present every time, over a five-year period, that such finds were made – Armstrong. He also underlines the 'urgency with which Armstrong later defended the Palaeolithic origins for the Norfolk site, and the passion with which he

attacked those … who doubted him' (ibid, 41). It is even possible that one final piece of evidence, a 'venus figurine', was planted at the site in 1939 amid increased criticism of the Palaeolithic theory – this was the famous 'chalk goddess' of Grimes Graves, found in the last shaft to be dug by Armstrong there. If this is indeed a modern fake, it is by no means clear whether Armstrong made the piece himself (especially as, by this time, he himself was starting to doubt the Palaeolithic age of the site) or was the victim of a hoax.

A new analysis by Varndell (2004) of the Grimes Graves flint crust figures has revealed that, once the Chinese white has been removed, the engraved lines are either barely visible or do not exist – Armstrong selectively joined up a variety of natural marks and scratches to produce animal figures. Such figurative engravings were only found at Grimes Graves during the Armstrong years – none has been found since.

It is unpleasant, of course, to cast aspersions on the reputation of an archaeologist who can no longer defend himself, especially as Armstrong's records of his excavations in Pin Hole are far better than any others that exist for Creswell (*see* Chapter 2). And while Russell (2000) clearly implies that Armstrong was involved in fakery in one way or another, it is doubtless fairer and more accurate to deduce with Varndell (2004) and Cook that, where portable engravings were concerned – whether at Grimes Graves or Creswell – he was the victim of an overactive imagination, of wishful thinking and of simply seeing things which were illusory. To be fair, he was not a professional archaeologist, nor was he working in the modern world in which the degree of scrutiny to which discoveries are subjected is much greater than in the 1920s. Even modern archaeologists can be subject to overactive imaginations.

Finally, it is worth noting that a further flurry of argument about the Robin Hood Cave horsehead arose in 1955, when Geoffrey Grigson published an article in which he accepted the Pin Hole engraving, but resurrected the old arguments against both the *Machairodus* tooth and the horse-head engraving, declaring that the latter was clean, white and dry, unlike the thousands of other, grubby, brown and damp bones in Robin Hood Cave (Grigson 1955; *see also* Grigson 1957, 33–5). He declared that the horse was genuine Upper Palaeolithic art, probably from France, and possibly bought from

a continental dealer, and planted in the cave by either Mello or Dawkins. A ferocious reply from Armstrong (1956a) stressed that Grigson's accusation was libellous and unsupported by a shred of evidence. But he failed to come up with any fresh insights into the problematic horse. Indeed, the situation regarding that object has not changed since the astute assessment of it by Garrod (1926, 129) – that is, it was certainly not a forgery, but it was a possible plant:

[it] has every appearance of being ancient. The lines are very fine, but they are not fresh, and there is no trace of the flaking of the surface which would be produced in drawing on a bone already partly fossilised. Moreover, on the opposite side of the rib there are a number of wavy lines, evidently drawn with a slightly blunted instrument, which in every way resemble those left by a flint point on fresh bone. The more general view appears to be that it is a genuine palaeolithic drawing, imported from a French site, but this seems very improbable.

Very improbable indeed, but not impossible. In short it is supremely ironic that the very objects which drew us to search Creswell Crags for cave art and to discover it there – examples of figurative Ice Age engravings, the only examples in Britain – may perhaps be a planted intrusion in one case, and illusory and non-existent in the others.

Further relevant evidence will come, of course, from the excavation and careful sieving of the mounds of sediments lying in front of Church Hole, Pin Hole and Robin Hood Caves at Creswell – a task begun by Paul Pettitt, Roger Jacobi and Andrew Chamberlain in 2006 (see Chapter 2). If they are found to contain quantities of portable art missed in the 1870s, it will be very interesting; if, on the other hand, modern excavation techniques fail to find any further examples of portable art, that will be equally interesting, for very different reasons.

The Palaeolithic archaeology
of Creswell Crags

PAUL PETTITT AND ROGER JACOBI

Introduction

The caves of Creswell Crags have a long history of archaeological investigation that stretches back to the 19th century. Although interested amateurs such as the artist George Stubbs had been aware of the palaeontological potential of the caves since the 18th century, formal excavations of the caves really belong to only two periods – 1875–8 and 1923–38. Most of the archaeology contained in the deposits of the gorge's five main caves – Dog Hole, Pin Hole, Robin Hood Cave and Mother Grundy's Parlour on the north (Derbyshire) side of the gorge, and Church Hole on the south (Nottinghamshire) side – was removed during these campaigns. Since then, materials have been dispersed to at least 11 known museums, with major collections now housed in the British Museum, the Natural History Museum, the Manchester Museum, and the Creswell Crags Museum and Education Centre, and with smaller but significant collections dispersed as widely as University College, Cork, and the National Museum of Natural History of the Smithsonian Institution in Washington, DC. Sometimes parts of the same artefact ended up in different museums (Fig 2.10). Sadly, an unknown quantity of material is now also lost.

Many artefacts were overlooked and allowed to become part of the spoil-heaps that accumulated in front of Church Hole (Fig 1.5), Robin Hood Cave (Fig 1.6) and Mother Grundy's Parlour during the Victorian excavations. Modern excavations into the spoil-heaps outside Robin Hood Cave by John Campbell in the 1960s and outside Church Hole by a University of Sheffield team led by us, which are ongoing, can do much to redress our understanding of how the caves were used by Neanderthals in the Middle Palaeolithic and by modern human hunter-gatherers in the Late Upper Palaeolithic. The major excavation campaigns have to be set against a background of minor excavations in the caves such as those in Pin Hole directed by Rogan Jenkinson in the 1980s, and investigations of the Holocene flora and fauna of the gorge in general and its smaller fissures (Jenkinson and Gilbertson 1984).

The gorge and its caves

The 1km-long gorge at Creswell cuts through beds of Lower Magnesian Limestone that were laid down under marine conditions during the Permian around 260 million years ago. The Magnesian Limestone is part of a long ridge some 20km in width that stretches from around Newcastle in the north to around Nottingham in the south. (It should be noted that, although the term 'Magnesian Limestone' is still widely used by botanists, architectural historians and archaeologists, the stratigraphic name used by geologists is the Zechstein Group). The ridge is dissected by west–east-trending gorges in several areas in Derbyshire and Nottinghamshire, which in the Ice Age would have formed obvious paths through which migrating animals and human hunter-gatherers could pass (Fig 2.1). The steep-sided walls of the Creswell gorge may have been important in channelling reindeer on the move to and from their spring calving grounds in the uplands of the southern Peak District and their winter grazing grounds in the lowlands of what is now Lincolnshire and South Yorkshire. The palaeontology of several caves in the Peak District indicates that reindeer calving certainly occurred in the very late Pleistocene, and it is conceivable that this traditional calving ground was already established at the time Late Upper Palaeolithic humans were using the caves at Creswell.

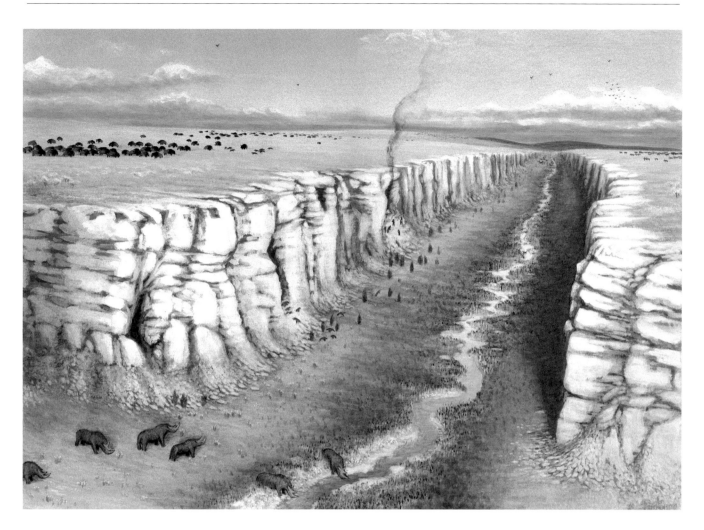

It is easy to imagine that the pronounced bulge of the limestone ridge and the impressive walls of the western entrance to Creswell Crags would have been visible for several miles in the relatively treeless landscape of the late Ice Age. It must have formed a pronounced landmark that would be relatively easy to find. Such points in the landscape are important to mobile hunter-gatherer groups in that they are easy to locate in the brief seasons during which they are used. The presence of caves – which offer shelter and perhaps a degree of cultural or spiritual significance – would further increase the importance of the place. It was also an environment in which several distinct ecosystems met: large herds of gregarious herbivores such as extinct wild cattle (aurochs), bison and mammoths would have grazed the plateaus above the gorge, whereas the lightly wooded environment protected within the gorge itself would have sheltered deer and smaller animals, and perhaps spanned the migration route that

would bring reindeer through Creswell in the autumn and spring.

From the bones excavated in the gorge's main caves we know that hyenas were using the caves for denning – apparently in the same part of the Upper Pleistocene that Neanderthals were occasional visitors – and that they were hunting and scavenging in an environment that included a wide range of animal species (*see below*). Hyenas, in particular, seem to have been attracted to the gorge in some numbers: their remains were abundant in Church Hole, and four complete skulls were found in Pin Hole. William Boyd Dawkins (1876, 245) felt that 'the greater majority of the animals in [Robin Hood] cave were killed and eaten by the hyaenas'. In addition, bears occasionally used the caves – a complete bear skull was found in Pin Hole – and fragments of eggshells may be from eggs carried into this cave by foxes (Armstrong 1926; 1929). A single tooth of the sabre-toothed cat (*Homotherium latidens*) suggests that even this fearsome carnivore may

Fig 2.1
Reconstruction of the gorge as it would have looked at the time of Neanderthal occupation around 50,000 years ago.
(Illus: © Robert Nicholls; courtesy of Creswell Heritage Trust)

have been present in the region towards the end of the Ice Age (Jacobi 2006, and see the discussion in Chapter 1 about the circumstances of this discovery). We know also that Late Upper Palaeolithic humans hunted horses and wild cattle, and trapped Arctic hares.

As well as the carnivores, the caves on either side of the gorge offered shelter to Middle Palaeolithic Neanderthals and Upper Palaeolithic *Homo sapiens*. Four major caves of the northern side of the gorge attracted Neanderthal and modern human hunter-gatherers. At the western end lies Dog Hole (sometimes called West Pin Hole), a narrow solutional fissure that extends some 20m into the cliff (Fig 2.2). Its earliest excavator, Robert Laing (*see below*), described its fauna as being similar to that of Pin Hole, which suggests that it probably contained rich material, but no finds or records of his excavations in the cave survive and it is impossible to know any details. Investigation of the sediments contained in a small fissure outside its entrance contained rare evidence of lynx in Britain (Hetherington *et al* 2005). To the east of Dog Hole is Pin Hole. Its 'main passage' is a similar solutional fissure, some 46m in length and 1–2m in width, which widens in places to form outer and inner chambers. It contained two principal sediment bodies: a lower yellow 'cave-earth', on top of which was an upper red cave-earth. In the Ice Age it saw brief but repeated occupation by

Neanderthals, anatomically modern humans and carnivores. Some 60m to the east of Pin Hole, Robin Hood Cave (formerly called Robin Hood's Hall) is the largest cave in the gorge. This was formed by the linking of several solutional fissures by lateral passages, and is fronted by two wide chambers, each with an entrance in the cliff face. The cave system extends some 50m into the cliff. Several periods of excavation have cleared Robin Hood Cave of vast amounts of sediment and material, and sadly records of these are very variable. The best are those of Mello, Heath and Dawkins, and after them of Robert Laing. From their accounts it is clear that the cave contained fauna as old as the Last Interglacial (Ipswichian), abundant evidence for hyena denning during part of the Last Cold Stage (Devensian), and artefacts documenting occupations by both Neanderthals and anatomically modern humans. A unique artefact found in the cave is a piece of rib-bone engraved with the forequarters of a horse (*see* Chapter 1).

Towards the eastern end of the gorge, Mother Grundy's Parlour is the last and easternmost cave of the north side. It takes the form of a narrow solutional passage extending some 12m into the cliff, fronted by a wide cave mouth that opens onto the gorge. Once again, it contained fauna going back to the Last Interglacial and evidence for use by hunters of the Middle and Upper Palaeolithic. A major

Fig 2.2

Plan of the gorge at Creswell Crags. Modern sewage works (shown as rectangles and circles, upper right) have now been dismantled and the land has reverted to meadow.

(After Jenksinson 1984, 284)

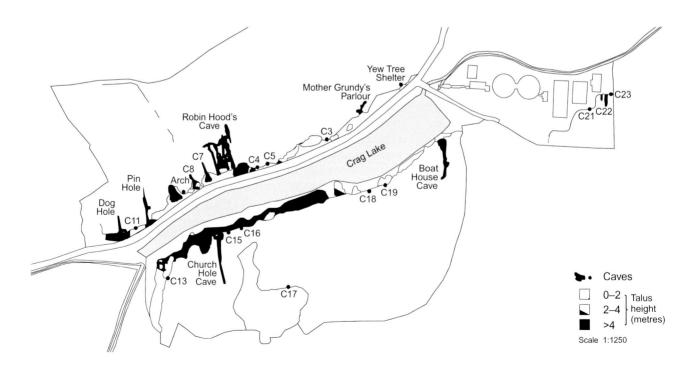

difference from Pin Hole and Robin Hood Cave is that most of the Upper Palaeolithic artefacts were excavated from outside the cave rather than from within it. The cave is also unique for having evidence for a rich Mesolithic occupation, while there are more human remains (probably of Neolithic age) from Mother Grundy's Parlour than from any of the other Creswell caves.

As far as we can tell from early excavation records, the caves of the north side of the gorge contained relatively abundant archaeology that suggests they were more frequently used as shelters than those of the southern side of the gorge. This is perhaps not surprising: they are south-facing, and would thus receive more sunlight, which may be the simplest reason why they were preferred. Alternatively, there may be stronger reasons why at least Church Hole came to be shunned after a time. These we discuss below (p 34).

From Church Hole, at the western end of the southern side of the gorge, looking across to the north side of the gorge one can see Pin Hole to the left and Robin Hood Cave to the right. Like Mother Grundy's Parlour, it is a narrow solutional fissure fronted by a wide cave mouth that faces northwards into the gorge; it possesses a side chamber (Chamber B) and stretches a little over 40m into the cliff. Accounts of early excavations indicate that its sedimentary fill again parallels that of the major caves of the north side. It contained evidence of Middle and Upper Palaeolithic archaeology, albeit apparently less rich than its counterparts in the northern face of the gorge. Finally, Boat House Cave, at the very eastern end of the southern side of the gorge, again possesses a wide cave mouth and a narrow solutional fissure that stretches back some 60m into the cliff. Excavation of this cave was unproductive, probably because the removal of sediments in the 1860s to create a mooring had already removed and destroyed any evidence that it did contain. It is now liable to flooding.

Overall, each of the major caves of Pin Hole, Robin Hood Cave, Mother Grundy's Parlour and Church Hole provides a remarkably similar picture of Ice Age human and animal occupations of the gorge. These were always brief, although there is plenty of evidence of repeated visits at least by Neanderthals, modern humans and hyenas. Faunal and artefactual materials accumulated in the caves piecemeal as a result of these visits. Although most were excavated

in the infancy of archaeology, records of which are either non-existent or found wanting by today's standards, meticulous work by modern scholars has proven remarkably successful in piecing together the story of Ice Age humans and their animal counterparts in the gorge. These provide a rich backdrop to the Late Upper Palaeolithic engravings.

History of investigations

The first Ice Age object recorded as coming from the gorge with any certainty is a woolly rhinoceros tooth from Church Hole. This was found by the manager of nearby Welbeck Quarry in 1872, and was probably left in the cave by hyenas. Systematic excavations began in 1875 when John Magens Mello, rector of St Thomas in New Brampton, investigated Pin Hole and dug a small trench in Church Hole. In the summer of that year he was joined by Thomas Heath, curator of the Derby Free Library, Museum and Art Gallery, and together they began an excavation of Robin Hood Cave. Heath also expanded the excavation of Church Hole that summer, removing much of the sediment from the cave mouth and from Chamber B, where evidence of hyena denning was particularly strong. By 1876 William Boyd Dawkins, who had only two years beforehand published his key book *Cave Hunting*, joined the team. He was plugged into an international scientific network and brought for the first time a continental perspective to the archaeological materials that were emerging. In 1876 the trio removed considerable amounts of sediment from Church Hole and Robin Hood Cave, and published accounts of some of their more major palaeontological and archaeological finds in the *Quarterly Journal of the Geological Society of London* (Dawkins 1876; 1877; Mello 1876; 1877). In the 1880s a medical doctor from Newcastle, Robert Laing, conducted extensive excavations in Dog Hole and Robin Hood Cave, and throughout the late 1870s and 1880s smaller scale excavations by the Cambridge geologists W H Duckworth and F Swainson continued in several of the caves, including an 'ossiferous fissure' (now known as Cave C8) adjacent to Robin Hood Cave. By the end of the 19th century most of the sediments had been removed from all the major caves, except Pin Hole.

Nearly four decades passed until Pin Hole's turn came again. An amateur archaeologist

from Sheffield, Albert Leslie Armstrong, was appointed to excavate the Creswell caves by a Committee for the Archaeological Exploration of Derbyshire Caves formed by the British Association for the Advancement of Science. He was to do this with the assistance of the palaeontologist (and Dawkins's successor at the Manchester Museum) Wilfrid Jackson. The team – which was to dominate Derbyshire cave archaeology until Armstrong's death in 1958 – worked in Pin Hole from 1924 to 1936 (Fig 2.3), joined occasionally by Dorothy Garrod, later to be Disney Professor of Archaeology at Cambridge. Armstrong's records of his excavations vary in quality, but are among the most detailed for any excavations in the gorge, enabling us to reconstruct much of its archaeology (Armstrong 1926; 1929). Armstrong also excavated under the rock-shelter overhang directly outside the mouth of Mother Grundy's Parlour (Armstrong 1925).

Following Armstrong, Charles McBurney from Cambridge excavated on the platform outside Mother Grundy's Parlour, and in turn John Campbell also excavated outside this cave and Robin Hood Cave in 1969, finding further evidence of Middle and Late Upper Palaeolithic lithics, including a small hand-axe and 'Cheddar' and 'Creswell' points (Campbell 1969). Until the present period, work following these was smaller in scope. Simon Collcutt, originally a student of Campbell's, investigated

the stratigraphic sequence of several of the caves in 1974, and Rogan Jenkinson, then ranger warden for Nottinghamshire and Derbyshire county councils, coordinated a small excavation deep within Pin Hole, as well as the coring and small-scale investigation of Robin Hood Cave, Dog Hole Fissure (outside Dog Hole) and Caves 22 and 23 in the Crags Meadow at the shallow eastern end of the gorge.

As well as through limited excavation, our knowledge of what may have happened at Creswell during the Late Pleistocene and during the time the caves were being used by humans has been considerably enhanced by detailed study of the now very scattered fauna and artefacts from the early excavations, and the relating of these to the surviving paper and photographic archives. In addition, there has been a large programme of dating, particularly radiocarbon dating, applied to bones and teeth which has allowed us to create an outline chronology for the archaeology of the Crags. Where dating has been applied directly to bones with cut-marks left during the process of butchery, we can date past human presence as well as identify the animals which were being hunted. In turn, similar research at other Pleistocene and Palaeolithic localities in the British Isles has allowed the reconstruction of a more reliable framework within which to set and interpret the results from Creswell.

A major stimulus to the most recent excavations at Creswell was the discovery in 2003 of the Palaeolithic engravings in Church Hole, Robin Hood Cave and possibly Mother Grundy's Parlour that are detailed in this book. Although most of the art is found in Church Hole, we know relatively little about the Ice Age human occupation of this cave, given the rapid nature and relatively cursory publication of the 1876 excavations which effectively emptied it of its sediments and archaeology. Because of this, excavations by the University of Sheffield, directed by Paul Pettitt and co-directed by Roger Jacobi, Andrew Chamberlain and Alistair Pike, were begun in 2006 on the deposits outside Church Hole immediately to the west of its entrance. These are aimed at recovering material discarded by the Victorian excavators, as well as evaluating the *in situ* Pleistocene and Holocene deposits.

The excavations are ongoing. At the time of writing the Victorian spoil-heap has yielded several dozen bones and teeth of Arctic (mountain) hare, wolf, brown bear, spotted hyena,

woolly mammoth, wild horse, woolly rhinoceros, red deer and reindeer. Of these, most of the reindeer and woolly rhinoceros remains are heavily gnawed, indicating that they were deposited in the cave by hyenas, whereas clear cut-marks on the Arctic hare bones support the inference that this species was important to Late Upper Palaeolithic hunter-gatherers (*see* next section). The spoil-heap has also yielded several quartzite implements of Middle Palaeolithic age and flint implements of Late Upper Palaeolithic age. Beneath the spoil-heap, *in situ* slope deposits contained archaeology of the post-medieval, medieval, Roman, Iron Age, Bronze Age and Neolithic periods, indicating that, after a long period of disuse from the end of the Ice Age, the cave was regularly used throughout the later prehistoric and historical periods.

The archaeology of the caves

The four main caves of the gorge preserve, variably, evidence of four, possibly five, discrete periods of human occupation. Of these the first, and probably second, reflect Neanderthal activity, and the more recent three reflect occupations by Upper Palaeolithic *Homo sapiens*. Table 2.1 summarises the Palaeolithic archaeology of the gorge by period and caves. In order to

gain a detailed glimpse of the archaeology the Creswell caves contained it is most rewarding to turn to Pin Hole (for example Mello 1875; 1876; 1877; Armstrong 1926; 1929). Dating evidence (discussed below) suggests that the fauna and archaeology of this cave are both younger than 64,000 years.

Thankfully, Armstrong recorded the location of finds in the main passage in terms of their distance into the cave and depth within the sediments, relating distance to a datum point at the entrance and measuring depth from a thin layer of stalagmite which capped the deposits. Although he did not record the location of finds relative to the width of the passage (as the cave is so narrow: 1–2m only), enough information was recorded to allow the reconstruction of a detailed longitudinal profile of the main passage on which lithic and other finds can be replotted (Jacobi *et al* 1998). This is reproduced here (Figs 2.4–2.6). The few diagnostically Neolithic finds are relatively high in the stratigraphy, as one would expect, and blades and bladelets characteristic of the Upper Palaeolithic were found in the upper sediments, the lower finds of which respect a fairly consistent line (Fig 2.4). In some cases broken pieces or sequential removals among these can be fitted back together – as indicated

Table 2.1 Periods of known human occupation of Creswell Crags by cave and by palaeoclimatic period

	Pin Hole	Robin Hood Cave	Mother Grundy's Parlour	Church Hole	Period
Mousterian (Neanderthals)	*	**	*	*	Oscillating conditions of Marine Isotope Stage (MIS) 3: 60000–40000 BP
Lincombian (leaf-point assemblages; Neanderthals?)	*	**			Oscillating conditions of MIS3: 38000–36000 BP
Gravettian (anatomically modern humans)	*				Cold tundra landscapes of late MIS3: 29000–28000 BP
Magdalenian (Creswellian) (anatomically modern humans)	*	**	*	*	First half of Lateglacial Interstadial ('Bölling'): 12600–12100 BP
Federmessergruppen (anatomically modern humans)	*	*	**		Second half of Lateglacial Interstadial ('Allerød'): 12000–11000 BP
Mesolithic (anatomically modern humans)	*		**		Postglacial ('Boreal'): 9000–8500 BP

* indicates presence ** indicates abundance.

Fig 2.4 Section of Pin Hole main passage plotting major finds.

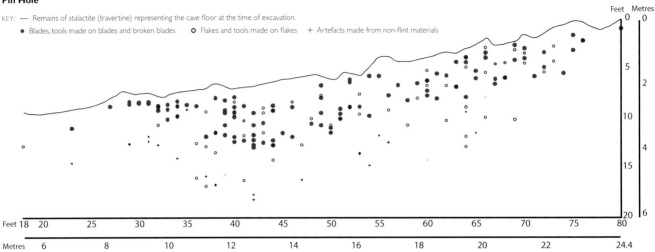

Pin Hole

KEY: — Remains of stalactite (travertine) representing the cave floor at the time of excavation.

● Blades, tools made on blades and broken blades ○ Flakes and tools made on flakes + Artefacts made from non-flint materials

Fig 2.5 Lines showing joins (refits) between Upper Palaeolithic lithics.

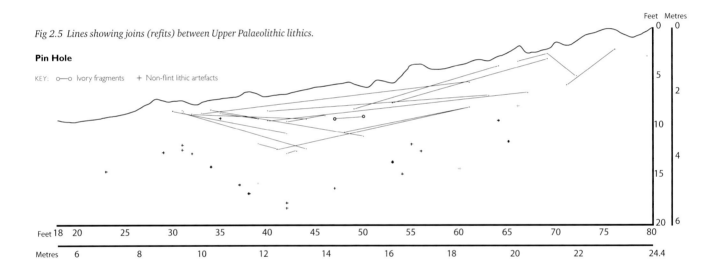

Pin Hole

KEY: ○—○ Ivory fragments + Non-flint lithic artefacts

Fig 2.6 AMS radiocarbon dates on animal bones associated with Middle Palaeolithic lithics, in thousands of years.

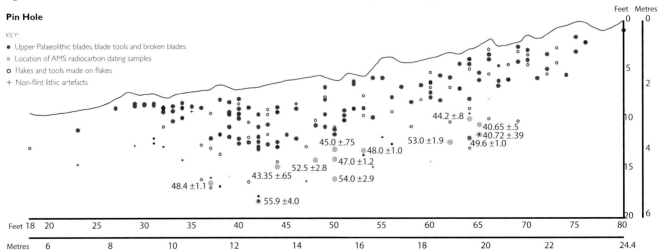

Pin Hole

KEY:
● Upper Palaeolithic blades, blade tools and broken blades
● Location of AMS radiocarbon dating samples
○ Flakes and tools made on flakes
+ Non-flint lithic artefacts

by the connecting lines on Fig 2.5 – and show how pieces have moved downslope either from the back towards the front of the cave or from the cave mouth into the outer chamber. There is a fairly well-established line of contact between these Upper Palaeolithic finds and those of the Middle Palaeolithic beneath, although there is some evidence from the radiocarbon dates of older bones becoming reworked upwards into younger contexts. Twenty-five Middle Palaeolithic quartzite arte-facts survive from excavations in the cave; of these, ten are various forms of scraper (a general cutting edge), one is a pointed chop-ping tool and one is a bifacially worked piece. A large number of faunal remains were recov-ered from the Middle Palaeolithic contexts, some of which have been dated directly by AMS (accelerator mass spectrometry) radiocarbon to between 56,000 and 40,000 years ago (marked on Fig 2.6 and discussed in the next section).

A broken 'leaf point' (Fig 2.7) was found in a narrow passage which opens off to the east of the main passage. This artefact, which would

have been pointed at its upper end, had been made on a flint blade. Its likely function was as a weapon-head. Because these leaf points are part of an Upper Palaeolithic technology and date from a time when there probably were both Neanderthals and anatomically modern humans in Europe, it is unclear which of these were responsible for their manufacture. We believe that Neanderthals made them, because the roots of leaf-point technologies lie in the European Middle Palaeolithic, and only Nean-derthals have been found associated with this. This find cannot be linked to the stratigraphy of the main passage, but a hyena jaw fragment found close to the leaf point has been dated by AMS radiocarbon to 37,800 ±1600 BP (OxA-4754: Jacobi *et al* 2006; *see* box on radiocarbon below, p 89).[1] This is in keeping with the general stratigraphy of the cave and with ages for leaf points elsewhere.

Two diagnostic Mid-Upper Palaeolithic 'Font Robert' points (Fig 2.8) were found in the main passage near the base of the spread of Upper Palaeolithic blades and bladelets. One was excavated from about 12.3m into the cave

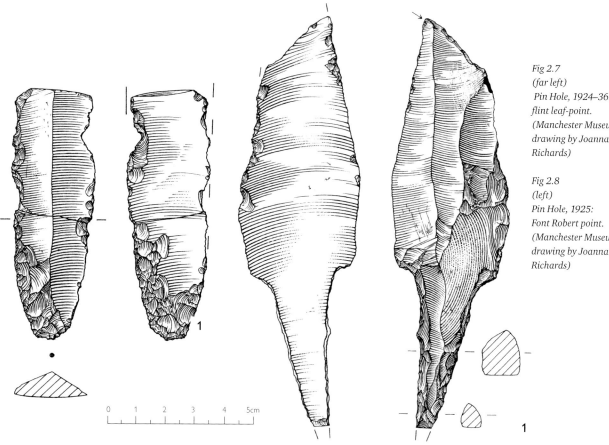

Fig 2.7 (far left) Pin Hole, 1924–36: flint leaf-point. (Manchester Museum: drawing by Joanna Richards)

Fig 2.8 (left) Pin Hole, 1925: Font Robert point. (Manchester Museum: drawing by Joanna Richards)

and 1.54m below the floor of the cave, and the other as three refitting pieces upslope from the first point and a further 10m deeper in. At sites elsewhere points of this type have been dated to 29,000–28,000 radiocarbon years ago.

The majority of the flint artefacts found at Pin Hole date from the Late Upper Palaeolithic, during a period of mild climate termed the Lateglacial Interstadial. Radiocarbon determinations from sites with preserved pollen and beetle remains, both potentially sensitive indicators of past climate, indicate that the Interstadial lasted between 13,000 and 11,000 radiocarbon years ago. At its warmest, near the beginning, temperatures reached those of today. The Interstadial had been preceded by a long period of intense cold when ice sheets in the British Isles reached as far south as the Gower Peninsula of south Wales and north Norfolk, although they failed to reach Creswell. This is known as the Last Glacial Maximum, and at this time Britain appears to have been deserted by humans. Recolonisation at the beginning of the Interstadial was part of a much wider resettlement of central and northern Europe by the Magdalenians (Housley *et al* 1997). The artefacts left by the first re-colonisers of Britain have sometimes been termed Creswellian, but we shall refer to them as Magdalenian.[2]

Artefacts found in Pin Hole and which are likely to be Magdalenian include backed blades and points, end-scrapers, piercers and a burin. Among the points is one given a trapezoidal shape by means of a pair of divergent oblique truncations and retouch of the shorter edge between them. This is what is termed a 'Cheddar' point, a reference to Gough's Cave at the mouth of Cheddar Gorge in Somerset, where such points are relatively numerous. These distinctive points have also been found in Robin Hood Cave (Fig 2.11, 2–3) and at Mother Grundy's Parlour, while there are probable fragments from Church Hole.

The processing of Arctic hares for their meat and fur was practised by Magdalenians in the cave, as two cut-marked bones of this animal recovered from the cave have been dated by radiocarbon to *c* 12,500 BP. A basal length of a weapon tip or *sagaie* of mammoth ivory, recovered in association with the Magdalenian lithics, bears an engraved design that has clear parallels among contemporary French and Belgian Magdalenian sites (Pettitt 2007). Pin Hole has also yielded the enigmatic engraving of a humanoid outline on a rib from a large herbivore – probably from a woolly rhinoceros – discussed in Chapter 1. Given the re-characterisation of the piece through conservation, one can only conclude that it depicts an upright human-like figure, perhaps a human, perhaps a bear, or even an imaginary being.

As Robin Hood Cave is the largest cave in the Magnesian Limestone of Britain, it is perhaps not surprising that its Palaeolithic archaeology should be so rich. It possesses two principal chambers with entrances onto the gorge – the Western and Eastern chambers. These are linked at their rear to the Central Chamber.

Excavation by Robert Laing in the Central Chamber produced a fauna of Last Interglacial (Ipswichian) age, which included hippopotamus. These bones are now lost. It is clear from what was published that the sediments in the Central Chamber were stratigraphically older than those of the Western Chamber, to which it is linked by a short tunnel. The Western Chamber was excavated by Dawkins, Heath and Mello and produced extensive evidence for hyena denning (Fig 2.9), as well as Palaeolithic human occupation. Palaeolithic artefacts were also found at its entrance onto the gorge and in front of this in scree deposits. While information is limited, it seems probable that most Middle Palaeolithic artefacts came from within the Western Chamber, while those of the Upper Palaeolithic came from its entrance and just outside.

Robin Hood Cave has produced the largest sample of Middle Palaeolithic artefacts from northern England. These were made from flint, quartzite and clay ironstone, with quartzite being the most prolifically used material. It is

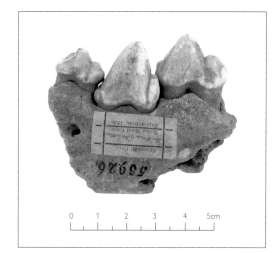

Fig 2.9
Partial jaw of spotted hyena (Crocuta crocuta) *found in 1876 at Robin Hood Cave. (Catalogue No. A58926, Department of Anthropology, Smithsonian Institution; photo: D E Hurlbert)*

Fig 2.10
Robin Hood Cave, 1875–6:
flint leaf points.
(1: Brewhouse Yard
Museum, Nottingham
2: Manchester Museum,
upper part, and Derby
Museum and Art Gallery,
lower part
3: British Museum, upper
part, and Manchester
Museum, lower part;
drawings by Hazel
Martingell)

difficult to be precise about how many quartzite artefacts have been recovered from Robin Hood Cave by its different excavators, but it may well have been in excess of 500. This material had been worked by the Neanderthals to produce flakes, many with a strip of skin left along one margin to provide a surface for the index finger when in use as a knife. There are also chopping tools made by removing intersecting flakes from two faces of a cobble. Flint, quartzite and clay ironstone were all used to produce small hand-axes which, by analogy with what is known from sites elsewhere, were probably intended for butchery tasks. Denticulates were made on flint flakes, and the most likely function of their deeply notched edges was as spokeshaves for shaping and pointing wooden spears. Use of the cave by Neanderthals probably took place after 55,000 years ago and most

probably between 50,000 and 40,000 radio-carbon years ago.

There are at least 11 flint leaf-points from Robin Hood Cave. One is completely bifacially chipped, while the others have been made by the retouching of triangular-sectioned blades (Fig 2.10). This retouch was aimed both at pointing the blades and at reducing any longitudinal curvature so that they accurately continued the line of the shaft into which they were fixed. These leaf points probably reflect relatively late Neanderthal activity which – on the basis of a small number of radiocarbon determinations from other sites, including Pin Hole (*see above*) – may have been between 38,000 and 36,000 years ago.

However, the majority of the flint artefacts excavated from Robin Hood Cave are clearly attributed to the Magdalenian. These include

Fig 2.11
Robin Hood Cave, 1875–6:
Late Upper Palaeolithic
(Magdalenian) flint
artefacts.
(1, 2 and 4: Brewhouse
Yard Museum, Nottingham;
3, 5 and 7: Manchester
Museum; 6: British
Museum; drawings by
Hazel Martingell)

1 'Creswell' point
2–3 'Cheddar' points
4 End-scraper
5 Burin on retouched
truncation
6 Piercer
7 Combined end-scraper
and burin on retouched
truncation

many backed blades, either Cheddar points or backed blades with just a single oblique truncation which are known as 'Creswell' points. There are also end-scrapers, burins, piercers and retouched blades (Fig 2.11). Faunal remains reveal that the hunting or snaring of Arctic hares was an important activity at this time (Charles and Jacobi 1994), and dating of cut hare bones indicates that this was going on about 12,400 radiocarbon years ago. Awls made from bones of Arctic hares suggest that soft hides or furs were worked in the cave, and it is tempting to link these with the processing of Arctic hare fur (see below). The engraving of the forequarters of a horse on a piece of rib-bone has clear parallels with depictions at Magdalenian sites in the Paris Basin (Sieveking 1992), so linking the users of the Creswell caves to a much wider network of shared ideas.

A human frontal bone found in scree deposits in front of the west entrance to the cave in 1969 was linked to other cranial bones and a partial mandible found in the spoil-heaps from the Victorian exploration of the cave. Originally thought to be Palaeolithic, and

interpreted as evidence for head-hunting, it has recently been shown, by means of a direct radiocarbon date, to be of Early Neolithic age. Fragments of post-cranial human bones have also been recognised from the spoil-heaps, thereby making the suggestion of head-hunting appear improbable.

The inside of Mother Grundy's Parlour was excavated by Donald Knight, who worked for Dawkins as a museum assistant at Owens College, Manchester. His work was published by Dawkins and Mello (1879). It is possible that internal deposits left undug by Knight were removed by Robert Laing, who also excavated at Dog Hole and Robin Hood Cave, but this is not known for sure. The deposits on the platform outside the cave mouth and beneath what would have been a rock shelter were investigated over many years by Leslie Armstrong, beginning in 1923 (Armstrong 1925).

The oldest sediments within the cave, a ferruginous sand and red clay, produced several spectacular fossils of hippopotamus, including dentitions, together with teeth of narrow-nosed rhinoceros and bones and teeth of bison. These had been brought into the cave

by spotted hyenas, which were also represented by abundant fossils, including skulls and jaws. This fauna clearly belongs to the Last Interglacial (Ipswichian).

A very small number of Middle Palaeolithic artefacts were found in the cave, including a hand-axe, now lost, made from clay ironstone. They came from a sandy cave-earth overlying the interglacial sediments. As at Pin Hole and Robin Hood Cave, human occupation appears to have alternated with that by spotted hyenas.

Large numbers of Late Upper Palaeolithic flints have been found at Mother Grundy's Parlour, principally by Armstrong. These include artefacts of Magdalenian type, similar to those from Robin Hood Cave. While at the other caves at Creswell such artefacts appear to have been associated with the processing of Arctic hares, at Mother Grundy's Parlour modified hare bones are completely absent and, instead, smashed bones and teeth of wild horses appear contemporary with the Magdalenian occupation.

Mother Grundy's also differs from the other caves at Creswell in the number of the artefacts which it has yielded belonging to a Late Upper Palaeolithic technology more recent than the Magdalenian. This material, related to the *Federmessergruppen* of the European mainland, dates from the second part of the Lateglacial Interstadial, while the Magdalenian belongs to its earlier part. The artefact type which identifies this younger technology is the 'penknife point', a blade or bladelet with one margin chipped to a convex outline. At the base of the point and on the opposite margin is an oblique or concave truncation. Where this meets the convex margin it forms an offset tang. There are 23 such points from Mother Grundy's Parlour, compared with 4 from Pin Hole and

just a single example from Robin Hood Cave. The smaller examples were probably arrow tips (Fig 2.12).

To the west of the platform deposits outside the cave and at the base of this area of the cave Armstrong exposed a roughly circular hearth formed by a scooped-out shallow hollow, with slabs of limestone lining the sides. The surrounding sand was burnt a bright red for a considerable area beyond and beneath the fire hole. Black ashes and bone fragments came from its fill, as well as several penknife points and fragments of such points (Armstrong 1925). It is not known for certain which animals were being hunted by the makers of the penknife points, but it is possible that some of the bones and teeth of wild cattle and red deer found at the cave might represent the remains of their prey.

Armstrong identified what he thought to be representations of reindeer, a bison-head and a rhinoceros-head on small fragments of ancient bone. None is believable, and most of the markings are probably due to root action (*see* Chapter 1). The exception may be the lines forming the horn of the rhinoceros. These appear to be genuine cut-marks. If so, they are some of the very few from Mother Grundy's Parlour.

Mesolithic occupation was centred on the east side of the platform. There are many microliths, mostly of simple non-geometric shapes. These include several with inverse chipping at their bases, a type common in the Midlands. There are also many small scrapers. Some of the artefacts have been made from cherts with a likely origin in the Peak District, implying considerable movements by the hunters who made them. Charred hazelnut shells indicate that the cave may have been used by Mesolithic hunters in late summer or

Fig 2.12
Mother Grundy's Parlour,
1923–5: Late Upper
Palaeolithic
(Federmessergruppen)
flint artefacts.
(British Museum; drawings
by Hazel Martingell)

1 Curve-backed bi-point
2–4 'Penknife' points
5–7 Thumbnail scrapers

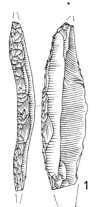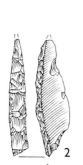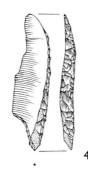

early winter. Radiocarbon dates suggest that this occupation took place between 9,000 and 8,500 years ago. Wild cattle were hunted, and a find unique in the British Isles is a fragment of rib-bone with an embedded microlith, presumably an arrow tip.

Remains of several human individuals were found in the cave, some apparently as partial burials. Radiocarbon dating has been made difficult by the organic preservatives applied by the excavators to some of the finds, but they are most probably Neolithic.

Church Hole is the only cave on the southern side of the gorge that is known to have contained archaeological remains. A picture of what Church Hole originally contained can be built up from known collections in Britain and Eire (Jacobi 2007), previously unrecorded collections housed in the Smithsonian Institution in Washington, DC (Pettitt pers obs), and materials recovered from the spoil-heap of the Victorian excavation of the cave during ongoing excavations. Despite the research on museum collections, some of the finds made in 1876, when the cave was excavated by the Creswell Caves Exploration Committee, remain lost. This is particularly the case for the flint artefacts, most of which appear to have been

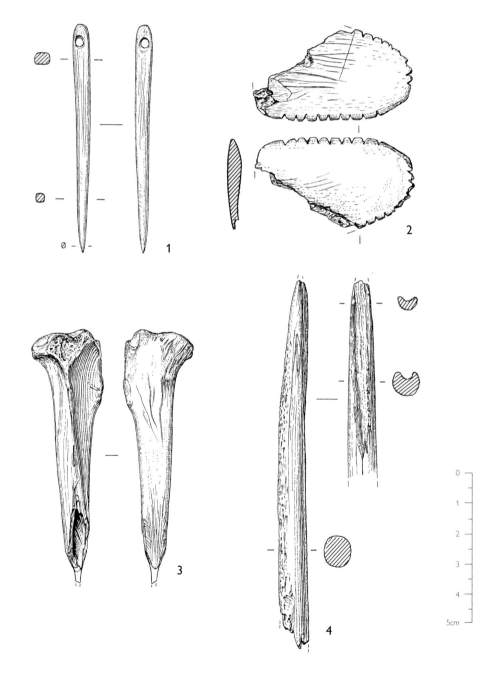

Fig 2.13
Church Hole, 1876: Late Upper Palaeolithic bone and antler artefacts. (British Museum; drawings by Jules Cross)

1 Bone needle
2 Thread-winder made from vertebral process
3 Awl made from tibia of Arctic hare
4 Part of rod with scooped end made from reindeer antler, probably a javelin foreshaft fragment

Magdalenian. The Middle Palaeolithic artefacts are made on quartzite, and include four cores; two of these show removals from a single striking platform created by the removal of one flake, while the other two are discoid cores showing the radial removals of flakes from a single surface. In addition to these, four crude chopping tools, a number of simple flakes, four naturally backed knives, a scraper on an elongated flake and a flake with bifacial retouch were recovered. The Late Upper Palaeolithic (Magdalenian) lithics are dominated by broken blades and bladelets; four unbroken examples of these are known, and the cave also yielded several flakes, crested blades resulting from knapping, burins, piercers and abruptly re-touched pieces. These indicate that flint cores were knapped in the cave, most often to produce blades and bladelets, and that a variety of tasks, including hide working and perhaps wood-working and engraving, were performed here.

In addition to the lithic items, Church Hole produced several worked bone and antler items of Magdalenian age (Fig 2.13). These include a bone eyed needle; a trimmed oval-shaped process of a lumbar vertebra of a large herbi-vore (possibly horse), bearing irregularly spaced notches which may have been used as a serrated flesher or as a thread-winder; two awls made from the tibiae of Arctic hare; and two incomplete parts of reindeer antler rods which have often been described as 'marrow scoops' but which probably functioned as javelin foreshafts (Jacobi 2007).

Neanderthals in the gorge

Recent research suggests that humans (Neanderthals) may have been absent from the British Isles for a period of over 150,000 years during the latter part of the Middle Pleistocene and the early part of the Upper Pleistocene (Ashton and Lewis 2002; Currant and Jacobi 2002). This is a length of time which saw great extremes of climate, from glacial to fully interglacial. During times of glacial cold, the environment was probably too severe for humans to have been able to cope, while during the Last Interglacial (130,000–115,000 BP) Britain was an island. The Last Interglacial is the last time that hippopotamus was found in Britain (Stuart 1976): bones and teeth of this animal have been found in Robin Hood Cave and Mother Grundy's Parlour, but, as we have

seen, in layers older than any of those which produced evidence for a human presence.

Late Middle Palaeolithic sites for which we have reliable dating evidence indicate that Neanderthals returned to Britain about 60,000 years ago. They were associated with a Middle Palaeolithic technology, and technologies of this type probably continued to be made up to 40,000 years ago. At Creswell there is evidence for the Neanderthal use of Pin Hole, Robin Hood Cave, Mother Grundy's Parlour and Church Hole. The evidence from each is similar, although there are intriguing differences between the archaeology they left in some of the caves. In each case, evidence for a Neanderthal presence is contemporary with a rich grouping of mammals, named after Pin Hole. Many faunas of this time were accumulated by spotted hyenas and, typically, their prey included woolly mammoth, wild horse, woolly rhinoceros, Irish giant deer and reindeer. Here and elsewhere in the UK, where Neanderthals are present they seem to have been part of this 'Pin Hole Mammal Assemblage Zone' (Currant and Jacobi 2001), probably as an efficient hunter sharing the top of the food chain with hyenas and wolves. Their characteristic signature at Creswell is relatively simple flakes and tools produced on the small quartzite cobbles they could pick up from the river that flowed through the gorge (Fig 2.14). These cobbles were used as hammer-stones to remove from cores simple flakes bearing a sharp cutting edge; they were modified as chopping tools, and probably used to break open the bones of prey to access marrow.

In addition to this heavy-duty quartzite toolkit the Neanderthals used flint that they had imported from more distant sources to produce finer tools such as scrapers (general-purpose knives) and small triangular hand-axes that are a characteristic signature of Neanderthals across western Europe at this time. A finely elongated Mousterian point (probably a knife) and five scrapers produced on flint were recovered from Pin Hole, as well as sharpening and thinning flakes that indicate scrapers or hand-axes were being made or refined in the cave. The production and use of scrapers was clearly dominant in Pin Hole, although bifaces (hand-axes) have been found in Pin Hole, Robin Hood Cave and probably Mother Grundy's Parlour. At Church Hole the presence of hammer-stones and simple flakes indicates that knapping took place here. Unlike

Fig 2.14
Middle Palaeolithic
quartzite artefacts from
Creswell Crags. These
include a chopping tool
(bottom left corner) and
flakes, many with a strip of
skin along one margin.
(Catalogue No. A58877,
Department of
Anthropology, Smithsonian
Institution; photo:
D E Hurlbert)

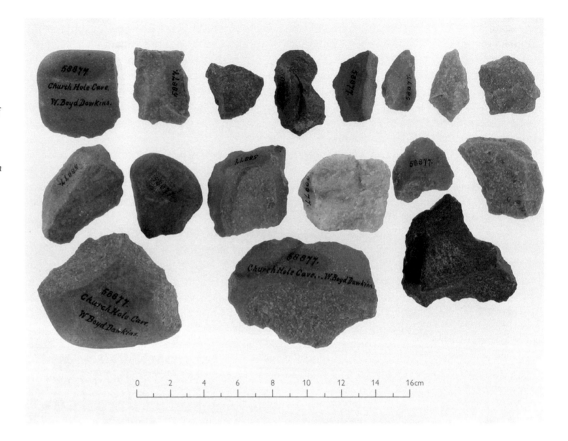

in Pin Hole, the production of simple flakes appears to have been most common, although, once again, several scrapers are in evidence. In addition to these, three flint artefacts may be ascribed to the Middle Palaeolithic. These are a flake, a flake bearing a simple Clactonian notch, presumably used for whittling, and a flake produced in making a notch on the bulbar face of a larger flake. It is difficult to identify the source of the flint used occasionally by the Neanderthals. Some is grey and opaque in nature and in this sense similar to flint found in north Lincolnshire and the Yorkshire Wolds, although it could possibly have been picked up in the Creswell area as glacial erratics.

Pin Hole is the cave where most effort has been expended in attempting to constrain the age of its Middle Palaeolithic (Neanderthal) use. Fragments of a stalagmite floor older than the cave-earth which contained the Middle Palaeolithic artefacts and Pin Hole type fauna have given ages, using uranium-series dating, as recent as 64,000 years ago. These ages give a *terminus post quem* for both the archaeology and fauna. A large series of radiocarbon and electron spin resonance dates on fauna found with the Middle Palaeolithic artefacts has given ages of between 38,000 and 55,000 years ago (Jacobi *et al* 1998; 2006). Similar radiocarbon ages have been obtained for bones and teeth found with Middle Palaeolithic artefacts at Robin Hood Cave.

Many of the dated bones have clearly been gnawed by spotted hyenas. This social carnivore was very abundant in Britain during the Upper Pleistocene, and at Creswell it was particularly abundant in Church Hole, where its remains were common in the cave mouth and smaller Chamber B opening off this. So far, all of the remains of woolly rhinoceros and reindeer recovered from new excavations outside Church Hole relate to hyena activity, not human.

So far, only a single cut bone has been identified which, from its radiocarbon age, was probably associated with Middle Palaeolithic use of the caves. This is a reindeer astragalus with very clear cut-marks on its external face. It is not known from which of the caves it was collected. Carbonised bone fragments from Pin Hole and Robin Hood Cave indicate that the Neanderthals used fire.

Creswell remains one of the most northerly find-spots of leaf points in the British Isles. We have already stated our belief that these

were most probably produced by Neanderthals and that this technology was still being made 36,000 radiocarbon years ago. The relative abundance of leaf-point find-spots in the UK as opposed to adjacent areas of Europe is of great interest and may suggest that Britain was a relatively rich hunting-ground for Neanderthals. Such a patterning would be difficult to interpret if, instead, these implements represented a pioneer population of anatomically modern humans. Perhaps this north-west extremity of the Ice Age world saw some of the last Neanderthal populations. For now, our picture is fuzzy, and only further excavation of newly discovered sites will allow us to date more precisely the latest Neanderthals to occupy the country, establish the conditions that allowed them to do so and perhaps evaluate the reasons for their local extinction.

Upper Palaeolithic hunter-gatherers: Gravettians and Magdalenians at Creswell

Neanderthals had probably stopped visiting the gorge by around 36,000 BP, and some 7,000–8,000 years were to pass until the next human groups once again sheltered in its caves. These people, the Gravettians of the Mid-Upper Palaeolithic, left behind two Font Robert points in Pin Hole. Evidence for Gravettian activity in Britain is very sparse, amounting to a handful of diagnostic artefacts from only seven sites. From this period, however, comes the spectacular burial of the 'Red Lady' in the Goat's Hole cave at Paviland on the Gower Peninsula. William Buckland, who excavated the skeleton in 1823, believed it to be a female of the Roman period – hence the name – but we now know that it was a young male Gravettian who died around 29,000 BP and was buried wearing clothing coloured with red ochre (Jacobi and Higham, 2008). With the body were wands made from mammoth ivory, ivory bracelets and periwinkle shells (Aldhouse-Green 2000). The lack of Gravettian archaeology in Britain can be taken as a reliable indication that they were only rarely operating this far north and west, probably because climatic conditions had already begun to decline towards the low of the Last Glacial Maximum centring upon the period 20,000–18,000 BP.

Conditions during the period of the Last Glacial Maximum (known in Britain as the Dimlington Stadial) were extreme, and the British Isles were probably deserted by humans. Radiocarbon determinations for animals are few, perhaps a reflection of the low contemporary biomass. Animals dated to the Stadial are Arctic hare, brown bear, musk ox and reindeer. Humans appear to have returned to Britain only about 12,600 radiocarbon years ago, shortly after the beginning of the Lateglacial Interstadial. This return may have coincided with that of wild horses, which were a principal prey. Over 40 find-spots of probable Magdalenian material are known from the British Isles (Fig 2.15). A single artefact of this age from Scotland is the earliest evidence for a human presence in that country. Remains of this period constitute the most abundant evidence of Upper Palaeolithic groups at Creswell.

The stone tools of these Late Upper Palaeolithic hunters have very direct parallels with material from France, Belgium, the Netherlands and Germany. This was unknown when Dorothy Garrod published her survey of the Upper Palaeolithic of Britain (1926). As a result she felt that the British material was something distinct, and coined the term 'Creswellian' to describe it. She chose this name because the caves of Creswell then formed Britain's primary resource for Late Upper Palaeolithic artefacts. This term remains with us today and is still widely used, although, as we have noted above, we prefer the term Magdalenian because this links these British industries to a much wider population dispersal into empty areas of Europe following the Last Glacial Maximum. This dispersal has its roots in the Magdalenian of south-western Europe (Gamble *et al* 2005). The discovery of cave art at Creswell gives a new and at the time unexpected level of connectedness between the British Late Upper Palaeolithic and the continental Magdalenian (*see* Chapter 4 and also Pettitt 2007).

Magdalenian sites in Britain cluster relatively tightly between 12,600 and 12,200 radiocarbon years ago, which places the sites in the relatively mild conditions of the first half of the Lateglacial Interstadial (*see* Table 2.2 for radiocarbon dates from Creswell Crags). During this time mean summer temperatures were close to those of today (Coope 1977). Despite this, there were few trees around, and much of the country, including the Creswell region, was dominated by open grasslands which supported a wealth of animals, such as Arctic hare, woolly mammoth, wild horse, reindeer and wild cattle, as well as carnivores,

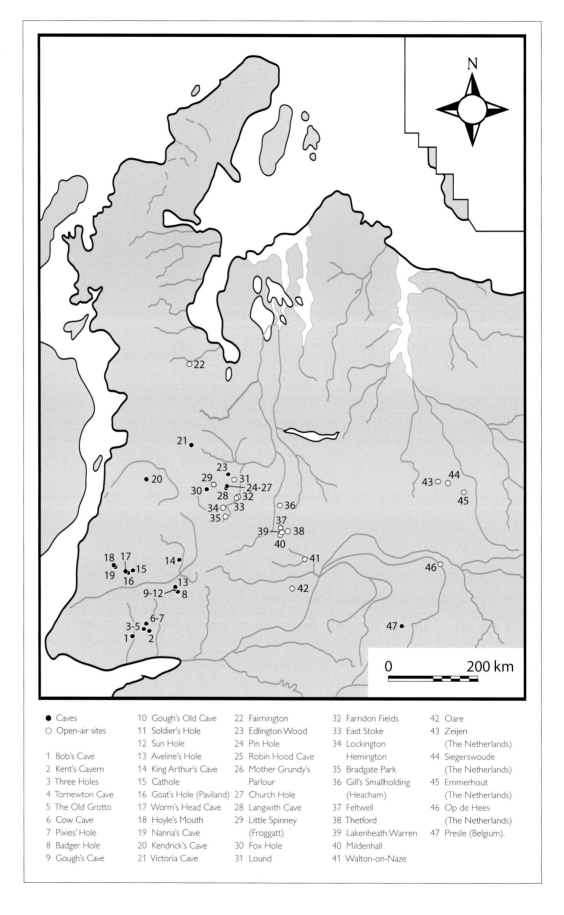

Fig 2.15
Map of Britain during the early part of the Lateglacial Interstadial, showing distribution of archaeological find-spots. Coastlines follow Lambeck (1995) and rivers follow Coles (1998).

● Caves	10 Gough's Old Cave	22 Fairnington	32 Farndon Fields	42 Oare
○ Open-air sites	11 Soldier's Hole	23 Edlington Wood	33 East Stoke	43 Zeijen
	12 Sun Hole	24 Pin Hole	34 Lockington	(The Netherlands)
1 Bob's Cave	13 Aveline's Hole	25 Robin Hood Cave	Hemington	44 Siegerswoude
2 Kent's Cavern	14 King Arthur's Cave	26 Mother Grundy's	35 Bradgate Park	(The Netherlands)
3 Three Holes	15 Cathole	Parlour	36 Gill's Smallholding	45 Emmerhout
4 Tornewton Cave	16 Goat's Hole (Paviland)	27 Church Hole	(Heacham)	(The Netherlands)
5 The Old Grotto	17 Worm's Head Cave	28 Langwith Cave	37 Feltwell	46 Op de Hees
6 Cow Cave	18 Hoyle's Mouth	29 Little Spinney	38 Thetford	(The Netherlands)
7 Pixies' Hole	19 Nanna's Cave	(Froggatt)	39 Lakenheath Warren	47 Presle (Belgium).
8 Badger Hole	20 Kendrick's Cave	30 Fox Hole	40 Mildenhall	
9 Gough's Cave	21 Victoria Cave	31 Lound	41 Walton-on-Naze	

such as fox and wolf. In Britain, as on the continent, Late Upper Palaeolithic groups were drawn to the margins of uplands, where a rich variety of resources could be found, including animals whose migration patterns could be predicted (Barton *et al* 2003).

Creswell is located at the fringes of the uplands (in this case the Peak District). Its four major caves provide evidence of Magdalenian activity, and it is probable that Dog Hole was also used at this time. It is by far the most abundantly represented period in the Crags. The nature of this archaeology is typical of the refuse that highly mobile hunter-gatherer groups would have left behind during relatively brief stays in the gorge. In no case does it suggest lengthy occupations. Instead, it is probably best to view Creswell as an area to which groups would return at certain times of the year in order to exploit seasonally abundant resources or as a place which, because of its caves, was good for a stopover when on journeys between other places, for example the Trent Valley and the Peak District, in both of which there are Magdalenian sites.

Armstrong (1925, 156) thought on the basis of water-scouring marks on the flint from Mother Grundy's Parlour that the most likely source was 'in glacial drift to the south or east', but modern chemical sourcing of the flints used for blades and bladelets in Robin Hood Cave indicates an origin down in Wessex, over 200km away (Rockman 2003). Flint from the same probable source has been identified at a large Magdalenian open-air site on a terrace of the River Trent at Farndon Fields, just southwest of Newark in Nottinghamshire. Farndon is only 33km from Creswell Crags, and it is difficult not to see a meaningful connection

between the two sites: perhaps they were used by the same group at different times of the year. The further demonstration that flint at these East Midlands sites could be from the same sources as that used in Cheddar Gorge (Jacobi 2004) opens up the possibility that very large scale annual movements took place at this time, perhaps using the major river valleys as corridors. Somewhere in their annual round the Magdalenians encountered reindeer, whose antlers they used to make artefacts such as the javelin foreshafts from Church Hole (Fig 2.13, 4). So far, these sites have not been identified, but it is important to remember in any consideration of the Magdalenian that much of the North Sea was land at this time – Doggerland (Coles 1998) – and that it is likely that its plains were also a part of the annual round. This explains why flint industries in Britain and the Netherlands are so similar.

The archaeology that does survive from the gorge provides some clues as to what Creswell could offer to Magdalenian groups during their brief visits. The ecotonal nature of the area would have provided a rich selection of resources within a relatively small space. Wild horse, wild cattle and Arctic hare were clearly important, and perhaps migrating reindeer would make it attractive in the spring. The abundance of Arctic hare bones in Robin Hood Cave and Church Hole (and their presence in Pin Hole) is suggestive of organised trapping of this animal – for its fur as much as for its meat (Charles and Jacobi 1994).

The presence of abundant charcoal fragments in sediment remnants adhering to the walls of Church Hole indicates that fires were being lit in the caves for warmth and light. A range of different tools were clearly being used

Table 2.2 Selected AMS radiocarbon dates on bones indicative of Late Upper Palaeolithic activity at Creswell Crags

Site and laboratory number	Sample description	Date (^{14}C years BP)
Robin Hood Cave OxA-3416	Awl made from Arctic hare tibia	12 580 ± 110
Robin Hood Cave OxA-3415	Human-modified Arctic hare bone	12 340 ± 120
Church Hole OxA-3717	Reindeer antler javelin foreshaft	12 020 ± 100
Church Hole OxA-3718	Reindeer antler javelin foreshaft	12 250 ± 90
Church Hole OxA-8730	Human-modified bovine bone	11 915 ± 75
Mother Grundy's Parlour OxA-8738	Human-modified horse tooth	11 970 ± 75
Mother Grundy's Parlour OxA-8739	Human-modified horse tooth	12 170 ± 80
Mother Grundy's Parlour OxA-5698	Human-modified horse tooth	12 280 ± 110

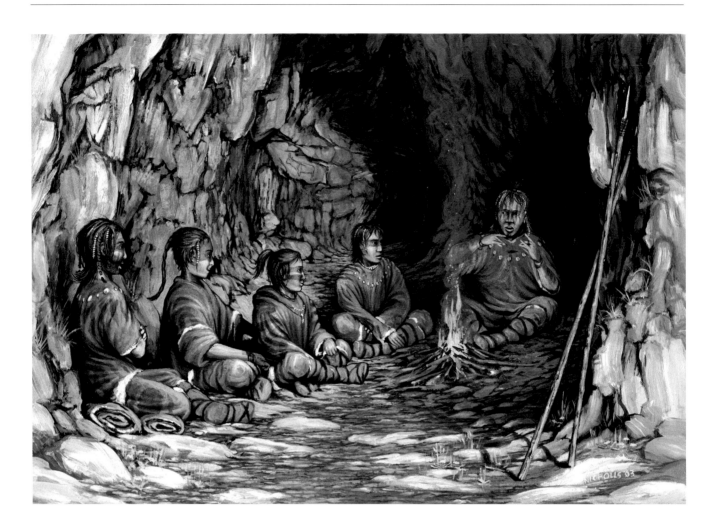

Fig 2.16
Reconstruction of Late
Magdalenian activity in
Church Hole cave.
(Illus: © Robert Nicholls;
courtesy of Creswell
Heritage Trust)

in the caves (Fig 2.11), and the discovery of a bone needle, awls and a possible thread-winder strongly indicates that the production or repair of clothing was practised in the gorge (Fig 2.13, 1–3). This may explain the importance of Arctic hares at Creswell. Perhaps the maintenance of clothing – for which the soft hide of reindeer calves may have been important also – was an important seasonal activity in the area. A brief note in Dawkins's excavation diary for Church Hole suggests that red ochre was also used in the cave (Fig 2.16). Although this may suggest that forms of art other than engraving were created in the cave, ochre is well known as a preservative for skins, and it is tempting to associate it with the clothing manufacture suggested by the other finds.

Finally, the cave art must be accounted for. With one or possibly two exceptions, all of the art is in Church Hole, which, on the basis of the low number of backed blades and bladelets found in it, seems to have attracted the least attention. If this is so – if Church Hole was really

not as important as a camp site as the caves of the northern side of the gorge – why did the Magdalenians expend so much effort on engraving its walls? Why also did they apparently not engrave the walls of the other caves, except for one 'vulva' in Robin Hood Cave and possibly one enigmatic sign in Mother Grundy's Parlour? It could be that Church Hole held some specific significance for them – perhaps it was more of a place of mystery or spirits rather than a place of the living. The other caves show evidence of human visits during the later part of the Lateglacial Inter-stadial and during the Early Mesolithic, but Church Hole's use came to an end when the Magdalenians left for the last time. Perhaps the very reason the art is there also made the cave taboo – the memory of what it signified kept people away from the moment the art was created. However we view this, it does suggest that the Magdalenians had complex views about the gorge – that they imbued landscapes with meanings far beyond the simple location of available meat.

Notes

1 Radiocarbon dates are expressed in uncalibrated years BP (before present) – *see* box in Chapter 5 (p 89). Although they can be calibrated with some precision back into the Late Glacial period, for consistency we report them in uncalibrated radiocarbon years BP here. Suffice it to say these underestimate dates in the Late Glacial period by 2,000 years or so, and radiocarbon dates earlier in the period underestimate by larger amounts. Radiocarbon dates of around 12,200 BP for the Late Upper Palaeolithic (Late Magdalenian) activity at Creswell, for example, equate in real (calendrical) years to 15,000–13,500 BP.

2 The term 'Creswellian' was coined by Dorothy Garrod (1926) to cover British Late Upper Palaeolithic material. Although this bore affiliation to contemporary material from the continent, Garrod felt that there were enough differences between this and the British material to warrant a separate term for the latter. As Creswell formed (and still forms) the richest source for Late Upper Palaeolithic archaeology in Britain she felt justified in using it eponymously. With the wealth of information available to us at the start of the 21st century, however, we feel that there are enough similarities between British and continental materials to warrant abandonment of this term. We, therefore, use the term Magdalenian for British Late Upper Palaeolithic groups previously termed Creswellian.

A review of the archaeological caves of the Creswell region

ANDREW CHAMBERLAIN

Introduction

The identification of Ice Age art in the caves at Creswell Crags is the latest and one of the most significant advances in our understanding of how the caves in the Creswell region have provided resources and opportunities for the inhabitants of this part of Britain for thousands of years. Although the region's caves, fissures and rock shelters are best known for their evidence of human activities and environments from the last Ice Age, in fact these sites were used throughout prehistory by humans and animals, and they contain much important cultural and environmental evidence from periods after the end of the Ice Age when the climate ameliorated and the landscape eventually became settled by farming communities.

Creswell Crags is located in the southern part of the Magnesian Limestone belt, where limestones of Upper Permian age form a gentle north–south orientated ridge running northwards from near Nottingham (Fig 3.1). This part of the Magnesian Limestone outcrop is cut through by a series of vales and gorges which expose caves, fissures and rock shelters along the cliff lines. The caves and fissures are generally of two sorts: *solution caves*, formed by ancient dissolution of the limestone along joints, fissures and bedding planes, and *rift-slip fissures*, which are formed when gaps open up between large blocks of limestone as a result of localised erosion causing instability of rock outcrops. The rift-slip type of cave and fissure formation is usually restricted to locations close to the edges of prominent scarps and steep valley sides, as seen for example in the Don Valley gorge (Fig 3.2), and some of these fissures have been reactivated in recent years as a result of subsidence induced by deep coal mining.

Caves, fissures and rock shelters have been discovered throughout the vales of the Southern Magnesian Limestone outcrop. Most of the limestone vales show subdued relief with low cliffs and rocky outcrops with small caves running into the sides of the hills (Fig 3.3). Although some of the larger caves have always been well known, it is only in the last few decades that systematic archaeological surveys have been undertaken, revealing many new caves, fissures and rock-shelter sites of significant archaeological potential. Thus caves and rock shelters are abundant in the local area, and although most of these localities have not been archaeologically excavated they constitute a valuable component of the region's historic environment resources.

Fig 3.1
The Southern Magnesian Limestone outcrop with the principal vales and gorges indicated.
(A Chamberlain)

Studies of cave usage in antiquity have found evidence for two distinct kinds of human activities that were focused in and around the entrances and passages of natural caves: broadly, these fall into the categories of subsistence-related and ritual behaviour (Bonsall and Tolan-Smith 1997). Popular accounts have sometimes suggested that caves were appropriate locations for everyday economic activities, such as domestic occupation, storage and industrial uses, and in many parts of the world caves have served as temporary refuges where individuals or small groups can isolate and conceal themselves from a pursuing enemy. In fact, few caves are suitable for long-term occupation, and the archaeological evidence preserved in caves in Britain is more often indicative of the cave having served as a location for specialised ritual activities, including funerary rites involving the placement of human remains and the deposition of pottery and metalwork, perhaps as votive acts.

Early researches at the Creswell caves

As noted in Chapters 1 and 2, the scientific exploration and study of caves in Britain began in the 19th century, with reports being published on the recovery of the remains of extinct animals from caves in Devon, Yorkshire and elsewhere (eg Dawkins 1874). These early discoveries alerted antiquarians to the likelihood of ancient remains being preserved in caves and fissures, and, with the increasingly large-scale industrial quarrying of limestone and construction of railway cuttings through limestone outcrops that took place during the Victorian era, many opportunities arose to investigate cave deposits. This was also a time when the antiquity of humans was under active debate by leading scholars, and the controversy surrounding the evidence at sites such as Kent's Cavern in Torquay, Devon –

Fig 3.2
Sediment-filled fissure in the Don Valley gorge. (Photo: A Chamberlain)

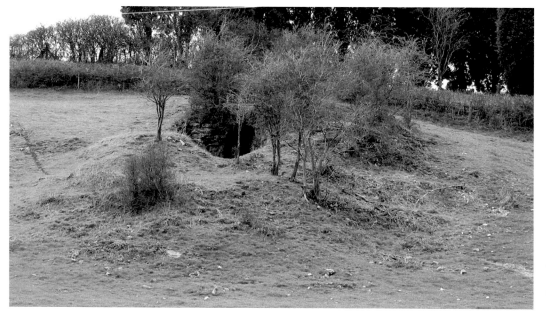

Fig 3.3
Langwith Cave: a small cave set into the side of a shallow limestone vale. (Photo: A Chamberlain)

where human-modified stone artefacts had been found alongside the remains of extinct animals – was pivotal in the development of knowledge and ideas concerning human evolution. It is in the context of this heightened interest in human antiquity and the recognition that caves might yield the answers to hotly debated questions that investigations commenced at the Creswell caves.

Scientific explorations of the caves of the Southern Magnesian Limestone outcrop began in the 1860s, when discoveries of extinct fauna were made in caves exposed by construction of buildings and a railway in Pleasley Vale, a limestone gorge about 10km south of Creswell Crags (Dawkins 1869). Between 1870 and 1875 sporadic discoveries of fossil animal bones were made at Creswell Crags, and scientific excavations were started in the Creswell caves in 1875 by the Revd J M Mello, assisted by Thomas Heath and George Busk, and joined subsequently by William Boyd Dawkins (*see* Chapter 2). These scholars, assisted by other members of the Creswell Caves Exploration Committee, carried out excavations in Church Hole, Pin Hole, Robin Hood Cave and Mother Grundy's Parlour. The excavations were of a reasonable standard when judged against the contemporary understanding of archaeological stratigraphy: although the deposits were excavated fairly rapidly, their changing nature at different depths was noted, some sieving for finds was undertaken, and the contexts from which finds were recovered were sometimes recorded.

Further campaigns of excavation were conducted in the Creswell Crags caves during most decades of the 20th century, but only limited explorations took place in the numerous other vales and gorges of the Southern Magnesian Limestone outcrop. In part this may have been because there are also many well-known caves in the Carboniferous Limestone region of the White Peak, situated just 30km to the west of the Creswell region, and these sites also attracted the attention of archaeologists searching for evidence of early human occupation of the region.

Caves in the other Magnesian Limestone vales

Pleasley Vale, the most southerly of the vales in the Magnesian Limestone, contains more than 20 caves, fissures and rock shelters, some of which were exposed during railway and mill construction works during the 18th and 19th centuries. Many of these caves and fissures contain ancient sediments, but only two of the caves have so far produced archaeological and palaeontological remains: the Devensian faunal site of Pleasley Vale Cave and the possible Late Upper Palaeolithic site of Yew Tree Cave, which was excavated by William Ransom in the 1860s and by A Leslie Armstrong in the 1930s.

Langwith Cave, which is situated in the Poulter Valley about 5km south of Creswell Crags, was excavated between 1900 and 1930, first by the Revd Mullins in the early years of the 20th century (Mullins 1913) and later by Dorothy Garrod, who presented her findings to the British Association for the Advancement of Science in 1927. Langwith Cave contained Late Upper Palaeolithic stone tools, Pleistocene fauna and the skeletal remains of a human adult and child. The adult skull was subsequently determined by radiocarbon dating to be just over 2,000 years old (Table 3.1).

In the Whaley Valley there are several rock-shelter sites, two of which were excavated in the 1930s and 1940s by A Leslie Armstrong (1949). Whaley Rock Shelter 1 contained shallow sediments and mainly Holocene

Table 3.1 Direct radiocarbon dates on human bones from Magnesian Limestone caves

Site	^{14}C date	Period
Ash Tree Cave	3730 ± 90	Neolithic
Langwith Cave	2330 ± 60	Iron Age
Markland Grips Cave	4760 ± 90	Neolithic
	4740 ± 90	Neolithic
Mother Grundy's Parlour	4640 ± 70	Neolithic
	3790 ± 70	Neolithic
	3720 ± 80	Neolithic
	2210 ± 80	Iron Age
Robin Hood Cave	5000 ± 40	Neolithic
	4870 ± 120	Neolithic
	2020 ± 80	Iron Age
	1785 ± 50	Romano-British
Scabba Wood Rock Shelter	4590 ± 30	Neolithic
Whaley Rock Shelter No. 2	3470 ± 65	Early Bronze Age

artefacts, with a few Upper Palaeolithic flint tools. Whaley Rock Shelter 2 yielded deeper deposits which Armstrong claimed contained Ice Age fauna and artefacts. Although subsequent work at the site by Jeffrey Radley in the 1960s failed to substantiate the existence of pre-Holocene artefacts, some faunal remains from the site have since been radiocarbon-dated to the Middle Devensian. A human skull from Whaley Rock Shelter 2 initially thought to be Palaeolithic, but subsequently radiocarbon-dated to the Early Bronze Age, again demonstrates the reuse of caves as sites for the deposition of human remains in the later prehistoric period (Table 3.1). Armstrong and his colleagues also excavated Ash Tree Cave in Burntfield Grips, a site that produced Early and Middle Devensian faunas and a small number of either Mousterian or Early Upper Palaeolithic stone tools (Armstrong 1956b). Further caves were explored by Armstrong in Hollinhill and Markland Grips, and one of the caves in Markland Grips was found to contain Neolithic pottery and human skeletal remains (Table 3.1).

To the north of Creswell Crags Pleistocene faunal remains were recovered from a limestone quarry at Steetley, 5km west of Worksop. Some of this material has been dated using the uranium-series method to the Early Devensian period. Further finds of Late Upper Palaeolithic material were made at Lob Wells Shelter and at Dead Man's Cave in Anston Stones Wood. Both of these sites, which were excavated by George White with the assistance of Paul Mellars, contained Late Upper Palaeolithic flint tools, and Lateglacial faunal remains were also recovered from Dead Man's Cave (Mellars 1969). Paul Mellars also excavated Creswellian flint artefacts from a disturbed surface deposit below the scarp of the Crags in Edlington Wood, and inferred that the artefacts may be derived from a nearby cave or rock shelter. In the Roche Valley possible Upper Palaeolithic and Neolithic flint artefacts have been reported from excavations carried out by the Rotherham Archaeological Society in a rock shelter at Stone Mill, and possible Mesolithic flints were also found in a rock shelter in Nor Wood, excavated by Jeffrey Radley in 1968.

South-west of Conisbrough near Hooton Roberts the Magnesian Limestone is exposed in a natural scarp edge at Hooton Cliff, which contains rock shelters, slip-rift caves and sediment-filled fissures with considerable archaeological potential. Late Upper Palaeolithic flint tools were collected from the parish of Hooton Roberts by the rector, the Revd Reginald Gatty, in the 19th century, and, although the precise localities of Revd Gatty's finds were not recorded, it is possible that some may have come from the rock-shelter sites along Hooton Cliff.

Extensive exposures of Magnesian Limestone can be seen along the south side of the Don Gorge between Conisbrough and Warmsworth, though this area has been heavily quarried in the past for lime burning. In 1878, during construction of a water pipeline in Nearcliff Wood, a sediment-filled fissure containing Pleistocene mammal bones was discovered, and specimens were sent to William Boyd Dawkins for identification. The identified species included woolly rhinoceros, mammoth, horse and red deer, and some of the bones appeared to have been gnawed by hyenas. Nearly 30 years later further Pleistocene mammal remains were reported from approximately the same location, during the construction of the Dearne Valley Railway. Pottery and human remains dating to the Neolithic period were excavated in the 1990s from a low rock-shelter a few kilometres north of the Don Gorge, in Scabba Wood near Sprotbrough (Figure 3.4 and Table 3.1).

The overall picture that emerges from this review is that a fairly continuous spread of archaeological cave sites exists across the Southern Magnesian Limestone outcrop, and that there is plenty of evidence that Palaeolithic hunters and their prey were using the whole of this landscape during the latter part of the last Ice Age. Recent surveys have identified more than 160 caves, fissures and rock-shelter sites in the Southern Magnesian Limestone that have a heightened archaeological potential (Davies *et al* 2004: this figure excludes the numerous known archaeological and palaeontological sites within the Creswell Crags gorge). Apart from at Creswell Crags, the scale of archaeological exploration of these cave sites has been limited, especially in comparison with other cave regions in Britain such as the Carboniferous Limestone outcrops of the White Peak and of Mendip in Somerset. It is therefore very likely that continued research on the Magnesian Limestone will enable additional cave archaeological sites to be identified and will help to elucidate the changing patterns of cave usage through time.

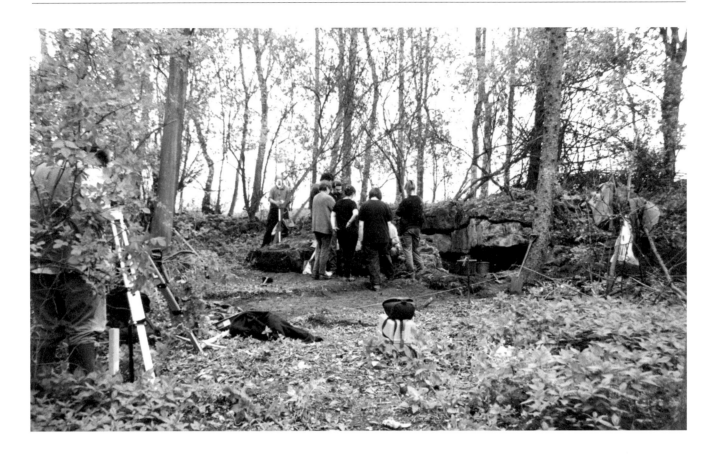

Fig 3.4
Excavation of a small
rock-shelter at Scabba
Wood, near Sprotbrough.
(Photo: A Chamberlain)

Changing patterns of cave usage

It is often difficult to reconstruct patterns of usage from the cultural evidence preserved at specific cave sites. The nature and quality of the archaeological evidence recorded from earlier cave excavations, the frequent lack of structural modifications within cave sites and the ephemeral nature of the activities themselves, which may reflect very brief episodes of occupation, all serve to render interpretations of past activities imprecise. However, some general conclusions can be inferred from the archaeological record of the caves of the Creswell area.

The caves and rock shelters of the Southern Magnesian Limestone contain an impressive amount of evidence for Palaeolithic human activity, mainly associated with the recolonisation of Britain by hunter-gatherers towards the end of the last Ice Age. Most of the limestone vales and gorges in the region are aligned to the regional east–west dip slope orientation (Fig 3.1), and these topographic features would have formed natural routeways for game animals migrating from the North Sea plain and the eastern lowlands to the Pennine uplands to

the west (*see* Chapter 2). In other parts of Britain it has been observed that Late Upper Palaeolithic sites tend to be concentrated at topographic locations that are marginal to the upland zones (Barton *et al* 2003). The location of the Magnesian Limestone ridge as an eastern outlier to the Pennine uplands fulfils this criterion of landscape preference by the Lateglacial and early Holocene hunter-gatherers, and explains the relatively high density of Upper Palaeolithic find-spots in the vicinity of Creswell Crags. Cave and rock-shelter use in this period is usually viewed as including temporary episodes of occupation or the utilisation of cave and shelter sites as workshops or storage locations, a view that may now need to be modified given the presence of decorative panels of engravings in Church Hole cave at Creswell Crags.

Later in prehistory, with the transition from foraging to farming as the primary basis for subsistence, the character of cave use in the area changed, and there is increasing evidence for the use of caves for votive deposition and as locations for the interment of human remains. Human remains radiocarbon-dated to the Neolithic and Early Bronze Age have been

found in six of the region's caves (Table 3.1), a pattern that is consistent with the extensive use of caves for burial of human remains throughout Britain and Ireland during the Neolithic (Chamberlain 1996). Artefacts of later prehistoric and Romano-British date are reported from many of the cave excavations, and these finds indicate that the cave sites continued to act as foci for human activities up to the beginning of the historical era.

Conservation and management

An appreciation of the wealth of material preserved in the caves of the Southern Magnesian Limestone brings with it the need to consider conservation and management strategies. Archaeological caves are sensitive sites that are vulnerable to natural processes of disturbance and to direct human interference. Examples of natural threats to cave deposits include the activities of burrowing animals, damage to cave entrances from tree fall, and the erosion or dissolution of deposited materials through water action. Caves may also be affected by human activity, particularly mineral extraction, dumping of refuse in landfill sites, pollution of groundwater from changes in land usage and the exploration of caves in pursuit of leisure activities.

At Creswell Crags a well-resourced management strategy has been devised which provides a high degree of protection for the caves and their immediate surroundings. All of the caves at Creswell are contained within the scheduled monument area, and further protection is provided by the designation of the Crags as a Site of Special Scientific Interest (SSSI). Most of the rest of the caves in the Southern Magnesian Limestone are not protected by scheduling as ancient monuments, the exceptions being Ash Tree Cave, Langwith Cave and some rock shelters located within the scheduled area at Roche Abbey. Several of the limestone vales benefit from landscape and wildlife conservation efforts through their designation as SSSIs, Regionally Important Geological Sites or Local Nature Reserves, but these conservation measures do not specifically protect the archaeological deposits at these sites.

An essential first step in conserving and managing the cave archaeological resource is to survey visible exposures of limestone, and record and characterise any caves that are present before they are excavated. As a natural feature, the form of a cave tells us nothing about its contents, so the default assumption is that all caves are possible locations for archaeological deposits. Systematic surveys in limestone regions have shown that about 20 per cent of British caves contain archaeological deposits, and many other caves may contain preserved faunal remains. The large number of caves and rock shelters now identified in the southern part of the Magnesian Limestone outcrop provide a baseline from which further detailed studies of the cave archaeological record can proceed.

4

The cave art of Creswell Crags

PAUL BAHN AND PAUL PETTITT

Introduction

The purpose of this book is to present a definitive account of the engraved motifs discovered at Creswell Crags in 2003 and 2004, and to place them within the context of the local geology and archaeology, as well as to compare and contrast them with figures in the Palaeolithic art of the continent.

The particular difficulties encountered in deciphering and interpreting figures on such eroded, friable and graffiti-covered surfaces have led to exaggerated claims in the past for the number of possible motifs in the cave of Church Hole. Thanks to a systematic, objective and critical reappraisal, helped enormously by the unrivalled expertise of Michel Lorblanchet, the world's foremost specialist authority on Ice Age art (and particularly on cave engravings), and by the expertise of geologists who know intimately the type of rock in which the caves formed at Creswell and the natural markings one might expect on it (Chapter 6), we are able here to differentiate the certain from the merely possible, and to remove some illusory or imaginative images from the record. There will always be some markings that cannot be confidently identified as human-made, and which therefore reside in the 'possible' category. We include some of these here for the purposes of completeness and objectivity.

After the discovery of the first figures at Creswell Crags during a brief study of the caves in April 2003 (Bahn *et al* 2003), work began on a more systematic survey for engravings as well as on the formal recording of those which had been found. Our initial assessment, based only on that initial, rapid survey with bad lighting and poor access to the high wall, was that we had evidence for an engraved ibex and two birds (*see* p 8). Subsequently, we realised that the ibex was actually a stag (the depiction of what we initially thought to be a horn was

actually an antler), and that the discrete panel which we thought contained two birds was actually more complex and comprised more figures (*see below*). In 2004, immediately before the international conference held at Creswell (Pettitt *et al* 2007), the 'ibis', made with a combination of engraving and bas-relief, was deciphered, and this led us to the realisation that some of the other figures probably also incorporated a certain amount of bas-relief. After a survey of the cave walls by geologists specialising in Magnesian Limestone, we realised that what we sometimes took to be 'chamfered' edges and gouged 'eyes' were actually trace fossils and erosional holes in the rock rather than human-made features (*see* Chapter 6).

We gradually learned that the Magnesian Limestone of Church Hole poses special problems which can make it particularly difficult to detect and decipher genuine engravings on its surfaces. Being a very soft, fine-grained, sandy rock, it has in places eroded a great deal over the millennia. The engraved lines in the entrance chamber have therefore become softened and blurred, so that many of them now resemble natural fissures; most importantly, the reverse is also often true, so that natural fissures often look superficially like engraved lines when they are not. This makes the process of search and identification very complicated, especially as the artists – as is normal in Ice Age cave art – often incorporated natural features into their figures.

In addition, most figures occur near the entrance, which has been subject to the most erosion, and which is in dim daylight; this therefore adds another perceptual difficulty. Much of our initial work in 2003 was carried out with artificial light, while in later campaigns natural light was used more frequently.

The eroded surfaces, the numerous natural fissures and reliefs, and the effects of shadow

Table 4.1 The Ice Age parietal engravings of Creswell Crags and their formal identification numbers

Classification	Description
MGP1	Non-figurative engraving
RHC1	Converging line 'vulva'
CH1	Part of CH1–CH4 'birds/females' group
CH2	Part of CH1–CH4 'birds/females' group
CH3	Part of CH1–CH4 'birds/females' group
CH4	Part of CH1–CH4 'birds/females' group
CH5	Lines to the right of the CH1–CH4 group
CH6	Horn-like motif to the left of the CH1–CH4 group
CH7	Engraved motif left of the CH1–CH4 group
CH8	Engraved motif above the CH1–CH4 group
CH9	Enigmatic motif similar to CH1, possibly bird/female
CH10	Motif to left of CH9
CH11	One of two engraved 'vulvas' (see CH12)
CH12	One of two engraved 'vulvas' (see CH11)
CH13	Incomplete engraving of horse
CH14	Converging lines 'vulva' on ceiling
CH15	Converging lines 'vulva' on ceiling
CH16	Incomplete engraving of quadruped
CH17	Part natural, part engraved/sculpted bird (ibis?)
CH18	Incomplete engraving of animal immediately left of CH19
CH19	Engraving of deer stag
CH20	Group of three incised vertical lines, part of CH20–CH21–CH22 group
CH21	Group of nine incised vertical lines, part of CH20–CH21–CH22 group
CH22	Group of three incised vertical lines, part of CH20–CH21–CH22 group
CH23	Incomplete engraving of bison

and light caused by different methods of illumination have all posed problems, and may explain in large measure the high total of figures claimed by the former team members from Spain: first 42 (Ripoll *et al* 2004b), then more than 50 and potentially up to 90 (cited in Bahn *et al* 2005, 226), and finally no fewer than 215 (Ripoll and Muñoz 2006, 572, 574; Ripoll *et al* 2007).

Today we do not accept these figures, and nor do the great number of Palaeolithic specialists who have viewed the cave walls since the 2003 discovery. Our own systematic study of the surfaces has led us to a far lower total, as we took a hard and objective view that, in order to be identified as a human-made engraving, a figure should be unambiguously distinct from natural lines. Our conclusions were confirmed by an official visit in November 2006 by Michel Lorblanchet, who carefully examined all of the surfaces and figures.

As a result, we publish here the official inventory of definite engravings in the Creswell caves. Towards the end of the chapter we also discuss markings thought by some to be engravings, but which are almost certainly natural. Thus we have 25 examples of Ice Age art at Creswell (Table 4.1). With the exception of one image in Robin Hood Cave and another in Mother Grundy's Parlour, all are located in Church Hole. We publish them here with inventory numbers to facilitate reference to individual images in the future.

Mother Grundy's Parlour

MGP1

One engraved motif, the first to be discovered on 14 April 2003 (Fig 4.1). Located around 15m from the entrance, it is just inside the inner chamber, on the left as one enters. It is *c* 12cm wide and 8cm high, and about 75cm above the rock ledge at the base of this wall. In 2003, with bad lighting, we had only seen the left end of the figure, and thought it could be a small horse-head facing left. Subsequently it proved to be a larger and more complex figure, shaped something like a downturned banana or boomerang. We cannot prove it is Palaeolithic, but this is highly likely.

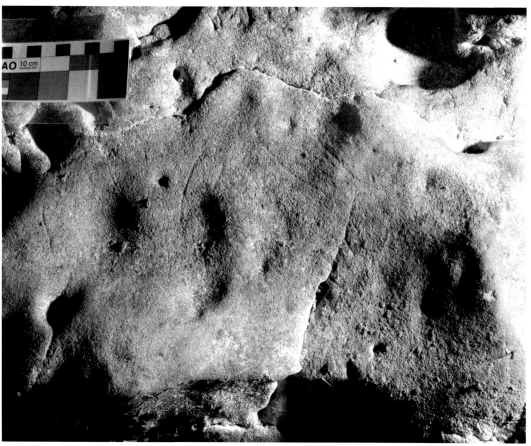

Fig 4.1
Drawing and photo of the engraved motif in Mother Grundy's Parlour (MGP1). (DP030348)

Fig 4.2
Drawing and photo of the
engraved triangle in Robin
Hood Cave (RHC1).
(DP027479)

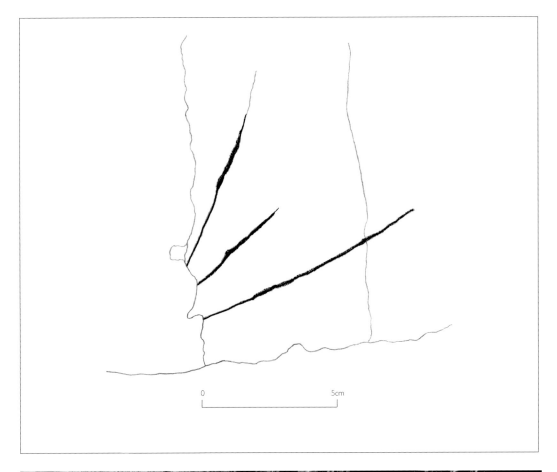

Robin Hood Cave

RHC1

One clearly engraved, inclined triangle, comprising three converging lines, the apex of which is overlain by thin stalactite (Fig 4.2); U-series dating of this provides a minimum age for the image (*see below*, p 94). It is 16cm long and 10cm wide, and is located on the right wall of the first chamber, about 7.35m from the entrance and 3.3m above the present floor. Stylistically this image, which one might identify as a vulva, is similar to an example in Church Hole.

Church Hole

In the following list we have abandoned the panel numbers used in previous articles, since it is now clear that the figures in panels I and II (eg 'bovid head': *see* Ripoll *et al* 2004a; Ripoll and Muñoz 2007) are almost certainly natural. We publish here a total of 23 definite markings, plus a number of possible figures (Fig 4.3).

Fig 4.3
The 'bird/woman' panel in
its context, showing position
of engravings CH1 to CH8.
(DP030321)

CH1 to CH4

An engraved panel (Fig 4.4), previously panel VII, located 50m inside the cave, in the dark zone. At the time of engraving, the CH1 to CH4 group would have been engraved around 50–60cm above the floor of the cave in a low-ceilinged tunnel approximately 1–1.5m in height. These figures would therefore have been engraved from a sitting, lying or crouching position (*see* Pettitt 2007 for a discussion of this). These motifs have already been described at some length (Ripoll *et al* 2004a; Ripoll and Muñoz 2007). Three of the four original team members see most or all of them as long-necked birds of some kind – the interpretations include cranes, herons, bitterns and swans (ibid) – while one sees them as schematic human females, drawn upside down because of the artist's crouching position (Pettitt 2007). Part of the group is clearly overlain by a thin stalactite film, U-series dating of which has provided a minimum age for the engravings and has provided independent verification of their Ice Age antiquity (see Chapter 5).

CH1

The first figure, at left (number 6 in figure 8.4 of Pettitt 2007), resembling the neck and head of a long-necked bird, 12.8cm in length by a maximum width of 2cm. The long, semi-parallel lines of its neck, each moderately concave and thus thinner at the centre, converge to within a few millimetres of each other at the edge of the rock projection on which CH1–CH4 are engraved, where they are partly covered by the thin calcite flow. At the other (upper) end the right-hand line diverges from the left and curves to form a 'bump' at the widest part of the image. Following this the lines converge sharply until they meet at a point.

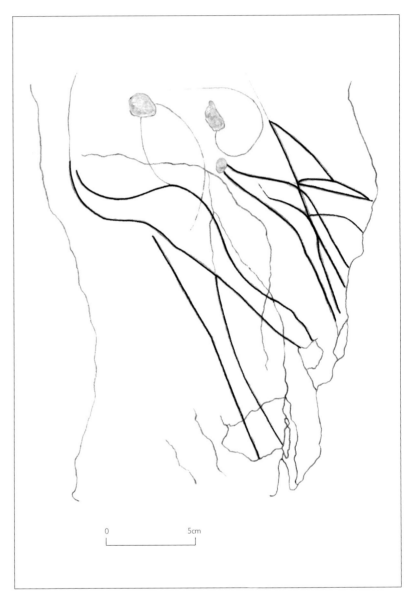

Fig 4.4
Drawing and two photos of the 'bird/women' motifs, CH1 to CH4.
(DP027442, DP027443)

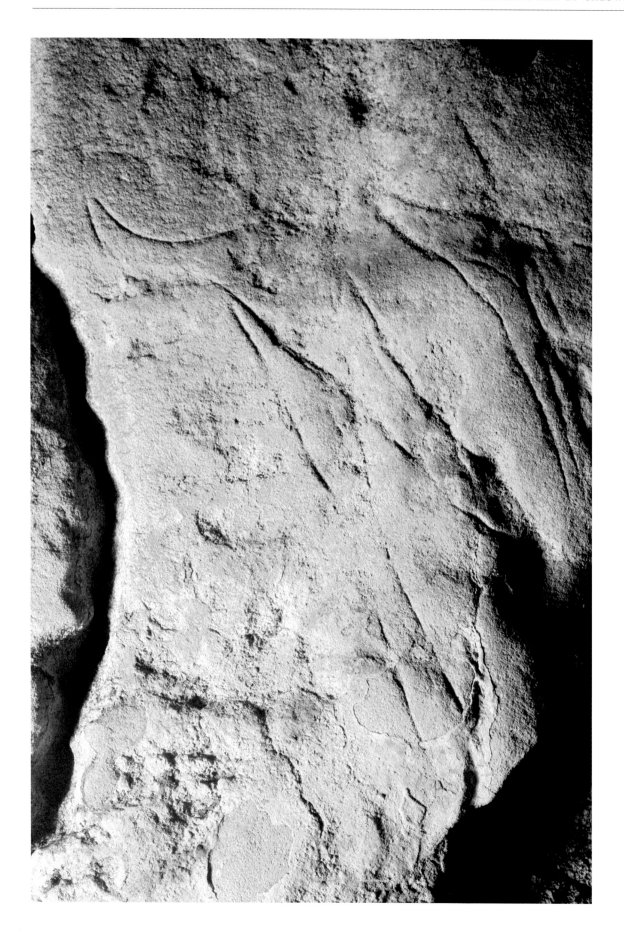

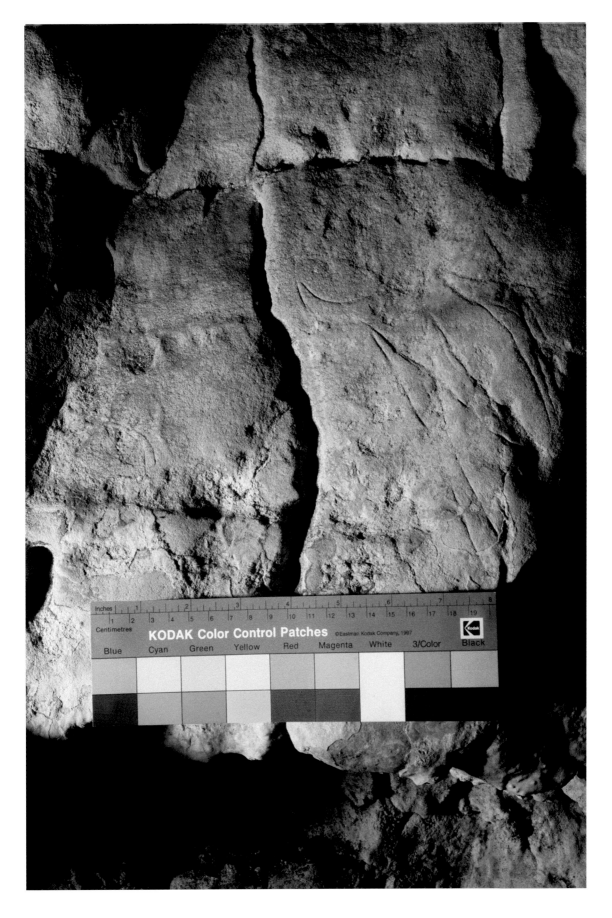

CH2

The central motif (number 5 in figure 8.4 of Pettitt 2007) and the largest of the group, measuring 14.5cm in length and 7cm in maximum width. This bears a general resemblance to CH1 in that it is orientated in the same direction, and comprises two parallel and converging lines, the right-hand one diverging in its upper third to form a 'bump' and then converging to meet the left line in an upper point. Unlike CH1, however, the convergence of the two lines at the lower extremity of CH2 brings them into pointed contact. In addition, the convex 'bump' of CH2 is more pronounced than that in CH1, and most strikingly there is a pronounced concavity of the right line and parallel convexity of the left following the bump/widest point before they converge to the uppermost point. The middle part of the left line of CH2 is shared with the upper third of the right line of CH1, and this may account for the relatively straight upper-third right line of CH1. If these do represent long-necked birds then CH1 has been depicted with a straight beak and CH2 with a strikingly upturned beak.

CH3

To the right of CH2, a similar set of two parallel lines, again with a similar orientation to that of CH1 and CH2, and bearing general similarities to them (number 4 in figure 8.4 of Pettitt 2007). It is 10cm long and 3cm wide. Unlike CH1 and CH2 the lower two-thirds of the image bear parallel lines which do not converge at its lower extremity. Furthermore, while there is a slight 'bump' in the upper third of the right line, this is less pronounced than the bumps in CH1 and CH2, and after this the two lines converge in an open, blunt curve rather than the pronounced points of CH1 and CH2. This figure resembles another bird facing left.

CH4

Possibly a fourth, smaller bird figure superimposed on CH3, but indistinct as a result of erosion. It is of interest that it appears to share the parallel-line/bump/converging 'beak' form of the others (most strongly resembling CH3).

We acknowledge that the group comprising CH1–CH4 is not easy to interpret in any clear way. While the sharpness and confidence of its lines and their isolation within a relatively clear part of the cave wall (that is, where natural cracks and so on are lacking) indicate that they are clearly engraved, the subject matter is not obviously forthcoming. We differ in our interpretations of this group, with one of us (Paul Bahn) preferring the interpretation of bird-heads/necks and the other (Paul Pettitt) preferring to see these as highly stylised depictions of human females. We stress in particular that we are by no means certain what the enigmatic central motif represents (if anything); it could be a large bird-head, facing either way, or it could be a schematic female of the contemporary Magdalenian *Gönnersdorf Darstellungsprinzip*. If it is a bird-head facing left, then the beak is upturned, but the drawing bears no resemblance to the avocet (*Recurvirostra avosetta*). If it is a bird-head facing right, then why does the neck end in a curved point?

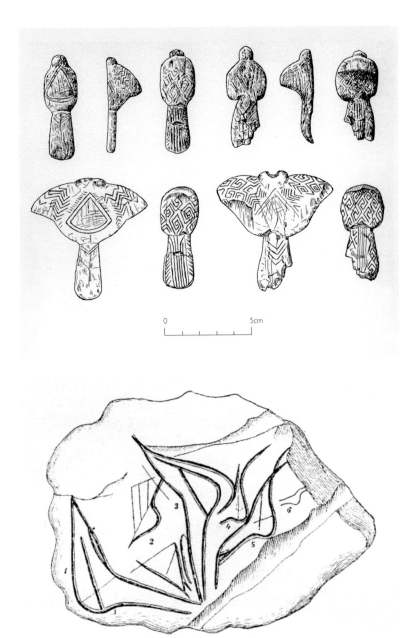

Fig 4.5
Statuettes from Mezin.
(From Abramova 1962;
pl xxxi, 287)

Fig 4.6
Magdalenian engravings
from Lalinde (Dordogne).
(From Peyrony 1930, 27)

elsewhere in France (Fig 4.6). Peyrony (1930, 27–9) said of the Lalinde engravings that 'A première vue, on dirait des têtes d'Oiseaux stylisés … A la rigueur, cette interprétation pourrait paraître satisfaisante' ('At first sight, one would say stylised bird-heads … At a pinch this interpretation could appear satisfactory'), but one or two of them have beak-lines that cross and continue. He added that Breuil 'pense qu'elles pourraient représenter des femmes sans tête très stylisées' ('thinks that they could represent very stylised headless women'), and that they saw analogies with the Petersfels jet statuette. Breuil (1957) reiterated this view concerning the similar block in Chicago.

But of course these are stone blocks with engravings in various directions, not parietal figures, so it is difficult to know their correct orientation. On the wall of Church Hole their orientation is clear, and appears to the modern visitor to be essentially upright. The floor of the cave, however, is some 1.5m lower than it was in the Ice Age, and this has led one of us (Pettitt 2007) to hypothesise that engraving these from a crouching position would, assuming the engraver was following natural lines of comfort, result in images that were, to modern eyes, upside down. It is, however, worth noting that in the profusely engraved cave of Les Combarelles (Dordogne), where the original artists always had to crawl instead of walk as we do today (thanks again to a greatly lowered floor), all the figures – including some females – were engraved the right way up, even where drawn at floor level. This may weaken the 'females' hypothesis but it is, of course, possible that the Creswell engraver(s) behaved differently from all those on the continent. Alternatively, if CH1–CH3 represent birds, one must accept that they are not only incomplete, but also each of a different form, the latter in terms of the neck, head and particularly beak. How can we account for the peculiar morphology of the 'beak' of CH2, and particularly for the convergence of the lines of its lower neck?

Regardless of interpretation, however, we can certainly agree that CH1–CH4 are clearly engraved, associated, similar and overlain by stalactite which provides a minimum age and thus confirms their Ice Age antiquity.

This is by no means the first time that the 'bird or woman' question has arisen in Palaeolithic art. For example, in the portable art from Mezin (Ukraine), some ambiguous statuettes have been seen as birds and/or stylised women (Fig 4.5; Abramova 1962, pl xxxi). The most famous case is that of the late Magdalenian engravings from Lalinde (Dordogne) and

CH5

Pointed motif just above the birds on the right of the panel, possibly another beak pointing upwards (Fig 4.7).

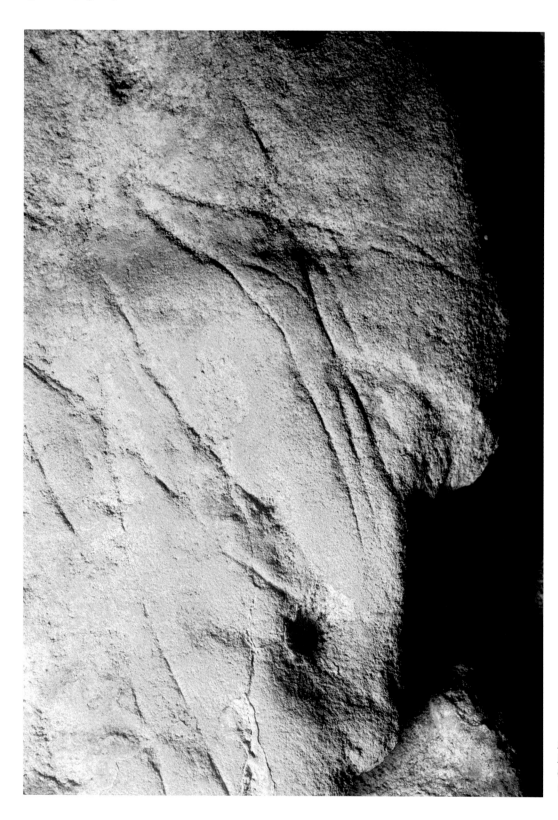

Fig 4.7
Photo of the pointed motif
CH5.
(DP027441)

CH6

Small horn-like motif just to the left of this panel (Fig 4.8).

CH7

Engraved motif to the left of the panel, 17cm high and 9cm wide (Fig 4.9). There are further lines on the surface to its immediate left.

Fig 4.8
Drawing and photo of the horn-like motif CH6.
(DP027444)

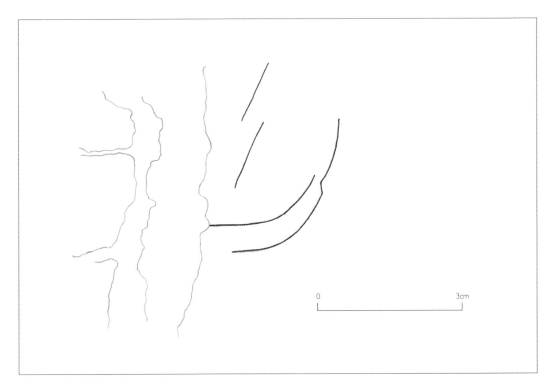

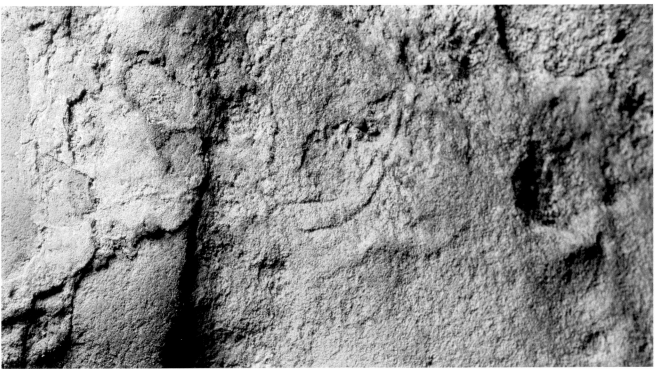

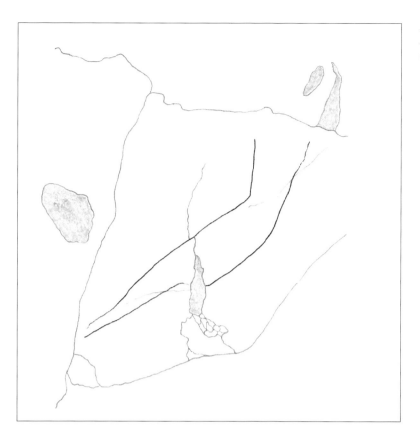

Fig 4.9
Drawing and photo of
engraved motif CH7.
(DP030319)

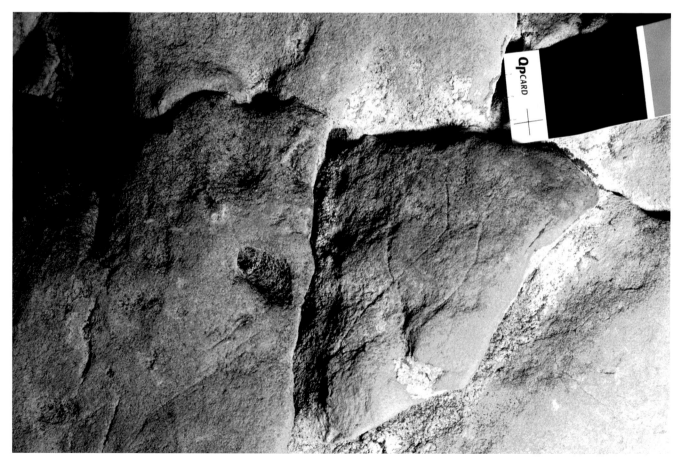

Fig 4.10
Drawing and photos of
the engraved motif CH8.
(DP027447, DP027448)

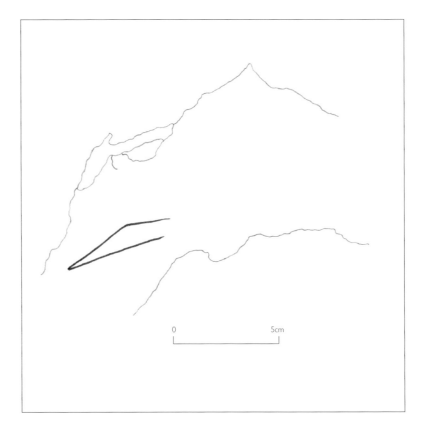

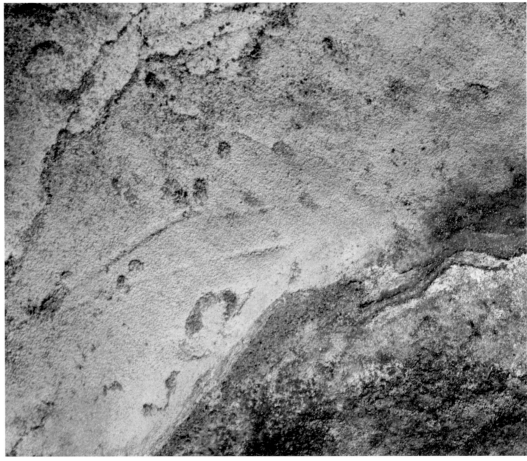

CH8

Engraved motif high above the panel, 4.5cm long and 2cm wide (Fig 4.10 *see also* Fig 4.3). Two parallel grooves converge at the left end – this again could be a very schematic human figure.

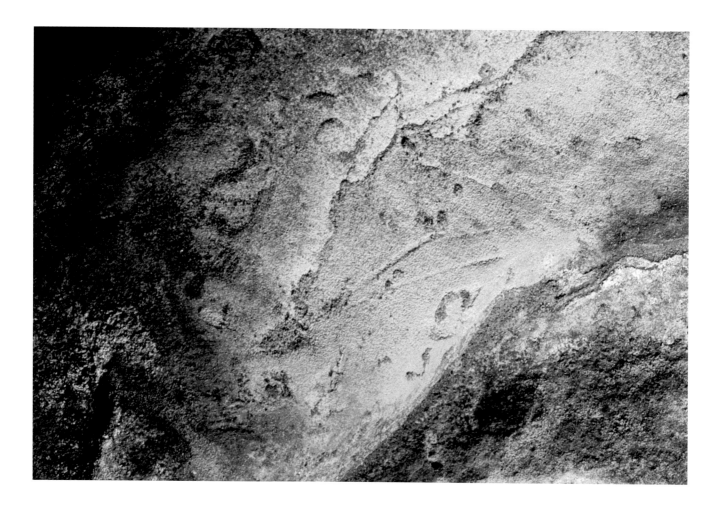

CH9

About 12m from the cave entrance, on the right wall, a little over head height for the Ice Age people and 2.8m above the present floor: a long, engraved motif comprising parallel lines, with kinks in it and pointed at both ends (Fig 4.11). It was described previously as panel X (Ripoll and Muñoz 2007). It is 17cm long and has a maximum width of 5cm. Like CH1–CH3 it is made up of two parallel/sub-parallel lines, a little over 1cm wide in most places. The lines converge to a sharp point at its lower extremity, but do not fully converge at its upper end. There are two blunt and open 'kinks' in the motif, which occur towards each extremity. The lower one is created by a convex 'bump' of the left line and a corresponding concave bump in the right line. In terms of this bump and a close convergence of the lines, this clearly resembles CH1. The second kink occurs towards the upper (open) extremity, where the left line curves to the left and then right creating a 'dogleg', and the right line follows this precisely. We are presented with similar interpretative problems to those in CH1–CH4. Is this representational, and, if so, is it a diving bird, a serpentiform or a stylised human female? Be that as it may, it is clearly a deliberate engraving.

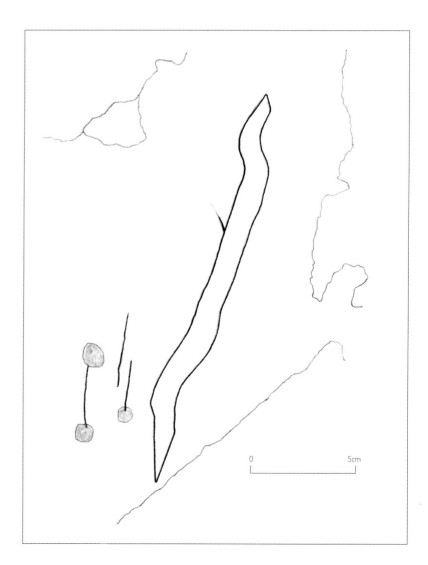

Fig 4.11
Drawing and photos of engraved motif CH9. (DP030322, DP030327)

Fig 4.12
Photo of motif CH10.
(DP027450)

CH10

Only 2cm to the left of CH9, a vague motif, comprising two lines which come to a point at their lower extremity, bearing an open and blunt 'bump' on the right margin (Fig 4.12). Although this marking is very indistinct – occurring on a rough patch of wall, covered by a very thin stalactite flow, and clearly eroded – its similarity in form to CH1–CH4 and CH9 makes it, in our opinion, highly probable that it is a deliberate engraving and probably part of the same panel as CH9. If this is correct, it is of great interest that we have two groups of these similar motifs, which – whatever their interpretation – suggests that a degree of repetition of a group of images was a significant part of the artistic repertoire at Creswell.

CH11–CH12

Two small triangles clearly engraved on the wall opposite the stag (previously panel XII), at around head height for Ice Age people and approximately 3.4m above the present cave floor (Fig 4.13). Preservational conditions vary between the two, and the left triangle (CH11) is far clearer than the right. The upper, horizontal lines of both may be natural. CH11 points downwards and is 7cm in length by 6cm wide along its upper (horizontal) side. CH12, the smaller right triangle, lies approximately 15cm from CH11, and is again a downward pointing triangle. In size it is a little smaller than CH11, 4.5cm in length by 5cm wide along its uppermost (horizontal) edge. It may have a small quadrangular motif inside. The form of the two is very similar to that of 'vulvae' which are relatively common in continental Late Magdalenian cave art.

Fig 4.13
Drawing and photos of
triangles CH11 and CH12.
(DP027456, DP027457,
DP027458)

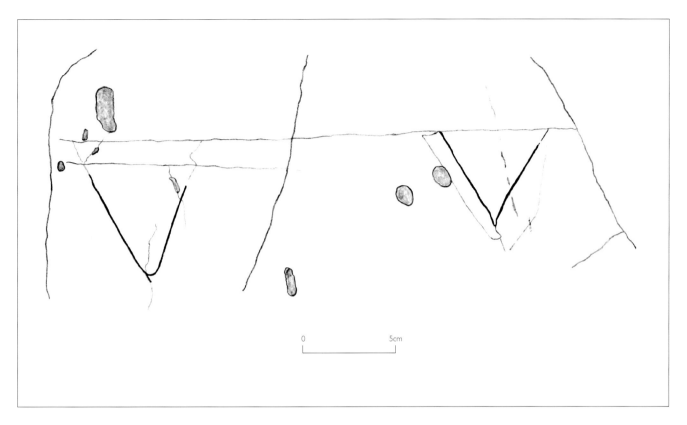

0 5cm

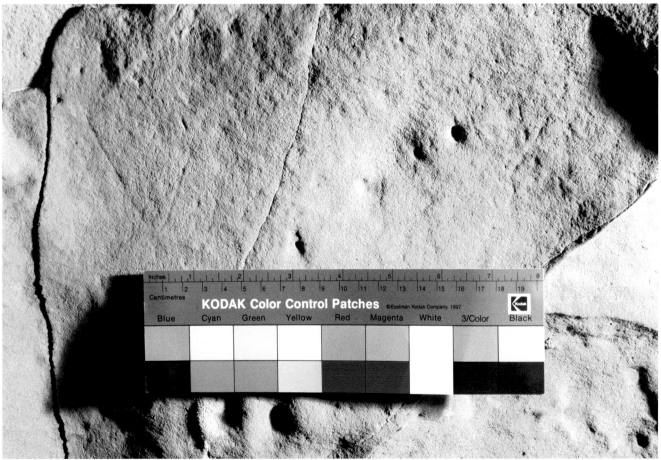

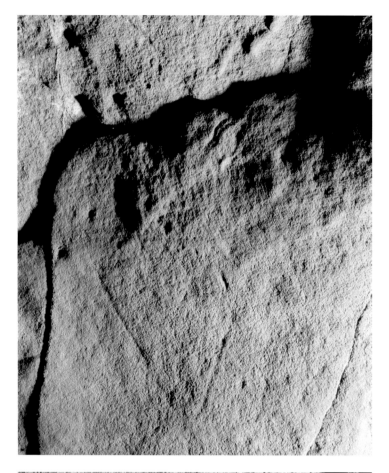

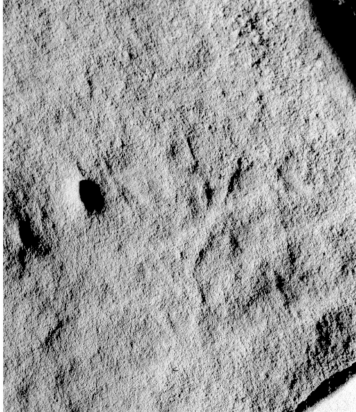

CH13

An incomplete figure comprising a clear cervico-dorsal line, front leg and adjoining parts of a ventral line and chest, and a *possible* depiction of a head, although the latter is highly eroded and barely visible (Fig 4.14). It has previously been published as panel IV and identified as a 'headless horse' (Ripoll and Muñoz 2007). The curve of the dorsal line – which is 23cm in length – is strongly reminiscent of the mane and back of a horse, and the shape of the leg is not inconsistent with this species. The positioning of the dorsal line and leg is anatomically consistent, and for this reason we feel justified in linking the two. The ventral line adjoining the left of the leg (the stomach) runs under a stalactite formation, although this is of such poor condition it proved impossible to date. We interpret the figure as a right-facing horse. There are some heavily eroded marks in the area where the position of the head can be predicted on the basis of the size and morphology of the existing engravings, although it is impossible to ascertain whether or not these are deliberate engravings. It is of interest to note that, if it is a depiction of a head, then the head is small relative to the body, a feature common in Upper Palaeolithic horse depictions (eg Lorblanchet 2007). Given the position or size of the head we feel that it is likely that this is a deliberate engraving, although given that we cannot demonstrate this we register it here as a *possible* element of CH13.

Fig 4.14
Drawing and photo of
the headless horse, CH13.
(DP027470)

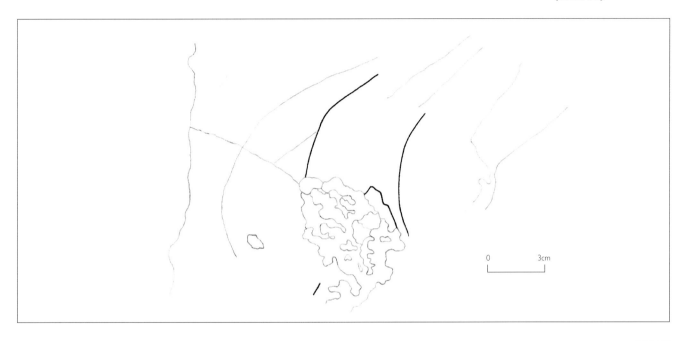

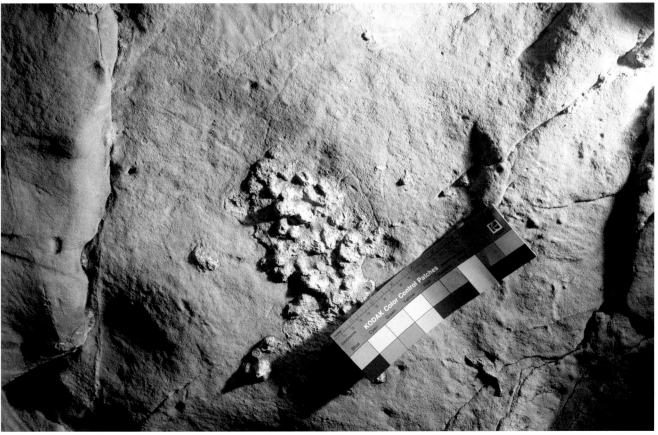

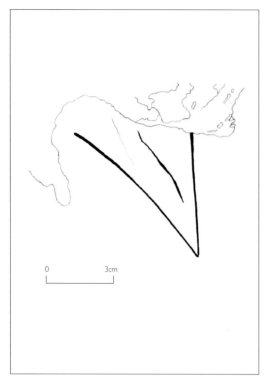

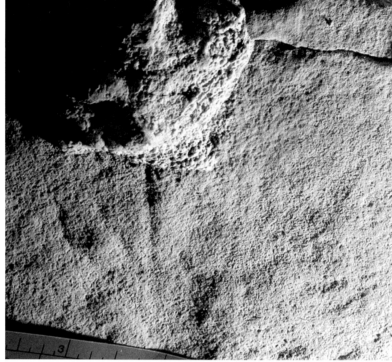

Fig 4.15
Drawing and photo of
triangle CH14.
(DP027464)

CH14

A small triangle engraved on the ceiling, about 30cm east of CH13, and between the walls bearing CH11–CH12 and CH19 (Fig 4.15). As with RHC1 it comprises three converging lines, one of which is natural but two are clearly engraved, and in this case one line is covered by a small stalactite which is of too poor condition to date. The similarity in form to RHC1 and dissimilarity to CH11 and CH12 are noteworthy. The length of the triangle is 4cm, and its maximum width is 3cm.

CH15

Second small triangle on the ceiling, with median line (Fig 4.16). Its length is 6cm, and its maximum width 2cm. It is located *c* 60cm south-west of the foreleg of CH13.

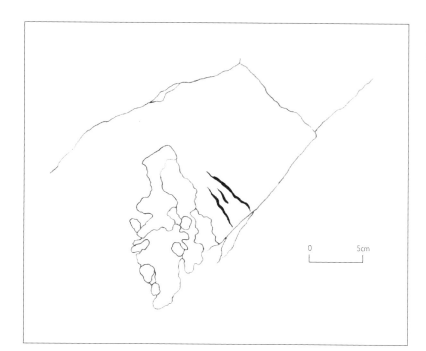

Fig 4.16
Drawing and photo of
triangle CH15.
(DP027473)

0 5cm

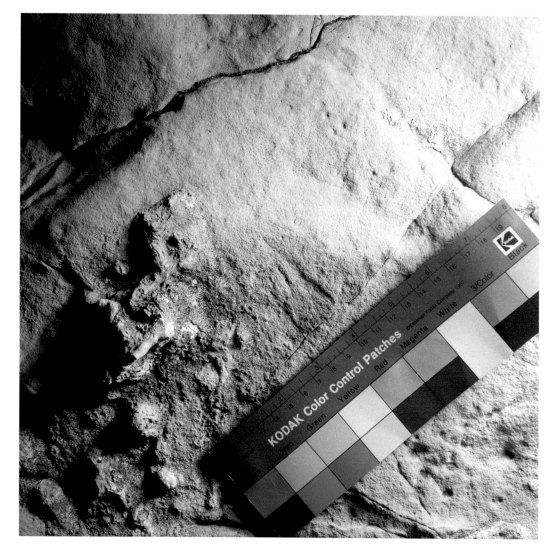

Fig 4.17
Drawing and photo of
the rear-end of a
quadruped, CH16.
(DP030333)

CH16

The engraved rear end of a quadruped, near the big modern 'J' on the ceiling, about 30cm south-west of the tip of the beak of CH17 (Fig 4.17). Unfortunately, the legs are insufficiently detailed to enable identification of the species depicted. The figure is about 9cm high.

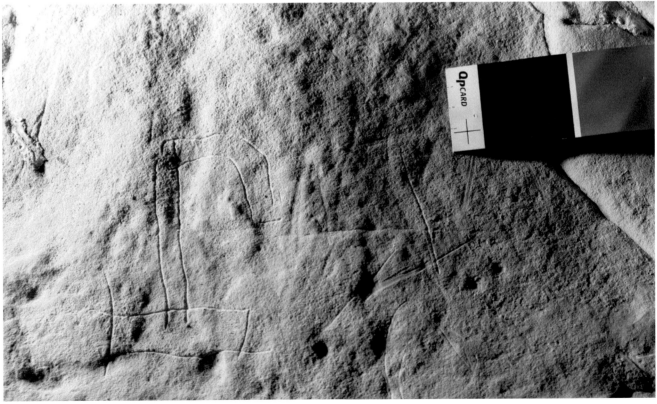

CH17

The 'ibis' on the ceiling, 34cm in maximum length and 13cm high at its widest, facing left (Fig 4.18). This figure is a mixture of natural and human-made features (*see* Mawson, p 101). There are clear traces of work along both sides of the beak, where the base of the original grooves can be discerned: what may have been a curved, natural feature has been clearly elaborated by champlevé sculpting (that is, made to stand out from the surrounding rock) to sharpen its clarity and to bring it to a point, thus producing a highly curved beak. It adjoins a natural erosional feature which resembles a bird's body; this has been underlined by an engraved line. The head and eye are probably human-made too, although the eye could also conceivably be a natural vug (*see*

Mawson, p 101) – the gap left after certain minerals have eroded away from the rock. Suffice it to say that, if the 'eye' is a vug, it is located in the head exactly where one would anatomically expect it, strongly suggesting that the presence of this natural feature guided the subsequent engraving/sculpting.

We interpret CH17 and its adjoining natural features as a bird. Obviously, Palaeolithic depictions are not photographs, and it is possible that this figure is a stylised representation of some common species such as a curlew. But it has to be said that it does not look anything like a curlew, whereas it is identical to depictions of ibises, such as those of Ancient Egypt (Fig 4.19). There is little or no evidence of ibis in the faunal remains of Ice Age Britain, but it should

Fig 4.18
Drawing and photos of the 'ibis', CH17. (DP027474, DP027490, DP027491)

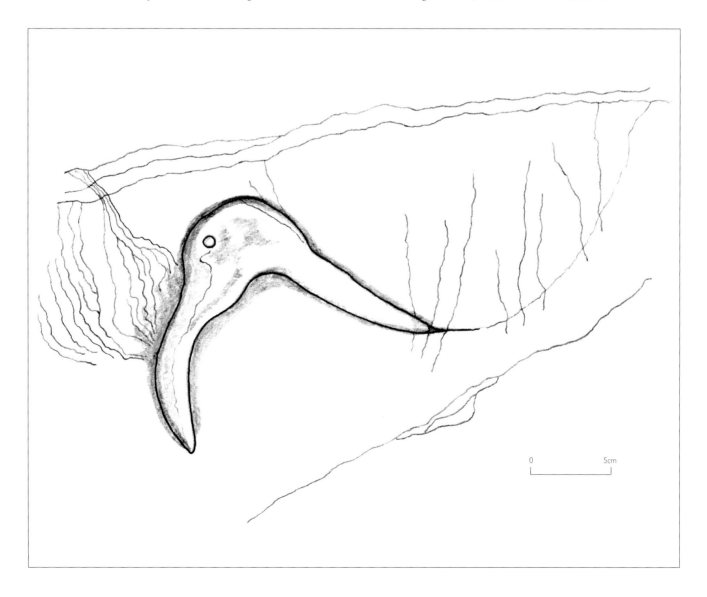

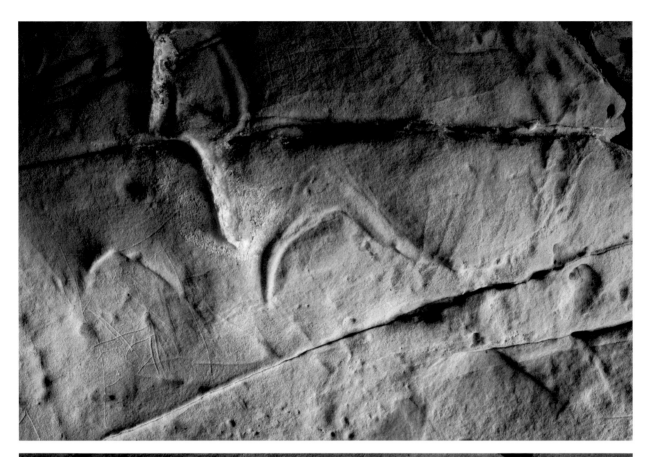

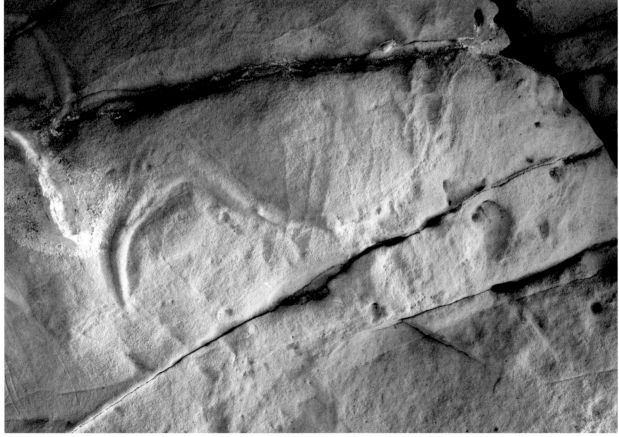

be remembered that the island was still attached to the continent at this time, and thus merely the north-western part of a landmass which definitely had ibises, and where these highly mobile people could certainly have seen them. Indeed, with regard to what is called 'Doggerland', the now submerged area we call the North Sea, it has been pointed out that, around 13,000 BP, 'the interstadial environment ... may have provided ideal feeding and breeding grounds for huge flocks of migrating wildfowl' (Coles 1998, 62). Moreover, even today, ibises occasionally visit Britain: in 2006

an African species, the Glossy Ibis (*Plegadis falcinellus*), appeared in southern England for the first time in 18 years (*The Times*, 9 September 2006), while the following year a flock of 17 were seen at Slimbridge, the biggest number since 1907 (*The Independent on Sunday*, 16 December 2007).

It is worthy of note that water species dominate the relatively short list of birds depicted in cave art – for example in Gargas, Hautes Pyrénées (Fig 4.20), Laugerie-Basse, Dordogne, and Ardales, Spain (Fig 4.21).

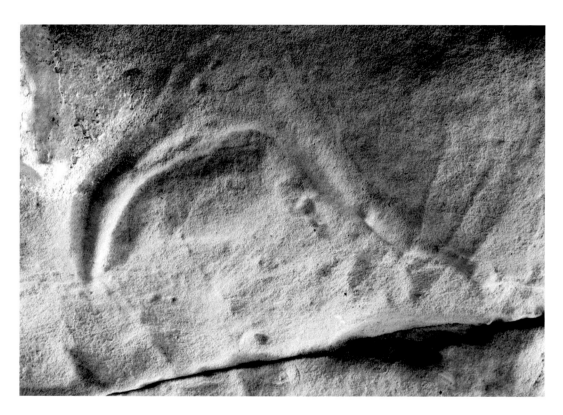

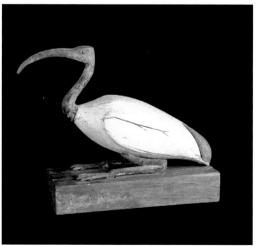
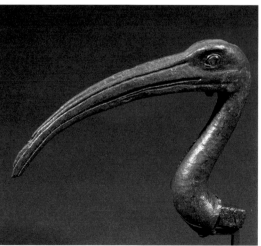

Fig 4.19
Ancient Egyptian carvings of ibises in the Louvre, Paris.
(Left: © Photo RMN/Christian Larrieu)
(Right: © 2005 Musée du Louvre/Christian Décamps)

Fig 4.20
Engraved waterbird in the
cave of Gargas, Hautes-
Pyrénées, France.
(From Breuil 1952, 256)

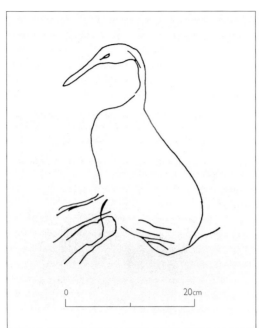
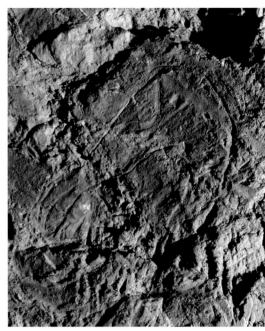

Fig 4.21
Engraved waterbird in
the cave of Ardales, Spain.
(Photo: Pedro Cantalejo
Duarte)

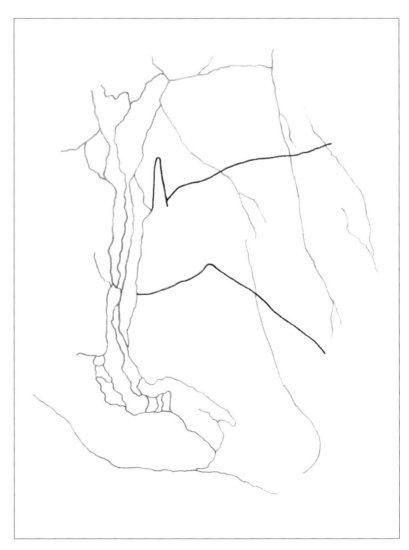

Fig 4.23
Drawing and photo of the
small animal CH18.
[DP030338]

CH18

A small incomplete engraved animal (Fig 4.23), 12cm wide and a maximum of 10cm high, facing left, just to the left of the stag CH19. The rock is quite eroded and covered in thin stalactite in this area. The figure's head disappears beneath the calcite.

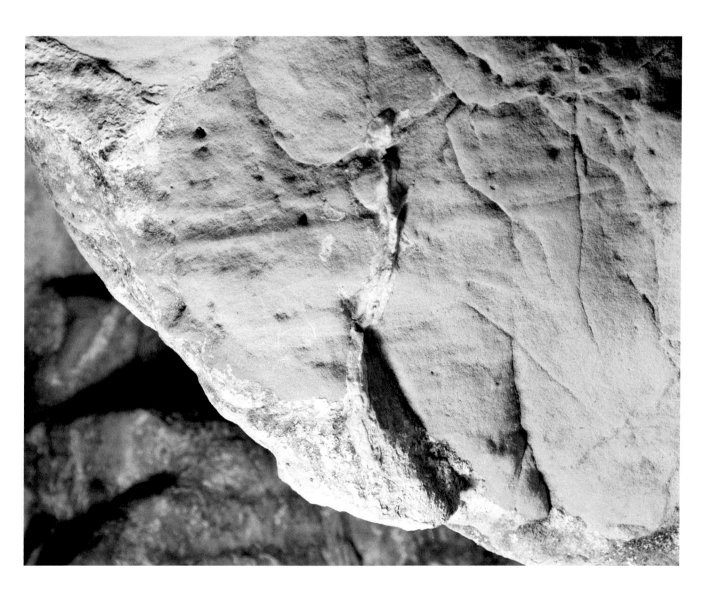

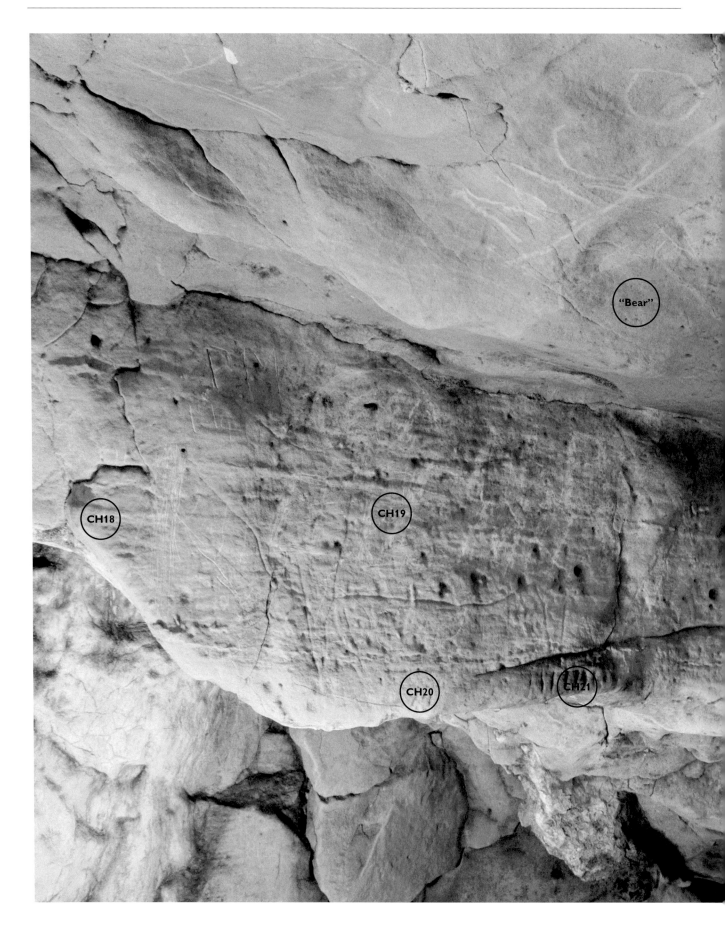

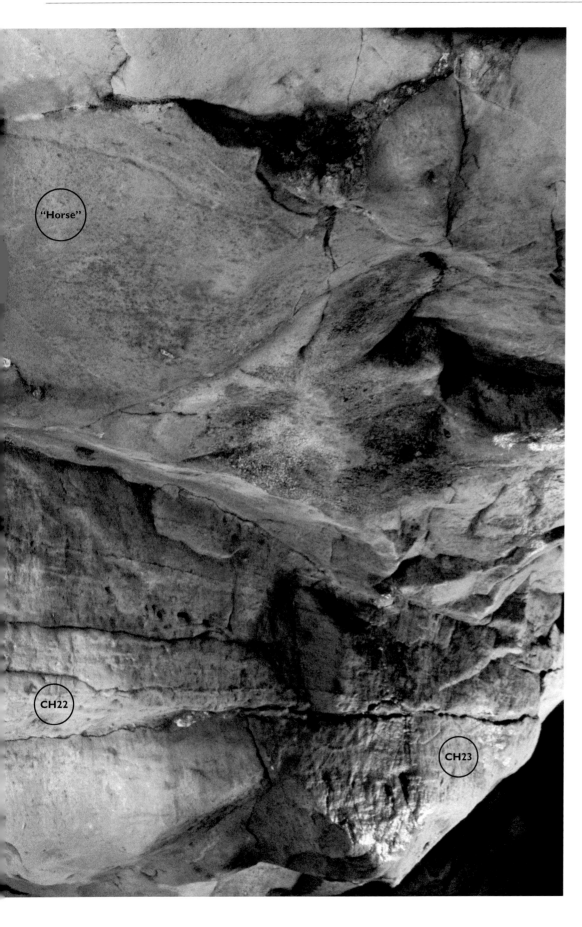

Fig 4.22
The principal panel in
Church Hole, showing
positions of engravings
CH18 to CH23.
(DP030339)

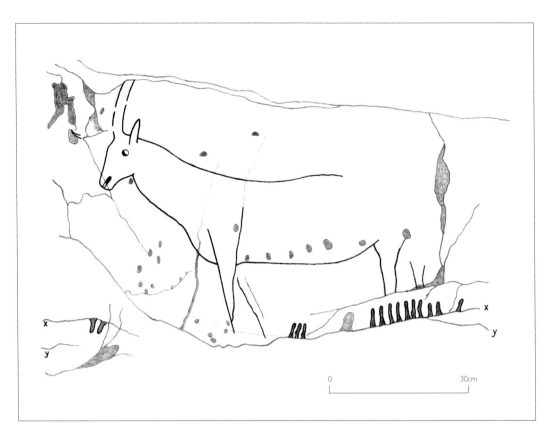

Fig 4.24
Drawing and photos of the stag, CH19. The photo of the stag (opposite, bottom; Paul Brown) has had the graffiti removed by computer.
(DP027481, DP027480)

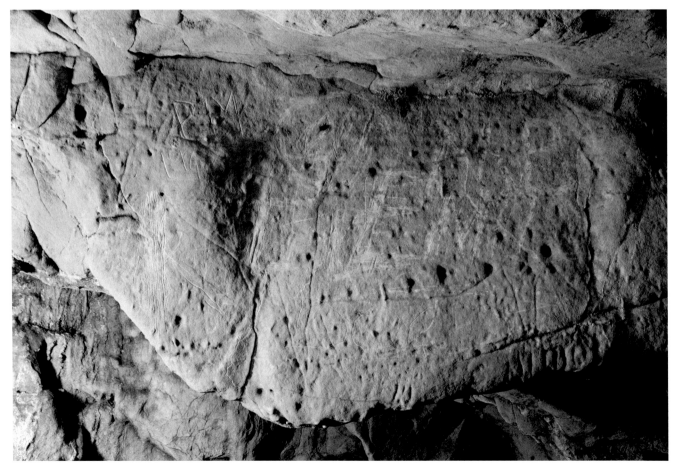

CH19

A clear depiction of an animal, engraved with boldly incised lines, which we interpret as a stag (Fig 4.24). Its maximum dimensions are 58cm long and 60cm high, and it faces left. It was originally published as panel III (Ripoll and Muñoz 2007). Much of the figure is covered by modern graffiti, making it extremely difficult to discern the back and especially the hindquarters. Other team members (*see* Ripoll *et al* 2004b, 2) believed that two superimposed deer are engraved here, and in addition that there are several small animal heads inside them. Many of these markings simply do not exist, and where markings do exist they are clearly natural (the same applies to the rough sketches of heads on the ceiling – ibid, 2). The whole vertical rock panel on which CH19 is engraved is scored with horizontal bedding planes which are themselves truncated in places by solution cracks, and the ensemble is covered in modern graffiti. There are no clearly engraved depictions in this area other than the CH19 outline. It should also be stressed here that the photo of the stag's head which appeared on the cover of *Current Archaeology* (May/June 2005) had been greatly modified by computer by one of the team (SR). This artificial modification included the removal of graffiti and an exaggerated depiction of its antlers. Although an engraved tine-tip does appear just to the left of the antler shaft, the continuation of the antler on the ceiling is not at all apparent; it seems that the abrupt transition between the vertical wall on which the stag is depicted and the horizontal ceiling brought the engraving to a truncated end.

An appropriate point to begin the description of this image is its eye which, perhaps like that of the CH17 bird, is a natural erosional vug. It is of interest that we may have two examples of such vugs being taken to represent an eye, with engraving occurring around these in anatomical proportion. Beneath this, a small remnant burrow in the rock suggests the form of a mouth, in approximately the correct position in relation to the eye. Together, these two natural features determined the scale and orientation of the figure. All other components of the image are clearly deliberately engraved. A clear muzzle, nose, brow, pointed ear, upper neck, and cervical and dorsal line flow clearly backwards from the face, although the line of the lower back and rump is lost to severe erosion and destructive graffiti in this region.

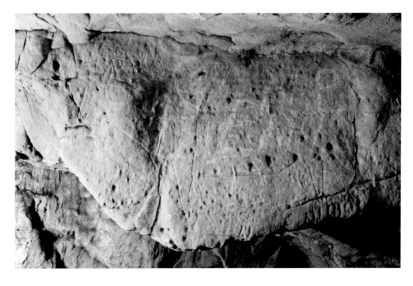

A clear antler comprising two parallel lines rises from the brow until it is truncated where the wall meets the ceiling. As the lines of the antler rise they cross several tightly spaced bedding planes in the rock, one of which has been extended by a small area of deliberate engraving in the position of a brow tine. It was the discovery of this feature that caused us to reinterpret this depiction as deer, not ibex. Beneath the eroded rump is a clear depiction of a rear leg, comprising two converging lines which are terminated before meeting and which do not possess a hoof. A clear ventral line connects to this and continues to a similarly elongated triangular front leg which dissects the chest line. Again the leg comes to an open end without the depiction of a hoof. In front of this is a clear although unpronounced dewlap, and a continuous line up to a strongly engraved jaw.

We have noted above that there is a considerable amount of graffiti on this panel. This is not surprising as the wall of the cave in this area is a relatively smooth, vertical, 'curtain'-like drop, which is very amenable to decoration. As we found when we discovered it, the section of wall was also still accessible, after the excavations of 1876 took the floor level down some 1.5m, by climbing onto a surviving ledge. We note that the appearance of the graffiti – which in some cases bear 20th-century dates – is far sharper and bright yellow in colour in comparison to the dulled lines of the Ice Age engraving. One graffitist clearly must have spotted CH19 and interpreted it as a depiction of a goat, as a long flowing 'beard' has been drawn from the jaw downwards.

We initially interpreted CH19 as a male ibex (Bahn *et al* 2003), but rapidly came to see it as a deer, far more likely a red deer stag than a reindeer because the dewlap is relatively unpronounced in the former. This change in interpretation has been criticised in some quarters. As explained earlier in this chapter, our initial assessment was due to the rapidity and poor lighting conditions of our first encounter with the drawing. Later careful study, together with the discovery of the small engraved tine-tip noted above, led to our amended identification. In our defence, it should be noted that someone else, before us, as mentioned above, had seen this figure, thought it was a male goat, and carefully engraved a long beard beneath its chin.

Moreover, a degree of ambiguity is actually quite common in Palaeolithic art, and this is by no means the first occasion when an Ice Age figure has been interpreted as both of these animals. For example, on an engraved block from the Spanish Pyrenean site of Abauntz, 'Il y avait un certain doute sur l'identification comme cerf ou comme bouquetin de la figure représentée en position frontale' ('There was some doubt about the identification as stag or ibex of the figure depicted in a frontal view': Utrilla *et al* 2004, 203). Even more remarkable is the case of the stag in the Salon Noir of Niaux (French Pyrenees) – probably the best known deer in cave art – which Schmid (1964) believed to be an ibex. She saw its tines as excrescences on the horn – if one removes them, this figure really looks like an ibex, with a curved forehead, short muzzle, and ears immediately behind the horns. A realistic stag would have a slight concavity at the base of the antlers, an elongated muzzle, and ears farther behind the antlers (Fig 4.25).

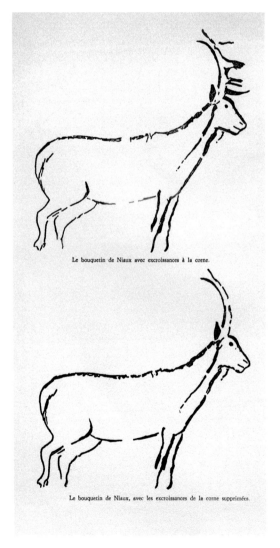

Le bouquetin de Niaux avec excroissances à la corne.

Le bouquetin de Niaux, avec les excroissances de la corne supprimées.

Fig 4.25
Drawings of the Niaux stag/ibex figure. The figure is about 70cm wide and 82cm high.
(From Schmid 1964, 34)

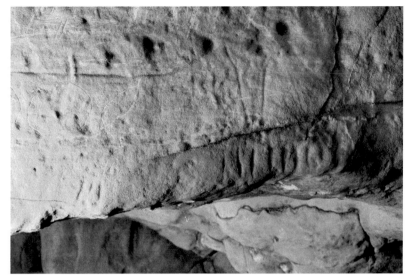

CH20–CH22

Three heavily incised sets of notches below the CH19 stag and to its right (Fig 4.26). From left to right these groups comprise three (CH20), nine (CH21) and two or three (CH22) vertical lines, their length varying from 3.8 to 6cm, and their width from 3 to 8mm. CH20 is located beneath the chest area of CH19, CH21 spans the area of its lower belly, rear leg and a little beyond the figure, and CH22 is located a little beyond the rear of the animal. A pronounced stalactite flowstone overlies several notches of CH21, which provides a minimum age for the incisions and thus provides independent verification of the Ice Age antiquity of the markings (*see* Chapter 5). Little can be said about these, although it is interesting to note that the three groups cluster on the same plane of the rock, are not found elsewhere, and occur in multiples of three. The principal analogy to these notches, albeit much earlier in date (probably Gravettian, *c* 27,000 BP, or even older), is the series above the bas-relief salmon on the ceiling of the Abri du Poisson, Dordogne (Fig 4.27).

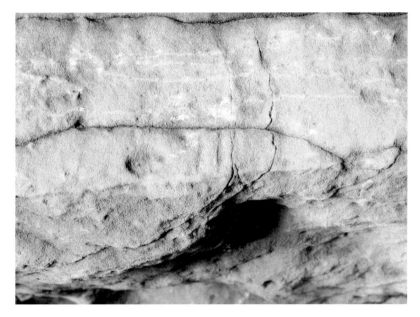

Fig 4.26
Photos of notches CH20
to CH22.
(DP030340, DP030341)

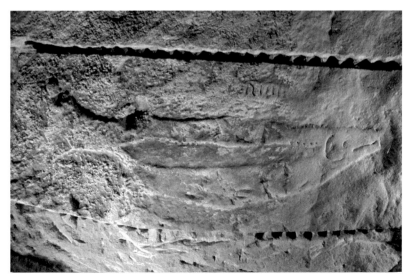

Fig 4.27
The notches next to the
bas-relief fish in the Abri du
Poisson, France.
(Photo: P Bahn)

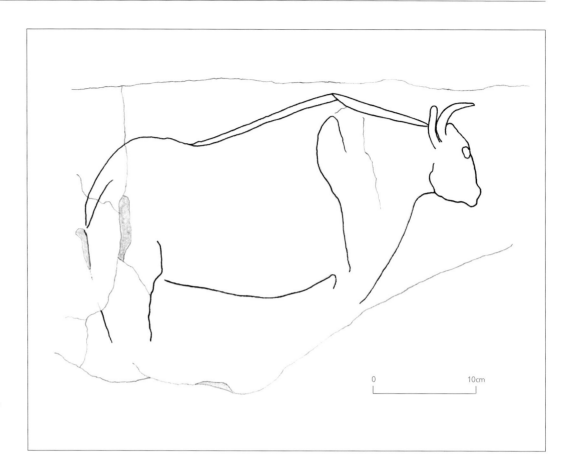

Fig 4.28
Drawing and photos of the
bison, CH23.
(DP030343, DP027486,
DP030344)

CH23

To the right of the stag, an incomplete engraving, clearly of a bovid (Fig 4.28), which was previously published as part of panel III (Ripoll and Muñoz 2007). In dimensions it is 34.5cm in maximum length and 16cm maximum height, and faces right. Like CH19 it is boldly engraved on a smooth, vertical 'drop' of wall, and its lower margins are truncated by the edge of the rock, which drops into space. The clearly identifiable bovid outline includes a strongly engraved and continuous rump, a dorsal line comprising the lower back, and a pronounced shoulder hump emphasised by a double line, two forward-curving horns (or a horn and ear), a clear and pronounced brow, nose and angular muzzle, and a chest line which terminates at the figure's lower extremity where the rock ends. There are lines inside the figure which might represent a muscular front leg.

Originally, interpretation leaned towards aurochs, partly because of the head-shape (more horizontal than vertical), and partly because of the forward-pointing horn(s). However, aurochs were never depicted in Ice Age art with a pronounced hump like this, let alone one emphasised by a double line, and there are many bison depictions with horns that point forward – including the carved bison from La Madeleine (Dordogne) of a bison licking its flank, perhaps the best known of all Ice Age bison figures. Some bison in Niaux (Ariège) also have horns projecting forwards. Lorblanchet (pers comm) considers the Church Hole depiction to be 'one of the most magnificent Magdalenian bison figures' for its proportions, execution and fluidity, and indeed believes that it is an anatomically realistic depiction of the European bison. Although a discrete and thin flowstone has run over the head area, the horn and ear seem to be human-made, but the eye is too eroded to be sure. The loop shape inside the shoulder is also human-made. It is conceivable that the horn, ear and hump may also be partly in bas-relief.

Figures of uncertainty

In any cave, there may be figures which are uncertain – mostly depictions which make great use of natural features, and in which human work is either minimal or even undetectable. Virtually every decorated cave contains examples of the use of natural shapes, so it would be strange indeed if Church Hole did not display some. And certainly, the stag and the 'ibis', and perhaps also the bison, incorporate natural features in their design.

One or two specialists have rejected this phenomenon – for example Gaussen (1984, 111–15) was sceptical and thought that use of relief was due to chance. Most scholars, however, recognise the use of natural features as a fundamental characteristic of cave art. But they are divided into those who scrupulously accept only those figures with clear human work, and those who are far more liberal in interpretation and acceptance: as Sauvet and Tosello (1999, 76) put it:

Certains préhistoriens adoptent une position très restrictive, refusant de prendre en compte l'utilisation d'un relief si elle n'est pas soulignée par un trait peint ou gravé … D'autres, au contraire, donnent une interprétation figurative de la moindre incision sur la paroi, n'hésitant pas à compléter le dessin par des fissures naturelles. On voit bien le double danger encouru: des critères trop sévères risquent de nous faire rejeter une grande partie des utilisations de reliefs et de marginaliser le phénomène, nous privant ainsi d'un aspect peut-être essentiel de l'art paléolithique; au contraire, en laissant libre cours à notre propre imagination, on court le risque de la substituer à celle des Préhistoriques et de ne trouver que ce que nous cherchons.

(Certain prehistorians adopt a very restrictive position, and refuse to take into account the use of a relief if it is not emphasised by a painted or engraved line … Others, by contrast, give a figurative interpretation of the slightest incision on the wall, unhesitatingly completing the drawing with natural fissures. One can clearly see the double danger here: excessively tough criteria risk making us reject a large number of uses of relief, and marginalising the phenomenon, thus depriving us of a perhaps essential aspect of Palaeolithic art; on the other hand, by giving free rein to our own imagination, we run the risk of substituting it for that of prehistoric people, and only finding what we are looking for.)

This dilemma has certainly been present during the study of the art in Church Hole.

Sauvet (2004, 167) has studied this phenomenon on the portable art from Bédeilhac (Ariège), and found that there is an 'utilisation presque constante, quasi-obsessionnelle des particularités morphologiques du support' ('almost constant, quasi-obsessive utilisation of the support's morphological peculiarities'); small details were added to the stones – eyes, muzzles, ears and so on. The obvious ones make it likely that others, with minimal additions, are also art objects.

It is precisely because of such studies that we must be cautious but open-minded about some of the doubtful figures in Church Hole. For example, one small 'vulva' engraved on the ceiling is probably acceptable as a figure, since only one of its three sides is made of a natural line. The same may be true of the 'square' on a surface beneath the stag (mentioned by Mawson, p 103), but here only one of the sides may be human-made (Fig 4.29).

Fig 4.29
Photo of the 'square'.
(DP030342)

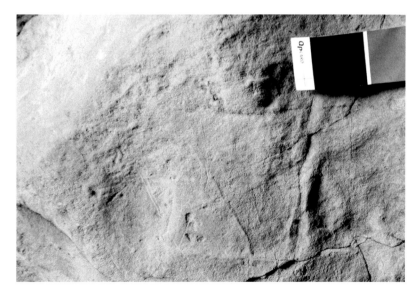

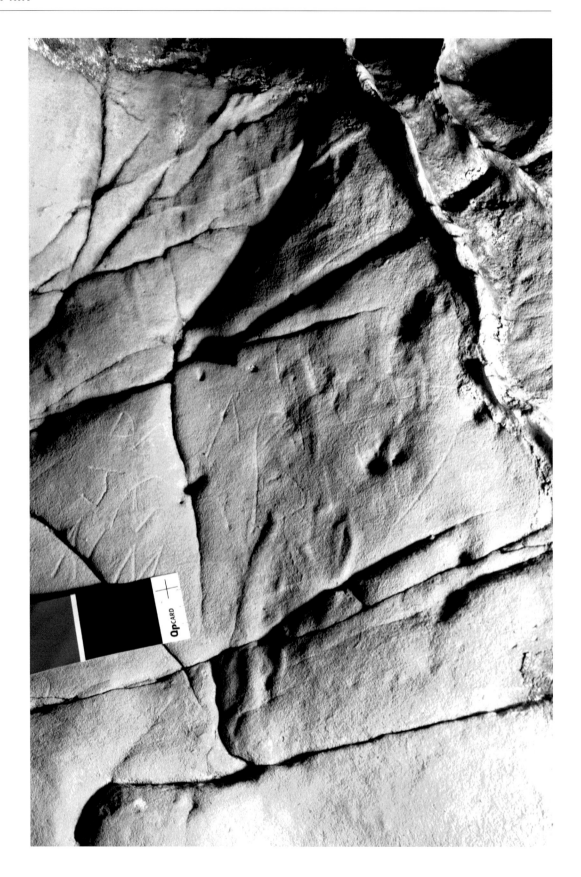

Fig 4.30
Photo of the 'bison-head
profile'.
(DP030337)

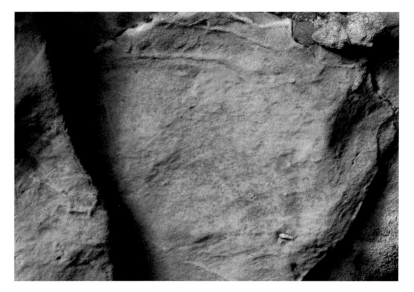

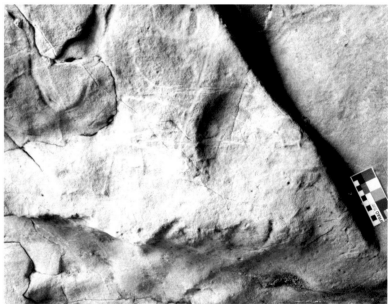

Absolutely no trace of human work can be discerned on some major ceiling figures which have previously been published. The 'bison-head profile' in bas-relief (Fig 4.30), close to the 'ibis', is one of these (*see* Ripoll *et al* 2004b, 4). It certainly resembles a bison-head in profile, but may well be natural (see Mawson, p 103). The 'horse-head' (Fig 4.31), which is also highly visible and resembles a heavily maned horse-head, likewise lacks any trace of work: it is a combination of erosion, black stains for the head, and natural burrow cast reliefs for the mane (*see* Ripoll *et al* 2004b, 6). And the 'bear' on the ceiling (Fig 4.32) has a shape which may well have been recognised and utilised by cave artists, but again it lacks any evidence of human work (*see* ibid, 5).

So at Church Hole – beyond the clear images listed above – we are left with a series of figures which may have been created or modified, but of which we cannot be sure at all. They may be considered possibilities, but no more than that.

It is certainly possible – perhaps even likely – that more figures exist in Church Hole than those listed. New figures are still being discovered in even the best-known and most heavily studied caves in France and Spain, as new eyes and different lighting methods are applied to them: for example, in the last few years alone, new figures have been spotted on some very famous panels in Ekain, Gargas and Les Trois Frères. One can also cite many instances where one specialist has seen a figure, while others simply cannot find them afterwards – for example, Leroi-Gourhan was shown two small bison 'faiblement sculptés' ('faintly carved') on the neck and shoulder of the big central horse at Cap Blanc (Dordogne), but their discoverer was later unable to show them to Roussot, who therefore believes that these pseudo-figures are 'dus au jeu des écaillages et altérations de la surface sculptée' ('caused by the play of the flaking off and weathering of the carved surface': Roussot 1984, 160). In cases such as these, the decipherment is probably wishful thinking, but it is not always possible to be absolutely sure.

Fig 4.31
Photo of the 'horse-head'.
(DP027484)

Fig 4.32
Photo of the 'bear'.
(DP030345)

Conclusion

In short, the discovery of Britain's first Ice Age cave art at Creswell Crags has proved a mixed blessing. Although an event of great importance for British prehistory, it involves rock surfaces which are particularly difficult to study because of their friable and eroded nature, their innumerable fissures and rounded shapes, and the interplay of relief and shadow. Each of the major depictions has posed some problems of interpretation, and we are left with a number of 'possibles' on which we may never be able to reach a definitive decision. At present, we believe that Creswell Crags have 25 indisputable engraved figures, together with a handful of possible ones and a large number of improbable ones. We summarise the former in Table 4.1.

The problem of Creswell's surfaces has important implications for all cave art studies, because today's tracings and recordings need to be painstakingly accurate and careful. Subjectivity in the recording of figures has caused many problems in the past (*see* Bahn and Vertut 1997, chapter 4) and, as shown above, has continued to do so at Creswell. It is necessary to place strict boundaries on what can safely be 'identified' on a rock surface and what cannot, and despite the temptation to magnify a cave's tally of figures, crossing that line must be avoided. To do otherwise is reckless and highly dangerous, and risks damaging not only the study of cave art, but rock art studies as a whole.

Verification of the age of the Palaeolithic cave art at Creswell Crags using uranium-series disequilibrium dating

ALISTAIR PIKE, MABS GILMOUR AND PAUL PETTITT

Introduction

Upon discovery of the Creswell cave art in April 2003, and a systematic survey and study of known images in June of the same year, there were several grounds for believing that the art was of Pleistocene antiquity. Stylistically many of the engravings resemble known Upper Palaeolithic art, particularly that of the Late Upper Palaeolithic Magdalenian culture. Physically, the profile and appearance of the engravings showed a greater degree of weathering than engraved graffiti dating to the 1940s. At least one of the images (the large bovid) represents a species known to be extinct in Europe, either since the 17th century AD (if identified as the wild cattle, aurochs, *Bos primigenius*) or since the Late Pleistocene (if depicting the extinct bison, *Bison priscus*). These and other observations (*see* Chapter 4) suggested the art was certainly of considerable antiquity, and in all probability contemporary with the Late Upper Palaeolithic (Magdalenian) archaeology, which can be dated relatively tightly in the UK to about 12,600–12,200 radiocarbon years ago (*see* box on p 89) and which is well represented by artefacts excavated from the Creswell caves (*see* Chapter 2).

Cave and rock art is, however, notoriously difficult to date stylistically and is problematic even using scientific dating methods (*see below*). Rock art is rarely accompanied by the additional evidence (stratigraphy, artefacts and so on) typically found in archaeological layers, which can be used to cross-check the stylistic or scientific dating, compare dates between sites, or compare records of climate change and faunal extinctions. Chronologies for rock and cave art are therefore less well defined than for

other archaeological materials such as bones and stone tools, and some engravings or paintings elsewhere have elicited age estimations from different specialists differing by more than 10,000 years (eg Pettitt and Bahn 2003; Zilhão 1995).

Despite the confidence of the discovery team that the engravings were Late Upper Palaeolithic in age, the need for independent verification of their archaeologically and stylistically based arguments was clear. With the support of English Heritage, a programme of dating of the flowstones which had flowed down over some of the engravings was carried out. Flowstones form when water percolating through bedrock picks up calcium carbonate in solution as it travels downwards. When this water and dissolved calcium carbonate reaches the atmosphere of a cave, the calcium carbonate is brought out of solution and forms rock once again, either as a gradual accumulation hanging from a ceiling (a stalactite) or accumulating upwards (a stalagmite), or accumulating as 'flowstone' from water running over the cave's walls (flowstone in some formations is known as 'frozen rivers'). It is the latter that are of interest at Creswell, as in a number of places a thin flowstone has formed over engravings. As these flowstones obviously formed after the art was created, dating their formation provides us with a minimum age for the art itself. While there need be no close relationship in time between the art and the stalagmites that flowed over them, dating the flowstones to the prehistoric period would considerably strengthen the claims on other grounds for a Palaeolithic and Pleistocene antiquity of the art. The scientific dating project has been successful in doing this for three separate

images, and given this, we feel it is highly likely that all of the identified art is of similar, that is, pre-Holocene antiquity.

Dating cave art

Establishing the age of rock art is usually considerably more complicated than dating objects excavated from archaeological sites (for a review of the scientific dating of cave art *see* Pettitt and Pike 2007). Complications arise because of the difficulty in confirming the association between the artefact (in this case, the art) and the material being dated. For a well-sealed archaeological layer it is often accepted that dates from one or two bones, or fragments of charcoal, or better still a sequence including dates from levels above and below the relevant deposit provide a reliable date or date range for the other artefacts in the layer. These dates can also be cross-checked with dates from layers in other archaeological sites with similar artefacts. In exceptional circumstances pieces of stone bearing engravings or paintings become detached from the walls and ceilings of caves and rock shelters, and are thus incorporated into datable archaeological sediments, as with the Late Upper Palaeolithic (Solutrean culture) sculpted panel from Le Roc de Sers in France (Tymula 2002). In the vast majority of cases, however, engraved or painted rock art is seldom part of a depositional sequence, and thus it is extremely rare that the age can be as well constrained.

Dates of 'rock varnish', weathering rinds or calcite deposits (flowstone) that overlie the art can provide only minimum ages, whereas radiocarbon dating of the charcoal-based pigments used to create paintings can provide only a maximum age, as the technique is actually dating the production of the charcoal rather than its use to create a depiction. Potentially the time delay between the preparation of wood to form a charcoal-based pigment and the use of that pigment can be assumed to be insignificant, but the use of old charcoal cannot be ruled out (eg *see* Pettitt and Bahn 2003). With regard to the latter problem, imagine that a small hearth was lit in a cave 15,000 years ago. The charcoal formed within the hearth lay undisturbed until it was excavated 15,000 years later. Let us say that the quality of the charcoal is still very good – if erosional events have been few in the cave it might well be – and that it would still, after all this time, provide a

useful material with which to mark the walls of the cave. Now, three people – let us call them Alistair, Mabs and Paul – pick up the charcoal and use it to write 'Alistair, Mabs and Paul were here' on the walls. Some time later a radiocarbon specialist scrapes some of the charcoal from this 'art' off the wall. It would date to 15,000 years ago, suggesting that Alistair, Mabs and Paul were alive in the Late Upper Palaeolithic and wrote English, whereas we all know they are 21st-century AD archaeologists.

This is the 'old charcoal' problem. Even if we can control for this – and we can on occasion – the dating techniques themselves have many potential inaccuracies. With the very small quantities of carbon available from rock art, contamination of radiocarbon samples is a big issue. We can only remove very small amounts of sample from precious cave art panels, and the smaller the sample the greater the effect of any form of contaminating carbon derived from elsewhere. With other methods it can be worse – for example cation-ratio dating, which measures the chemical changes over time of certain mineral skins that can form over rock art (eg Nobbs and Dorn 1988) – as they are affected by factors such as the average temperature over time, which at best can only be estimated in an imprecise way.

Even when it can be assumed that the dating methods are accurate, the relationship between the material dated and the art itself must be completely secure. It is important to remember that the date of a calcite flowstone layer provides a minimum age for the art only if it overlies the art and is not potentially contaminated with earlier flowstones. Furthermore, there may be a delay of many thousands of years between the making of the art and the growth of the flowstone. We have no other way of telling. Thus, while a minimum age can be obtained for art, it may not be particularly useful in understanding its specific age. In the case where the art was made on already-deposited calcite and subsequently covered by further calcite, it may not be possible to remove samples from only those layers above the art, and thus a date for the calcite will not relate to the date of the art. It may seem a trivial assumption that a black charcoal-based pigment comprising part of a figurative depiction has an obvious temporal relationship to the figure, but the possibility of retouching, overdrawing or later deposition of soot from lamps may complicate the picture. Attempts to date

rock art, therefore, must proceed with significant caution, using only the securest samples and controlling for contamination. They should certainly be regarded as developmental, and not routine, chemistry.

Inaccuracies in dating may go undetected, or may be in obvious conflict with the stylistic interpretation or the archaeology in the immediate vicinity. In the case of conflict it would be a circular argument to rely entirely on the stylistic attribution of a date over absolute dating methods, but neither should we ignore stylistic interpretation simply because we have absolute dating methods.

The rock art at Creswell takes the form of engravings cut directly into the limestone bedrock, and we therefore lack datable charcoal pigment that could be dated directly with the radiocarbon method. Fortunately, however, a number of the Creswell images were overlain by thin flowstone veneers. The formation of each of these can be dated by the uranium-series (U-series) disequilibrium method. In April 2004 a number of samples of flowstone were taken with this aim in mind, which if successful would, we hoped, confirm our suspicions of a Palaeolithic age for the art. We present in this chapter the results of this project.

Radioactive dating

Uranium-series disequilibrium dating is one of a suite of archaeological dating methods that, like radiocarbon dating (*see box*), use radioactive phenomena to provide a measure of time. Radioactive isotopes decay, and the process of decay is essentially random, but one that can be predicted with considerable precision. It is uncertain exactly when any single radioactive atom will decay, but the radioactive behaviour of a large number of atoms can be predicted. In the same way, just as it is impossible to reliably predict the number rolled on a single throw of a die, we can guess fairly accurately the number of 6s that will appear when rolling 1,000 dice, and guess even more accurately when rolling many millions of dice. In fact, predicting the rate of decay of radiocarbon (^{14}C) in a gram of modern wood is like throwing a billion dice, since this wood contains about a billion atoms of radioactive carbon. With so many dice we could predict the number of 6s rolled with a margin of error better than one one-hundredth of 1 per cent. Unlike some physical or chemical processes

Radiocarbon dating

All things that live take in carbon from their environment. Carbon is present in living things in three atomic masses. Around 99 per cent of carbon is ^{12}C (that is, carbon with an atomic weight of 12); around 1 per cent is ^{13}C, and around 1^{-10} (that is, around 1 in a million million atoms) is ^{14}C. Of these, ^{12}C and ^{13}C are stable – they do not decay. ^{14}C, on the other hand, is unstable, or radioactive, and is subject to constant decay. For this reason it is known as radiocarbon.

^{14}C is created in the upper atmosphere, and, like the stable isotopes of carbon, is incorporated into plants through photosynthesis, into herbivores when they eat the plants and into carnivores when they eat the herbivores. In this way (and in more complicated ways in marine and aquatic environments) it reaches all life on Earth. When something is living it is constantly 'topping up' its carbon, replacing the ^{14}C that is constantly decaying. When that organism dies, however, the replacement ceases, and it is at this point that the 'ticking clock' of radioactive decay becomes useful for archaeologists. As carbon will no longer be replaced, the loss of ^{14}C in a once-living thing can be used to assess the date that the organism died and ceased to exchange carbon with the environment. This age is usually expressed as 'before present' (BP). All specialists need is the amount of ^{12}C and ^{13}C in the sample, which will be the same as the organism had in life, and from which the original amount of ^{14}C in the sample can be predicted. It is then easy to estimate exactly how much ^{14}C has decayed.

We know that around 50 per cent of ^{14}C decays over the course of approximately 5,730 years. Thus the bone of a human who lived around 6,000 years ago would retain 50 per cent of its original carbon: one that was twice as old, ie 12,000 years, would retain half again (25 per cent of its original in life), and so on. With this knowledge we can turn the figures into a date. This date, however, is reliant upon the levels of production of ^{14}C in the upper atmosphere, which can accelerate and decelerate over time. At certain times in the past, therefore, the radiocarbon 'clock' was ticking relatively quickly; at others, slowly.

In order to turn these uncalibrated radiocarbon measurements into true calendrical dates, we need to calibrate them using a curve derived from the radiocarbon dating of known-age samples (usually tree rings that form annually within trees and can thus be dendrochronologically counted backwards). Calibration has shown us that radiocarbon dates quite often underestimate real ages. Thus, the uncalibrated radiocarbon ages discussed in Chapter 2 should be regarded as underestimates. Those measured on samples from the Late Upper Palaeolithic (Magdalenian) occupations of around 12,500–12,000 BP would, when calibrated, actually reveal a true age of around 15,000–14,000 years ago.

With scientific methods of analysis there is always a degree of uncertainty in results, and in the case of dating this uncertainty is expressed as an error after the mean date. Scientists – in this case dating specialists – state their results in terms of confidence, usually an error expressed as a standard deviation. 'Sigma' (σ) denotes a level of error, thus 1σ is one standard deviation (there is a 68% chance of results lying in this range); 2σ increases the chance to 95%, and thus is the preferred level of confidence used by scientists.

used as dating methods, the rate of radioactive decay is unaffected by environmental parameters such as temperature or moisture. With only one or two exceptions, radioactive dating methods require very few, if any, estimations or assumptions (for example of past temperature) to calculate a date. It is because of this that radioactive dating methods provide the majority of the absolute chronologies available for archaeology and geology.

The rate of decay of radioactive atoms is exponential – that is to say, the number of atoms decaying in a given time decreases as more of the element decays. This becomes obvious if we use our dice analogy, where rolling a 6 signifies the atom has decayed. Say we start with 216 dice (this number has been deliberately chosen), one-sixth of them (36) will decay in the first roll, leaving 180 dice. In the subsequent roll of the remaining dice, one-sixth of these (30) will decay, leaving 150, then 25 will decay and so on. The number of decays per roll decreases at each roll at a rate defined by the probability of rolling a 6 (or in our case the probability of an atom undergoing radioactive decay). For radioactive elements that persist for long enough to be useful in archaeology, the probability of radioactive decay of a single atom is very small, so to avoid having to deal with tiny numbers, it is more convenient to deal with the concept of a 'half-life' to describe radioactive decay.

The half-life of a sample of radioactive atoms is the time it takes for half those atoms to have decayed. This value is independent of the number of atoms remaining and thus the half-life is a constant for a given radioactive species. This is illustrated for radiocarbon ^{14}C in Fig 5.1. ^{14}C has a half-life of 5,730 years. Thus, half the atoms will have decayed in 5,730 years, another half after 11,460 years (leaving a quarter of the radiocarbon, or 0.25) and so on. In principle, to calculate a date using simple radioactive decay we simply need to know the number of atoms we started with, the fraction of those we have in the sample today, and the half-life of the radioactive decay. For radiocarbon dating this calculation is complicated by the variation in the past of the amount of ^{14}C in the atmosphere, and consequently the number of starting atoms of ^{14}C, but this has been overcome by calibration using measurements of ^{14}C concentrations in tree rings of known date.

Uranium-series disequilibrium dating

When radiocarbon decays it forms stable nitrogen-14 (^{14}N), but the most common form of uranium, ^{238}U, decays to an unstable 'daughter', thorium-234 (^{234}Th). This is itself unstable, with a half-life of just 25 days, and decays to protactinium-234 (^{234}Pa), which is even more unstable and has a half-life of less than 7 hours. ^{234}Pa decays to another unstable isotope and so on. This 'decay chain' continues

Table 5.1 The uranium series

Nuclide	Half-life
^{238}U	**4.47 x 10⁹ yrs**
^{234}Th	24.1 days
^{234}Pa	6.69 hours
^{234}U	**2.54 x 10⁵ yrs**
^{230}Th	**7.57 x 10⁴ yrs**
^{226}Ra	1600 yrs
^{222}Rn	3.8 days
^{218}Po	3.0 mins
^{218}At	1.6 secs
^{218}Rn	0.035 secs
^{214}Pb	26.9 min
^{214}Bi	19.7 min
^{214}Po	1.6 x 10⁻⁴ secs
^{210}Tl	1.3 mins
^{210}Pb	22.6 yrs
^{210}Bi	5.0 days
^{210}Po	138.4 days
^{206}Hg	8.2 mins
^{206}Tl	4.2 mins
^{206}Pb	stable

Note: The parent ^{238}U decays to ^{234}Th which decays to ^{234}Pa and so on down the list. The isotopes in bold are those with long half-lives and of interest to archaeology and geology.

Fig 5.1
Exponential decay of ^{14}C. The ^{14}C remaining is expressed as a fraction of the starting quantity. The broken lines represent the age of a sample containing 0.5, 0.25 and 0.125 of the starting quantity, ie 1, 2 and 3 half-lives. These quantities correspond to 1×, 2× and 3× the half-life of 5,730 years.

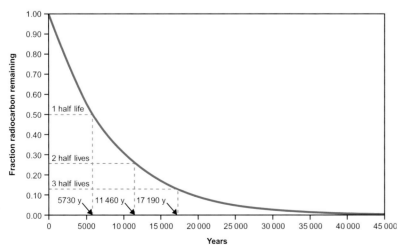

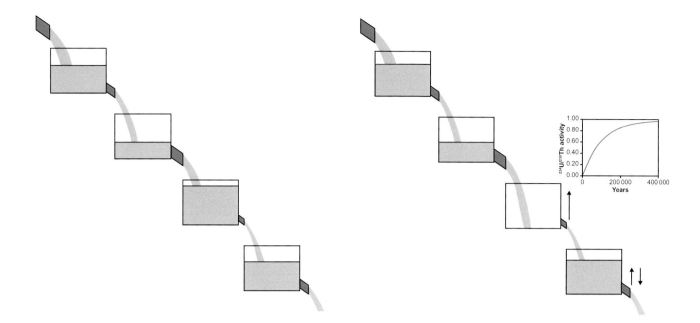

until after 19 decays the original atom of ^{238}U becomes lead-206 (^{206}Pb), which is not radioactive (see Table 5.1). Most of the daughter isotopes have very short half-lives, some only a few seconds or less, but ^{234}U and ^{230}Th, with half-lives of 245,000 years and 76,000 years, persist long enough to be useful for dating archaeological timescales. The method has the advantage that the long half-life of Th extends the method back to about 500,000 years, well beyond the practical limit of ^{14}C dating of about 50,000 years.

Because the number of decays of a particular isotope at any one moment is proportional to the number of atoms of that isotope remaining (as it was for the dice), the rates of decay of each of the isotopes in the chain will eventually become equal to each other, so for every atom of ^{238}U that decays one of each of the 19 daughters will also decay. A good analogy to this is a series of buckets of water with different-sized holes in them placed under a tap. If we turn the tap on, water will flow from one bucket to another at different rates until the water flowing from each bucket is equal (Fig 5.2). This is known as 'secular equilibrium'. If we empty one bucket, the water level in that bucket will gradually rise until there is enough water in the bucket to exert enough pressure to increase the flow out of the bucket to the rate of the flow in Fig 5.3. This 'emptying of a bucket' can happen through natural processes to some of the daughters in the uranium-series decay chain, and it is the build-up of daughter

isotopes back to their equilibrium levels that provides us with a measure of time.

In uranium-series dating it is the disequilibrium of ^{238}U and its long-lived radioactive decay products ^{234}U and ^{230}Th that can be used to date precipitated calcite such as flowstones, stalagmites and stalactites (eg Richards and Dorale 2003). A radioactive disequilibrium occurs in flowstones because they are precipitated from water seeping into the cave. This water has traces of uranium, but very little thorium because of its low solubility, and consequently uranium is precipitated with the calcite, but thorium is absent. Effectively, the precipitation of calcite empties the ^{230}Th bucket. The date since formation of the calcite can be derived from ingrowth of radiogenic ^{230}Th formed from the radioactive decay of ^{234}U, as the radioactive equilibrium is slowly re-established. The potential disequilibrium between ^{234}U and ^{238}U, which can be caused by other natural processes, needs to be measured and accounted for. An additional problem is the incorporation of detrital material (for example sediments) into the precipitating calcite. Detritus brings with it U and ^{230}Th, usually leading to overestimated U-series dates. But it also brings with it common thorium (^{232}Th) which will not be present in uncontaminated calcite, and hence can be used to detect the presence of contamination. Where the $^{230}Th/^{232}Th$ of the contaminating sediment can be well characterised, usually by measurements on the insoluble residues from dissolved

Fig 5.2
(above, left)
Radioactive decay chains presented as a series of buckets with water flowing from one to the other through holes of differing size. Eventually the water levels in each bucket will reach the point where the flow into the bucket equals the flow out – secular equilibrium. In radioactive decay chains this is seen when the decay rate of all the members of the series is equal.

Fig 5.3
(above, right)
Disruption of secular equilibrium. Natural processes can disrupt radioactive equilibrium, effectively emptying one or more of the buckets – the different solubility of U and Th means U is incorporated in stalagmites whereas Th is not. ^{230}Th gradually increases until equilibrium is once again established.

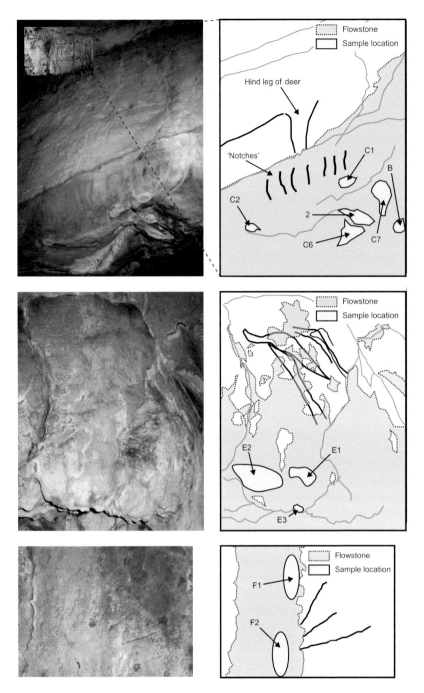

Fig 5.4
Photos and sketches of the same three areas of cave wall. White areas are stalactite. The sketches show sample locations:
(top) the 'notches' immediately below the hind leg of the deer (Church Hole);
(middle) the 'birds/females' (Church Hole);
(bottom) the 'vulva' (Robin Hood Cave).

calcite or directly on sediments taken from the cave, a correction can be applied (eg Schwarcz and Latham 1989). Alternatively, the measured U-series isotopic ratios on same-age samples that are contaminated to different degrees can yield a corrected age (eg Ludwig 2003).

The interstratification of rock art and flowstone has been used to verify the authenticity of Palaeolithic cave art, for example in the Grande Grotte and Grotte du Cheval at Arcy-sur-Cure, France (Liger 1995). Verification of the specific age of the art by actual dating of flowstone

remains rare, however. One example of this, using U-series dating of calcite, has provided minimum dates for cave paintings at Covalanas cave (Cantabria, Spain: Bischoff *et al* 1999). It is important that the stratigraphic relationship between the bedrock, the art and the calcite deposit is secure for the resulting U-series dates to be meaningful. At Church Hole and Robin Hood Cave there are several motifs that are clearly incised into the bedrock, with subsequent thin flowstone formation partially covering the engravings. Three areas where this stratigraphic relationship is unambiguously represented were sampled for U-series dating (Fig 5.4) – the vertical 'notches' below the stag (CH19) and the 'bird/female' forms (CH1–CH4) in Church Hole, and the RHC1 engraved 'vulva' in Robin Hood Cave. Calcite samples were removed by manually scraping the thin (0.5–2mm) layers of calcite in shallow spits. The calcite–bedrock junction was clearly represented by their contrast in colours, and the lowest portion, which might contain a mixture of the bedrock with calcite, was discarded. Thicker samples (>2mm) and small stalactites were removed using a coring drill (*see* Fig 5.5).

U-series measurements were made using a standard total dissolution procedure for carbonates (eg Edwards *et al* 1987). During this, the entire sample is dissolved in various acids, and therefore the results represent the combined U-series isotopes from both the precipitated calcite and contaminating detritus.

All the samples have ^{230}Th/^{232}Th<20, which indicates relatively high levels of detrital thorium from contaminating sediments, which is not uncommon in young samples. High levels of detrital contamination such as this will result in apparently older ages unless a correction is applied, since they represent an average of the age of the calcite and the usually much older geological age of the contaminating sediments. Same-age samples could not be guaranteed in such thin calcite, so a correction to the ages was

Table 5.2 U-series results from leached insoluble detritus collected from Church Hole

Detritus	^{234}U/^{238}U (activity ratio)	^{232}Th/^{238}U (molar ratio)
	0.567 ± 0.0058	4.12 ± 0.10
	0.770 ± 0.0081	3.94 ± 0.11
	1.194 ± 0.012	3.602 ± 0.009
	1.197 ± 0.012	3.667 ± 0.007
Mean ±2σ	**0.932 ± 0.631**	**3.8 ± 0.5**

applied using the measured ^{232}Th and ^{238}U concentration in leached sediments collected from the cave. We correct using a molar ^{232}Th/^{238}U value of 3.8 ± 0.5 calculated from the measurements on four separate sediment samples from the cave (Table 5.2). This value encompasses the Th/U ratio of the Earth's upper continental crust, which has a range of 3.6–3.8 (Taylor and McLennan 1995; Wedepohl 1995) and is often used as an average value to apply corrections where no measurements on contaminating sediments have been made. There is a large variation between the four detritus samples, but the errors that arise from this variation are included in the errors on the corrected dates.

The corrected and uncorrected U-series results are shown in Table 5.3. It can be seen that the effect of detrital correction is very marked when the ^{230}Th/^{232}Th is low, indicating more detrital contamination. In the worst case the corrected age is about 10,000 years younger than the uncorrected age, but in some cases the correction is less than 1,000 years. There is also considerable variation in the corrected U-series dates between different samples from each location (Table 5.3, Fig 5.6). This reflects a multiphase development of the flowstones. In general the thicker flowstones and stalagmites (eg samples CHC-B, C1, C7, E3, RHC-F1, F2) give younger dates which would be consistent with an increase in calcite precipitation in the last few thousand years, or continuous deposition. The thinner calcite deposits (eg samples CHC-2, C6, E1, E2) showed flaking and weathering consistent with little or no recent deposition, and gave the oldest ages. Since these deposits necessarily post-date the engravings, we take the younger value (including the error) of the oldest dates to provide a minimum age for each engraving. Thus we conclude in Church Hole the 'notches' are more than 12,630 years old, the CH1–CH4

'females/birds' are more than 12,800 years old and in Robin Hood Cave the RHC1 'vulva' is more than 7,320 years old. The results from the 'notches' and the 'vulva' are from the cleanest calcite and thus less affected by any limitations in our detrital correction, and are therefore the most secure dates.

Implications

Each of these dates for the formation of flowstone in Church Hole and Robin Hood Cave at Creswell is consistent with a Late Upper Palaeolithic antiquity for the art. They eliminate in two cases the hypothesis that the art is of Holocene age and in one case that it is younger than the early Holocene. A series of radiocarbon determinations, largely on human-modified Arctic hare bones found in association with Late Upper Palaeolithic stone artefacts from Robin Hood Cave, Church Hole and Pin Hole, give a tight cluster of calibrated dates in the range 15,700–13,200 BP (Table 5.4, Fig 5.7). As yet, these represent the best chronological estimate for the occupation of Creswell Crags by humans in the Late Upper Palaeolithic, and are paralleled at other sites in the UK with identical stone tool industries – for example Gough's Cave at Cheddar (Jacobi 2004). Our minimum dates for the 'notches' and the 'females/birds' are in excellent agreement with these radiocarbon dates. The date of more than 7,320 years BP for the 'vulva' is not inconsistent since we expect the flowstones to have formed over a considerable period of time. Thus, we feel it most likely that the engravings we have dated, and probably the majority of the engravings at Creswell, were made by Late Upper Palaeolithic individuals. This confirms the suspicion on the grounds of stylistic comparison with contemporary (Magdalenian) art from continental sites.

There are of course earlier human occupation levels at Creswell, including the enigmatic Leaf Points of Robin Hood Cave and Pin Hole, and the Font Robert points of Pin Hole (*see* Chapter 2). We thus cannot entirely rule out the possibility that the art is significantly older than the dates we present here. This would be particularly possible should the engraved human form on bone from Pin Hole turn out to be Early Upper Palaeolithic in age. However, there are no known convincing examples of Middle Palaeolithic art in Europe (*see* Pettitt 2004 for a discussion of a possible Middle

Table 5.3 U-series results from Church Hole and Robin Hood Cave

Sample name		U(ppm)	$^{234}U/^{238}U$	$^{230}Th/^{234}U$	$^{230}Th/^{232}Th$	Uncorrected Age (ky)	Corrected Age (ky)[a]
Flowstone overlying 'notches', Church Hole							
CHC-2 top overhang	Thin layer under	0.6177 ± 0.0013	1.0845 ± 0.0074	0.1214 ± 0.0028	12.4 ± 0.38	14.12 +0.35 −0.35	14.12 +0.42 −0.39
CHC-B	Small stalagmite under overhang	0.4977 ± 0.0008	1.0798 ± 0.0066	0.0485 ± 0.0013	2.702 ± 0.097	5.43 +0.16 −0.16	3.29 +0.38 −0.38
CHC-C1	Small stalagmite on lip of overhang	0.8532 ± 0.0019	1.0700 ± 0.0077	0.0129 ± 0.0003	3.187 ± 0.107	1.42 +0.04 −0.04	0.85 +0.10 −0.10
CHC-C2	Small stalagmite on lip of overhang	0.5168 ± 0.0011	1.0775 ± 0.0087	0.0911 ± 0.0020	2.049 ± 0.061	10.43 +0.24 −0.24	5.40 +0.91 −0.86
CHC-C6	Thin layer under overhang	0.5117 ± 0.0011	1.0967 ± 0.0080	0.0844 ± 0.0015	7.535 ± 0.198	9.63 +0.19 −0.19	8.33 +0.28 −0.29
CHC-C7	Thick deposit under overhang	0.4892 ± 0.0013	1.0800 ± 0.0101	0.0462 ± 0.0011	7.999 ± 0.259	5.17 +0.13 −0.13	4.47 +0.18 −0.17
Flowstone overlying 'birds', Church Hole							
CHC-E1	Thin layer below 'birds'	1.0177 ± 0.0031	1.2805 ± 0.0102	0.1914 ± 0.0037	2.392 ± 0.064	23.02 +0.50 −0.50	14.40 +1.70 −1.60
CHC-E2	Thin layer below 'birds'	1.2202 ± 0.0028	1.2907 ± 0.0091	0.1487 ± 0.0033	2.405 ± 0.073	17.49 +0.43 −0.43	10.90 +1.20 −1.20
CHC-E3	Small stalagmite below birds	1.6365 ± 0.0054	1.2922 ± 0.0093	0.0614 ± 0.0017	6.858 ± 0.248	6.91 +0.20 −0.20	5.97 +0.25 −0.25
Flowstone overlying 'vulva', Robin Hood Cave							
RHC-F1	Thick layer above 'vulva'	0.6174 ± 0.0015	1.2343 ± 0.0107	0.0846 ± 0.0035	2.151 ± 0.106	9.63 +0.42 −0.42	5.20 +0.83 −0.82
RHC-F2	Thick layer above 'vulva'	0.7771 ± 0.0019	1.2565 ± 0.0105	0.0792 ± 0.0074	11.17 ± 1.140	8.99 +0.89 −0.88	8.20 +0.86 −0.88

Errors given at 2σ; ppm: parts per million; ky: 1,000 years.

[a] Dates corrected for detrital Th using measured detrital values given in Table 5.1 and Ken Ludwig's Isoplot software (e.g. Ludwig 2003) using half lives given in Cheng et al (2000).

Palaeolithic sculpture); the pre-Magdalenian Upper Palaeolithic at Creswell (and elsewhere in the UK for that matter) is very scant, and we feel stylistic parallels for the Creswell engravings are to be found most clearly in Late Upper Palaeolithic contexts, as discussed above. Thus, we feel that a Late Pleistocene antiquity of the art is the most parsimonious interpretation, that is, in the 15th–14th millennia BP. Furthermore, these results rule out the possibility that the engravings are of recent origin, and independently demonstrate their antiquity and therefore authenticity.

At Creswell we have successfully demonstrated the application of U/Th dating of thin flowstone deposits that overlay cave art to provide minimum age estimations. With this result as inspiration, a survey was undertaken that has identified at least 200 painted or engraved Upper Palaeolithic images in caves in northern Spain where similar flowstones have formed. In some cases the images have been painted on flowstone, allowing both a minimum and maximum age to be determined. We will be sampling these flowstones in the near future, and we hope that the dating of these will provide a much firmer chronology for the phenomenon of parietal art in Europe. Through this ongoing project, the discovery of engravings at Creswell will, indirectly, have had an impact on our understanding of the chronology of cave art in Europe, and directly on our understanding on the Late Magdalenian world.

Table 5.4 Radiocarbon determinations from human-modified bone and antler from Creswell (Hedges *et al* 1994, 1996)

Lab reference (OxA)	Sample description	Radiocarbon years (BP)	Percentile probability calibrated age-range distributions at 95.4% level of confidence
Robin Hood Cave, Creswell			
OxA-3415	*L. timidus* cut-marked bone	12 430 ± 120	15 450–14 050 Cal BP (95.4%)
Pin Hole, Creswell			
OxA-3404	*L. timidus* cut-marked bone	12 510 ± 110	15 550–14 150 Cal BP (95.4%)
Church Hole, Creswell			
OxA-3717	Antler rod 'scooped end'	12 020 ± 100	15 275–14 675 Cal BP (22.0%)
			14 340–13 805 Cal BP (68.8%)
			13 780–13 640 Cal BP (4.6%)
OxA-3718	Antler rod 'scooped end'	12 250 ± 90	15 425–14 565 Cal BP (46.0%)
			14 425–14 060 Cal BP (45.7%)
			13 935–13 840 Cal BP (3.7%)

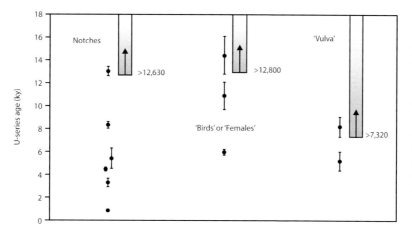

Fig 5.6
U-series results for flowstones overlying engravings in Church Hole and Robin Hood Cave (ky=1,000 years). Points represent the individual U-series dates, corrected for detrital contamination, and the blocks represent the minimum age of the underlying engravings suggested by these dates.

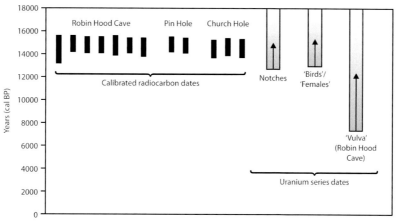

Fig 5.7
U-series results for flowstones overlying engravings in Church Hole and Robin Hood Cave, and calibrated radiocarbon dates of human-modified bones from Creswell. The calibrated radiocarbon dates are given as the 2-sigma range (see Table 5.4 and box on p 89).

The bedrock geology at Creswell Crags

MICHAEL MAWSON

Introduction

The following is an account of the bedrock geology at Creswell Crags, the main purpose of which is to describe the natural elements incorporated in or associated with the cave art. This work is based mostly on observations in Church Hole made during three visits to Creswell Crags. Further data specific to Creswell Crags regarding the bedrock geology can be found in Eden *et al* (1957), Jenkinson's monograph (1984) and Kaldi (1986). The geological terms used throughout are as given in Tucker (2001; 2003).

Bedrock

The bedrock at Creswell Crags is of Upper Permian age and is assigned to the Sprotbrough Member of the Cadeby Formation, which, in turn, is part of the Zechstein Group or Magnesian Limestone (for further details see Smith 1989; 1995). In older literature, the Cadeby Formation is referred to as the Lower Magnesian Limestone. The Cadeby Formation is on average ~45m thick in the Worksop area; at Creswell Colliery it is ~39m thick (Eden *et al* 1957). The Sprotbrough Member comprises around half the thickness of the Cadeby Formation; ~18m are exposed at Creswell Crags (ibid).

The bedrock is composed of oolitic dolomite, much of which is relatively hard and calcareous, suggesting that it has, in fact, a composition intermediate between that of dolomite, $CaMg(CO_3)_2$, and limestone, $CaCO_3$, rather than being pure dolomite. One possible explanation for this is that the rock, which was originally limestone, has been only partly altered to dolomite (ie dolomitised). Primary limestone is, however, rare in the Sprotbrough Member, and it is more likely that it was subject to complete dolomitisation followed by subsequent partial dedolomitisation, a diagenetic (chemical) process by which a rock composed of dolomite is converted back to one composed of limestone. This produces 'secondary limestone' and involves the precipitation of calcite cement as well as the replacement of dolomite by calcite. Evidence that some dedolomitisation has occurred at Creswell Crags is provided by the following: (1) flowstone and chalky calcite is seen within the caves, and (2) harder and more cemented (lithified) rims are seen adjacent to many fractures within the rock (*see* section on fracture traces below). The dedolomitisation most likely occurred at a shallow depth in the subsurface during an episode of large-scale uplift and exhumation that affected the British Isles during the Tertiary Period.

The fact that the rocks have been dedolomitised could be significant since rocks altered in this way are, on the whole, harder than 'pure' dolomite, which is generally quite soft, and this may have been a factor in preserving the cave art. It is also possible that dedolomitisation may have promoted the formation of the caves themselves (assuming that this occurred after dedolomitisation), since limestone is much more soluble than rocks composed of dolomite.

Texturally the bedrock is a grainstone (it contains little or no lime-mud) and, as mentioned previously, it is oolitic and composed of ooids (rounded, spherical grains of inorganic origin consisting of concentric laminae formed around a central nucleus). These characteristics are typical of the Sprotbrough Member. The ooids are of fine to medium sand-grade and preserved as moulds (that is, the ooids have been dissolved away). The rock is moderately well stratified and generally thickly bedded (Fig 6.1), and displays large-scale cross-bedding, a primary depositional structure in which stratification is formed at an angle (ie is

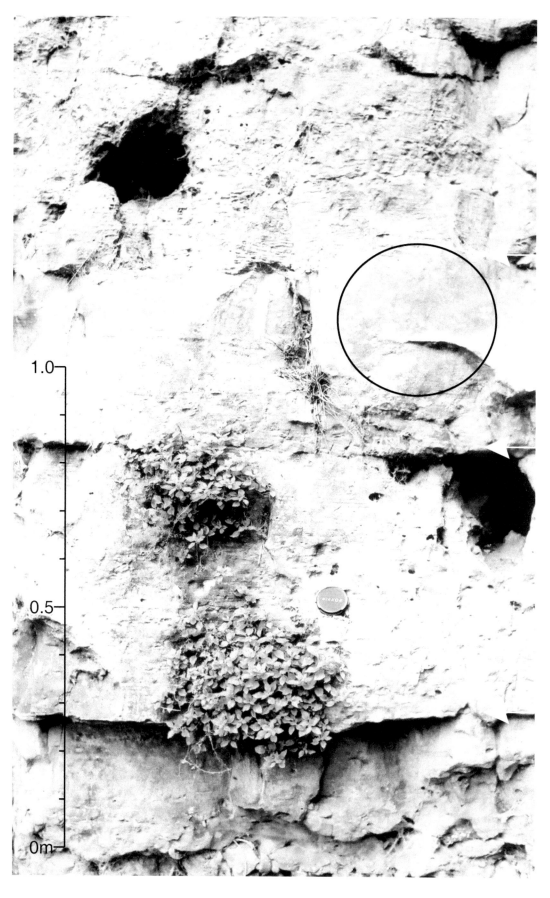

Fig 6.1
General view of the Sprotbrough Member at Creswell Crags near the entrance to Church Hole (lens cap for scale is ~6 cm in diameter). Three bedding planes are visible (white arrows at right). Thinner and more diffuse cross-laminae occur within the beds; where these are not visible, the sediment may have been bioturbated (circle). The bedding planes and cross-laminae appear near-horizontal in this view, but at Creswell Crags they generally show a much higher primary, depositional dip. Many vugs are also seen, including two that are much larger, and more irregularly shaped. Burrows are hard to discern outside Church Hole; they are most easily seen on the undersides of bedding planes.
(M Mawson)

inclined) to the horizontal as a result of the migration of sedimentary (geomorphological) features such as dunes. The cross-laminae which constitute the cross-beds are relatively planar or slightly trough-shaped (concave up) and up to ~5mm thick; they are, alternately, positive and negative weathering and caused by subtle compositional and textural differences. Because of weathering, the cross-laminae are best defined outside the caves where they are visible on most exposed surfaces in the gorge (Fig 6.1); within the caves, they are generally visible as diffuse traces (Fig 6.2; *see* section on cross-laminae traces below). The massive nature and lack of cross-laminae in some of the rock could be due to intense bioturbation (the activity of organisms within the sediment) for which there is abundant evidence at Creswell Crags in the form of burrows (Fig 6.1; *see* section on burrows below).

Individual bedding surfaces and cross-laminae have an observed relief of up to 4m (possibly up to ~10m) and generally show a relatively high angle of dip (inclination from horizontal) of up to ~35°, mostly towards the north-east or south-east (Kaldi 1986; author's own data). This, as explained above, is predominantly depositional; the amount due to later

(tectonic) folding of the rocks is probably low. These sedimentary structures are interpreted as sandwaves, which are linear, dune-like features that, at the present day, form sub-aqueously in high-energy shallow marine environments (Tucker and Wright 1990). The bedding planes mark relatively brief sedimentary hiatuses. Avalanching of the ooids down the sides of the sandwaves produced the cross-laminae; their compositional and textural differences were caused by short-term fluctuations of current strength. The sandwaves in the Sprotbrough Member formed in water depths of at least 12m, equal to the maximum documented relief of their cross-beds (Kaldi 1986; Smith 1989).

Caves

The caves at Creswell Crags most likely date from the Pleistocene (Jenkinson 1984). They are probably all of phreatic origin (Jenkinson 1984; Ford and Williams 1989) – that is, formed below the palaeo-water-table – and, as demonstrated by Church Hole and Pin Hole, most have a simple geometry consisting of a single, elongate chamber, roughly oval in cross-section. As an exception, Robin Hood Cave has several chambers and a more irregular floor

Fig 6.2
Ceiling of Church Hole (panel 4): bedding-plane surface on which the 'ibis' is drawn. Note its smooth nature, which is in contrast to fresh bedding-plane surfaces which are much rougher (Fig 6.3). Three tectonic fractures (small filled arrows at right), orientated approximately N–S, cut the bedding-plane, as do irregular non-tectonic fractures (small unfilled arrows). Many vugs are seen in the middle of this view where they form three intersecting 'trains'. The feature to the left of the 'ibis' could be a roughly horizontal, bedding-parallel burrow, two of which also form the neck and bill of the ibis. Chalky calcite is also seen in this view.
(M Mawson)

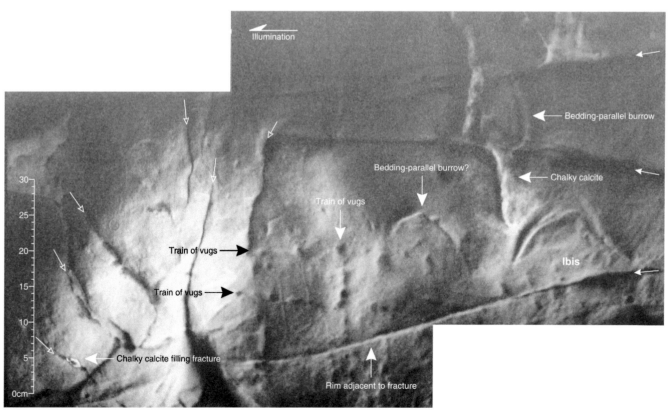

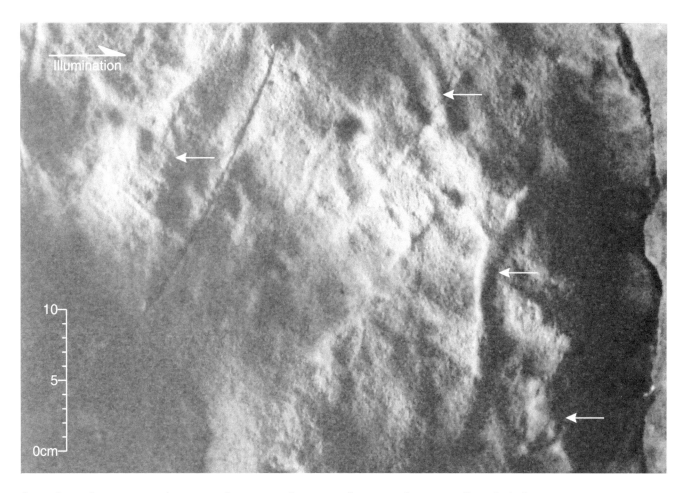

than the other caves. The caves have a NNW–SSE to north–south orientation and appear to have developed along tectonic fractures (Eden *et al* 1957), as is evident inside Robin Hood Cave and at the entrance to Church Hole. Measurement of fracture orientations in the gorge demonstrates that they are the same as that of the caves and confirms this view. No obvious displacement is associated with these fractures: they are therefore not faults. For further details regarding the caves and the Quaternary deposits they contain, as well as the geomorphological history of the area, *see* Jenkinson (1984).

The following descriptions are based on observations in Church Hole.

Surfaces used for the cave art

The surfaces used for the cave art include those formed by bedding planes, fractures and processes associated with the formation of the cave as well as by later weathering. In terms of their area, most surfaces in Church Hole are relatively small, particularly in the ceiling of

the cave; they are also generally relatively irregular (non-planar) but smooth.

Bedding planes

Bedding planes are orientated horizontally to sub-horizontally and mostly form surfaces in the ceiling of the cave. The bedding planes are relatively planar, and, when fresh, their surfaces are slightly irregular and rough (Fig 6.3). Fissile partings have formed along some bedding surfaces and also cross-laminae by exploiting the textural differences associated with them. The partings are sharp, generally ~2mm thick and formed as a result of slight dissolution caused by compaction during burial; where more substantial dissolution has occurred, some partings are stylolitic (that is, are irregular and sutured). Since most of the bedding planes display moderate amounts of 'primary' depositional dip (*see* section on bedrock, above), it can be hard to distinguish them from some non-tectonic fractures (*see* below). On the ceiling, the surfaces on which the 'ibis' (Fig 6.2) and 'bovid-head' occur are probably bedding planes.

Fig 6.3
Burrows, Church Hole. The burrows are filled and preserved in epirelief and, in this view, occur on a fresh, overhanging bedding plane located below the stag. Note the more irregular nature of this surface compared to those on which the cave art occurs. Many burrows are visible; most are orientated bedding-parallel. They are ~1 cm in width; the best defined are arrowed. Vugs are also visible, as are a few fractures.
(M Mawson)

Fractures

Fractures have a vertical to sub-horizontal orientation and mostly form surfaces on the sides of the cave. They developed after the sediment which formed the bedrock had been lithified, and are of tectonic or non-tectonic origin. Tectonic fracture surfaces are sharp, relatively planar and orientated almost vertically. They are probably associated with faulting: many faults have been mapped in the Creswell area, one of the most important in the vicinity being the Park Hall Fault (Eden *et al* 1957); a smaller fault, the Creswell Fault, has also been mapped at Creswell Crags (Jenkinson 1984). The stag is probably drawn on a tectonic fracture surface. As noted above (section on caves), the tectonic fractures have specific orientations, and this aids their identification.

Irregular fracture surfaces (or joints) are more likely to be non-tectonic in origin and probably formed much later than the tectonic fractures, either during burial or during Tertiary uplift of the rock. It should be noted that some fractures could also have developed as a result of ground subsidence related to coal extraction. These obviously post-date the cave art. Non-tectonic fractures display a wide range of orientation, and generally form non-planar surfaces. Many occur along bedding surfaces or cross-laminae within the rock, although generally they follow them only approximately. Most fractures in Church Hole are probably of this type, including the ceiling surface on which the 'horse-head' appears. The small size of many of the surfaces in Church Hole, for example those in the ceiling of the cave, is a consequence of the relatively high fracture density of the bedrock in the cave. The shapes defined by the fractures have, in some instances, been used as the basis for some of the drawings, for example the 'horse-head'.

Surfaces produced by dissolution, mechanical erosion and weathering

Many of the surfaces were probably also produced or altered by dissolution and/or mechanical erosion of the rock during the formation of the cave, as well as by later weathering. The smooth, rounded nature of many of them (Fig 6.2) is markedly different from those formed by fresh bedding planes and tectonic fractures, and could result from these natural processes. Alternatively, the cave artists themselves may have prepared the surfaces; it is

hard to be certain without specialist knowledge and careful examination. Irregularities in the surfaces also appear to have been used by the cave artists as a basis for some of the bas-relief figures, but again it is difficult to establish the degree to which these surfaces have been worked. Examples of this include the surface on which the bovid is located.

Natural elements utilised in the cave art

The natural features incorporated or associated with the cave art consist mainly of burrows and vugs; of much less importance are fractures and possibly also cross-laminae.

Burrows

Burrows ('trace-fossils' or ichnofossils) are sedimentary structures produced by the activity of organisms – such as annelids (worms), crustaceans and molluscs – within unconsolidated sediment. For simplicity, all the ichnofossils present are herein termed burrows, even though some may have been produced in other ways. For example, many of the 'burrows' are probably feeding trails made on the surface of the sediment (Kaldi 1986). The burrows are orientated either parallel or perpendicular to bedding and are seen on all the types of surface discussed previously. Many examples are seen. They are largely preserved in relief but may also occur as unfilled vuggy pores.

The most common types of burrow are sinuous, linear, bedding-parallel features that are preserved in epirelief (that is, they weather proud of the rock surface) and are up to ~1cm in width and ~8cm (probably more) in length (Fig 6.3). The amount of relief varies; they project by up to ~5mm. This kind of burrow is seen on a number of bedding-plane and fracture surfaces in Church Hole, where, for example, they constitute the bill and neck of the 'ibis' and most or all of the 'bovid-head'. The outlines of the two burrows associated with the 'ibis' appear to have been accentuated by carving. Although it can be shown that the burrows in the 'ibis' now have no relief relative to the surfaces surrounding the figure, it is likely they originally projected slightly from the adjacent bedding plane and so would have been evident as slightly raised features. This excess relief could have been removed when the 'ibis' was being drawn or by subsequent weathering. Burrows of this type also occur on fresh bedding

planes outside Church Hole elsewhere in the gorge (near Boat House Cave, for example), conclusively demonstrating that they are natural features and are not anthropogenic.

Cross- or longitudinal-sections of burrows orientated perpendicularly (with an approximate vertical orientation) relative to bedding are also common. They are oval (~5mm in diameter) or elongate to sub-elongate in shape. Many burrows of this type are also filled and seen in epirelief, as in the nostril of the stag. Many are unfilled, however, and these are difficult to distinguish from vugs produced by the dissolution of anhydrite nodules (*see below*); a sub-vertical unfilled burrow or vug may form the stag's eye.

Vugs

Vugs are empty cavities or large pores within the rock. The vugs are equant (roughly square or round) to sub-elongate in shape (long axes are bedding-parallel), have sharp or diffuse margins (Figs 6.1, 6.2 and 6.4), and display a wide range in size, from <0.2cm to ~6 × 4.5cm. Although they can be formed in many ways, these vugs were produced by the dissolution of nodules within the rock. The nodules probably grew during the burial of the rock and were most likely originally composed of anhydrite ($CaSO_4$) precipitated from pore fluids which were rich in dissolved anhydrite.

Consequently, as at Creswell Crags, nodules and vugs often occur along partings or fractures which acted as conduits for these fluids. The anhydrite, as a result of its high solubility, was readily dissolved by meteoric fluids (ie fresh water) and in this way the vugs were formed. The dissolution process can enlarge the original nodule or vug as can later surficial weathering to produce large vugs, which tend to be more irregularly shaped (Fig 6.1). Dissolution of the anhydrite probably occurred during the phase of Tertiary uplift mentioned previously, and was probably associated with dedolomitisation of the bedrock (p 96). Some of the vugs have subsequently been refilled by the precipitation of chalky calcite. Vugs are seen on surfaces of any orientation, often (for the reasons given above) in 'trains' along fractures, partings or cross-laminae; examples of this are seen on the surface associated with the stag.

Vugs are used in many instances to form the eyes of figures, as for example in the stag, although, as mentioned above, this may also be a sub-vertical, unfilled burrow. The most diffuse and/or shallow vugs are very hard to differentiate from supposedly human-made features, as in the case of the eye of the 'ibis', which could be a vug that may or may not have been worked. Alternatively, the entire eye could have been carved. As mentioned

Fig 6.4
The 'ibis', drawn on a sub-horizontal bedding surface that is much smoother than fresh bedding surfaces (compare with Fig 6.3). One fracture trace is also visible in this view. The eye of the figure is probably formed by a vug that may or may not have been worked, or it could be entirely human-made; compare with other vugs (circled). The bill and neck are each formed by a single filled, bedding-parallel burrow, the outlines of which have been accentuated by carving. Fine, slightly raised lines are fractures occluded by calcite. A number of these are associated with the 'ibis' and may have been intended as ornament; note that at least three (small filled arrows) apparently cross-cut the carving adjacent to the neck. This proves the antiquity of the figure, as does the fact that chalky calcite has also been precipitated over the carving adjacent to the bill. (M Mawson; based on DP027491)

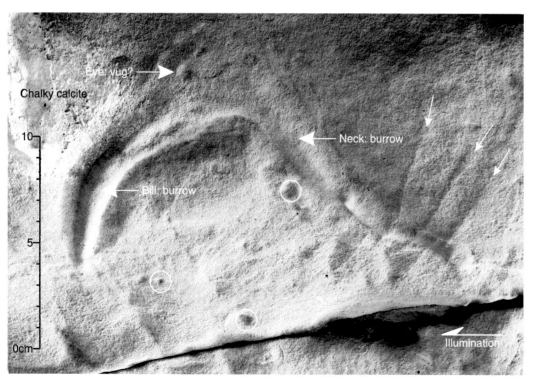

Fig 6.5
Head of stag, drawn on a
vertical fracture surface.
The outline is formed by
engraved lines. A sub-
elongate vug or an unfilled,
sub-vertical burrow forms
the eye. The nostril may
comprise one or two filled
sub-vertical burrows.
A number of other filled
burrows (small filled
arrows) and vugs (circles)
are visible. Diffuse lines are
the traces of cross-laminae
(small unfilled arrows).
(M Mawson; based on
DP027480)

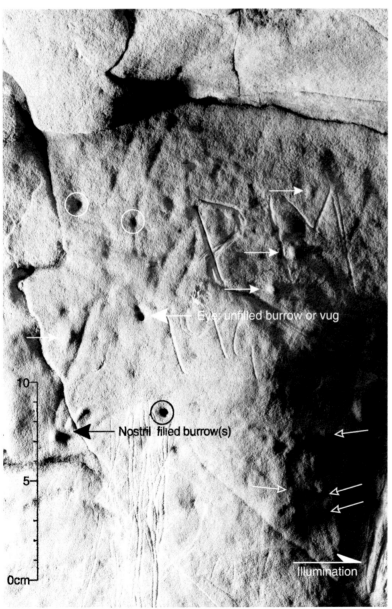

previously, it can also be hard to distinguish some vugs from unfilled burrows, as in the 'horse-head', the nostril of which is either a vug or an unfilled part of a burrow containing chalky calcite.

Fracture traces

In addition to forming surfaces, fractures are also seen where they intersect surfaces, such as bedding planes, which have a different orientation to them. Thin, slightly elevated rims, up to ~3mm wide, are seen adjacent to many fractures (Fig 6.2). They are more strongly cemented (and therefore harder) than the rest of the rock. The cement, which is probably calcite, may also occlude the fracture itself;

chalky calcite also fills some fractures. The fluids that caused this alteration used the fractures as conduits. The alteration rims are a diagenetic (secondary) feature, probably related to dedolomitisation (*see above*) and/or precipitation of flowstone within the caves; some could post-date the cave art (*see* p 100).

Fractures with these alteration rims weather in relief, often appearing as relatively fine, raised lines, and some can resemble burrows, at least superficially. Many examples are seen in the ceiling of Church Hole. Fine, occluded fractures of this kind are seen extending from the body to the neck of the 'ibis'. It is unlikely that such fine features could have been carved. If examined carefully, some or all of these fractures clearly cut the carving next to the burrow that forms the neck of the 'ibis'. This suggests that the calcite cement occluding the fractures was precipitated after the figure was made, and that these features as now seen may not have been part of the original design; more importantly, they also prove the antiquity of the figure. A fine, vertically orientated fracture (with no alteration rims) may form part of the stag's front leg.

Engraved lines can be distinguished from natural fractures, firstly, and most obviously, by their shape (design), as for example the figures in the 'bird panel'. Obviously, they also do not penetrate into the rock to the same extent as natural fractures; if hammered, the rock would more easily break along the natural fractures than the engraved lines. In comparison to natural fractures, engraved lines also appear to be generally less sharp as well; compare, for example, the vertical engraved lines at the base of the stag panel and natural fractures on this surface. Engraved lines can also cut all the natural features described above. As noted previously, tectonic fractures can be distinguished by their approximately vertical orientation and relatively smooth, planar surfaces.

Cross-laminae traces

As discussed previously, traces of cross-laminae appear as diffuse or very diffuse lines (often parallel or sub-parallel) on many vertical or sub-vertical surfaces inside Church Hole. Although associated with some of the figures, including the stag (Fig 6.5), it generally appears that they have not been incorporated into their design. The only example where this may occur is below the stag, where traces of cross-laminae appear to form the top and base

of a 'square'-shaped drawing. It is not clear, however, if this square is a genuine example of cave art.

Summary

The bedrock is composed of oolitic dolomite that is relatively calcareous. The hardness of this rock may have contributed to the preservation of cave art. The figures in Church Hole occur on horizontal or sub-horizontal bedding planes and vertical or sub-vertical fracture surfaces. Many surfaces were also produced or altered by dissolution and/or mechanical erosion during the formation of the cave, as well as by later weathering. In addition to the rock surfaces themselves, which may or may not have been worked, geological features utilised in the cave art consist mostly of burrows and vugs; of much less importance are fractures and possibly also in one instance the traces of cross-laminae. Nearly all of the cave art contains at least one of these elements. It goes without saying that, for any cave art to be identified as such, it must contain at least one element that is unequivocally not natural in origin or a natural feature that has been clearly altered by a human agency.

Appendix: natural elements present in some figures in Church Hole

Since it requires very specialist knowledge, the degree to which the surfaces on which the figures occur have been worked is not commented upon below.

STAG

Drawn on vertical fracture surface. *Nostril*: one or two sub-vertical filled burrows. *Eye*: single vug or sub-vertical unfilled burrow; many filled burrows (vertical to sub-horizontal) are visible on the surface. *Part of front leg*: vertically orientated non-tectonic fracture with no alteration rims. Other non-tectonic fractures are also visible, as are traces of cross-laminae and at least one train of vugs.

BISON FIGURE

Drawn on sub-vertical fracture surface. *Outline*: vertical filled burrows possibly used; also seen within the body.

'SQUARE'

On vertical fracture surface. *Right side*: fine fracture with no alteration rims. *Top and base*: each defined by the trace of a single cross-lamina associated with a fine parting. The left side of the square could be engraved. Vugs and occluded fractures are seen within the square.

'IBIS'

Drawn on sub-horizontal bedding plane. *Beak and neck*: each formed by single burrow, the outlines of which have been accentuated by carving. *Eye*: single vug? Vugs are visible within the body and on adjacent surfaces. *Ornament between body and neck*: fine fractures occluded by calcite; possibly not part of the original design.

'BISON-HEAD'

On sub-horizontal bedding plane. *Outline and other features*: bedding-parallel filled burrows. Vugs (some possibly unfilled vertical burrows) are also visible.

'HORSE-HEAD'

On sub-horizontal, non-tectonic fracture surface or bedding plane. *Nostril*: part of single bedding-parallel unfilled burrow or vug containing chalky calcite. *Eye*: single vertical filled burrow. *Outline of back of neck*: two bedding-parallel filled burrows; a number of other filled burrows are visible on this surface, as are at least two fractures which have alteration rims.

The continuing search for cave art in England and Wales

PAUL BAHN AND PAUL PETTITT

When we envisaged a systematic search for possible Palaeolithic art in the UK in 2003 we saw this from the start as being exhaustive. We set as our goal to work in suitable caves all over England and Wales, and, as a guiding principle, Paul Pettitt drew up an itinerary that focused on caves that either had contained evidence of late Ice Age occupation or which were located in areas where such evidence existed. We were open-minded as to whether or not anything would be found, and we recognised that if we could conduct systematic surveys of cave surfaces, then ruling out the possibility of art in certain caves – that is, generating negative results – would still be relatively useful information. Perhaps the Upper Palaeolithic societies that infrequently operated in Britain during short pulses of Upper Pleistocene time were not interested in producing cave art. It is true that much of it is restricted to France and Spain, yet it is found elsewhere and there were no a priori reasons as to why it should not have been part of the behavioural repertoire of British Upper Palaeolithic hunter-gatherers which, after all, derived from the contemporary societies of the continent.

Nor did we believe arguments that art would not be found because the relatively severe climates and periglacial environments that the UK experienced during the Late Pleistocene would have been responsible for eroding the art away as an eraser does pencil graphite. Some of the most spectacular cave art that has come down to us in remarkably good condition – such as that in the French Pyrenees and northern Spain – experienced equally severe climates. It is true that any paintings or even engravings that may have been placed in the open air, like those which have survived in special microclimates in Portugal's Côa Valley and elsewhere, can be expected to have been destroyed, but caves – even small ones with wide mouths – can be remarkably favourable to the preservation of art. Micro-organisms will cause micro-erosion of cave walls, and may certainly remove the pigments used for paintings over long periods of time, yet deeply incised engravings are more resistant to this form of damage. We felt that a truly open mind, in combination with systematic survey methods and correct use of lighting, justified a fresh look at the English and Welsh caves.

Statistically speaking, what are the chances that we would discover the only cave art in England or Wales on the first morning of the search? It seemed to us obvious that there must be more, perhaps far more, examples to be found. Either that or Creswell was in some way special, at least in an artistic sense.

Consequently, the search for other decorated caves began immediately after the Creswell discovery, and continues today in a systematic fashion. In selecting caves for exploration, two major factors predominate: first, of course, we focus on those caves with known occupation material from the last Ice Age or those located in areas which saw Ice Age occupation; second, we also include any caves which are likely to have been accessible to people in the Ice Age, even if they left no known archaeological traces at the sites. There is, of course, no reason why art should not be found in caves that were not major habitation sites – many decorated caves on the continent have no known occupation material, and there may even be some justification for the view that some caves had relatively prosaic functions whereas others, including those containing art, had less obvious functions. We have been greatly helped in drawing up a 'shopping list' of caves, as well as in the exploration of some of them, by Andrew Chamberlain and the

National Audit of English Caves, a project funded by English Heritage.

Taking advantage of the advice and knowledge of local archaeologists and speleologists, as well as information from the interested public, together with the archaeological data already compiled, we drew up a list of caves worth investigating. Their geographical distribution and the time available for each campaign dictate the order in which they are visited. Another factor involved is their orientation, so that optimal conditions of natural light can be used to full advantage. Moreover, the degree of erosion, weathering and calcite formation in each cave greatly affects its potential. The position of the original Ice Age floor level needs to be assessed where possible, as well as which galleries and chambers might have been accessible during that period. On that basis, the team – utilising knowledge acquired in the decorated caves of Europe – can estimate the heights at which markings might be expected, and the most promising rock surfaces to be scrutinised. Oblique lighting of various types and strengths is applied to the walls and ceilings (where applicable) in a slow and systematic way in order to see engravings, bas-reliefs or even traces of paintings. If markings are found and, after full discussion, reckoned to be important or noteworthy, they are measured, sketched and photographed with a scale, and their distance from the cave entrance or some other landmark is recorded.

We often note shallow vertical incisions which have been left by animals. Sometimes these can be left by bears, or carnivores such as foxes and badgers, as they sharpen their claws on the hard walls of the cave or use them for leverage as they traverse difficult areas. Smaller incisions can be left by bats as they try to gain purchase to hang while resting. Clearly, if even animal clawmarks are being spotted, then it is highly unlikely that we are missing recognisable engravings if they exist or are minimally visible. That said, it remains possible that we have overlooked images: perhaps revisiting the caves with future survey techniques will reveal some surprises yet. At present all we can say is that with patience we have done our best, and can have a degree of confidence in ruling out the possibility of art on a major series of walls from a series of sites. The ability to rule out a whole series of sites as undecorated (or at least with no surviving decoration) is an important contribution to the assessment of England's caves. The

walls of some sites, such as Gough's Cave in Cheddar Gorge, and Kent's Cavern in Torquay, are extensively covered in stalactite flows which probably obscure any art that may exist in them. Future survey techniques which are being developed now should allow us to see beneath these flowstones, but at present we leave these areas of covered walls as 'unexplored'.

The day after our initial discovery at Creswell, we surveyed the famous Paviland Cave (actually 'Goat's Hole at Paviland'), on the coast of the Gower Peninsula, where the Ice Age burial of the 'Red Lady' (actually an adult male) had been found in 1823. However, we found that the surfaces of its walls are far too rough and eroded for art to have been made, or at least to have survived, on them. We also examined the walls of Gough's Cave at Cheddar, but this cave is extremely wet with active calcite growth, and it is most unlikely that any Ice Age markings could still be visible on its surfaces, at least without some means of seeing beneath the stalactite. Subsequently, a claim was made by local speleologists for a pseudo-mammoth figure in that cave (Mullan *et al* 2006) – more specifically, a possible bit of engraved line close to a vague natural shape – but it is almost certainly a natural marking that bears a (very) passing resemblance to the dorsal line of a mammoth. Given the morphology of the cave and its sedimentary fill this area of the cave may well have been inaccessible during the Ice Age. Finally, we investigated Kent's Cavern in Torquay: it is extremely probable that this large site, Britain's foremost Ice Age habitation cave, originally contained some Ice Age imagery. However, it is a particularly wet cave, with very active formation of stalactite concretions – for example a famous, deeply engraved inscription on a stalagmite, dating to 1688, is barely visible today through the calcite, so how could anything from Ice Age times possibly be visible? As noted above, science will eventually devise a method for seeing through thick calcite layers to the wall or ceiling beneath (at present, ultraviolet light can help with this to some extent – *see* Marshack 1975; Baffier and Girard 1998, 65), but we saw nothing at Kent's Cavern.

In 2004 we turned – naturally enough – to cavities in the Creswell region, in particular nearby Langwith Cavern, which had revealed evidence of Ice Age occupation, as well as the rock shelters of Markland Grips and Anston Stone Gorge. The latter are shallow,

Fig 7.1
Probable animal
markings in Fox Hole.
(Photo: A Chamberlain)

with heavily weathered rock, while Langwith contained no sign of decoration.

In 2005 our attention focused on the caves of the southern Peak District, not far from Creswell Crags. It is known from studies of cave art in France and Spain that major decorated caves rarely exist in isolation – where there is one, it is highly likely that there are others within the same region. The Peak District contains a number of caves that have yielded Ice Age artefacts (primarily Ossom's Cave, Thor's Fissure, Fox Hole and Dowel Cave), as well as others with spacious chambers and well-preserved or flat expanses of wall that could preserve ancient engravings and which could have been accessible to artists even if not used for occupation. However, it rapidly became apparent that none of these caves contained visible traces of images – most had surfaces that were too rough, or heavily weathered. Nevertheless, incisions were discovered here and there, notably in Fox Hole and Darfar Ridge Cave, which seem to be animal clawmarks (*see* Fig 7.1). If such marks are being detected, it is fairly certain that we are not missing any human-made activity.

In 2006 we returned to Kent's Cavern to make a more thorough and meticulous search of this major cave. We spent one week there, but once again nothing was found other than a few minor clawmarks. At the same time, we examined other sites in the south-west, such as Ash Hole Cave and the Kitley Caves (from which comes evidence of late Ice Age occupation), but no art was found on their walls.

In 2007 we examined a number of caves in the Yorkshire Dales, particularly the huge Victoria Cave. Here 19th-century investigators had removed large quantities of sediments – far more than in Church Hole – and thus there was a possibility that figures which Ice Age artists might have put on the then-accessible ceiling were now out of reach and out of sight. However, a close scrutiny of the ceiling failed to detect any traces of decoration. At Kinsey Cave, Tim Taylor of Bradford University had found some external incisions near the entrance but, as he suspected, these are very probably clawmarks: even if human-made they are most unlikely to date back to Ice Age times.

Other caves in Yorkshire look very promising, and we intend to explore them further in the near future, as well as other sites elsewhere in England, and a whole series of caves in Wales. We still have high hopes that more traces of decoration will be discovered eventually. If so, they will almost certainly be engravings or bas-reliefs which have remained unnoticed hitherto because they are often virtually invisible unless actively sought, and with oblique light. There is absolutely no reason why Britain should not contain Ice Age cave paintings, but these are generally far more visible than engravings. For paintings to be found, we need either a totally unknown cave to be discovered, or an unknown chamber inside a known cave. We are confident that this will happen in the not-too-distant future. After all, an average of one new decorated cave per year is still being found in France today, with even more turning up in Spain.

GLOSSARY

absolute dating technique One of a number of laboratory dating methods used on sediments, bones, minerals or other materials to establish their age. Sometimes referred to as 'chronometric techniques', these usually rely on principles of radioactive decay as a 'clock'. The most widely known, **radiocarbon dating**, was developed in the late 1940s, and other techniques (eg **electron spin resonance**, thermoluminescence and **uranium-series dating**) followed.

AMS radiocarbon Radiocarbon dating by accelerator mass spectrometry: an **absolute dating technique**. Developed in the mid-1980s, the AMS technique uses sophisticated nuclear physics to ionise samples of carbon and accelerate them though a cloud of argon gas. This causes predictable behaviour of the carbon atoms, allowing the separation, collection and measurement of individual atoms of ^{12}C, ^{13}C and ^{14}C. It requires samples as low as one tenth or less of those required for conventional radiocarbon dating.

astragalus The ankle-bone.

awl A **borer** or **piercer** made of organic material (antler, bone) for working holes into soft materials such as hides and furs. At Creswell and elsewhere Magdalenians used tibiae of Arctic hare for awls.

backed Of an edge of a lithic **flake** or more commonly **blade** or **bladelet**, blunted to facilitate prehension or hafting. *See* **Cheddar point** and **Creswell point**.

blade A lithic product knapped from a **core** that is at least twice as long as it is wide, ie, is laminar.

bladelet A small form of lithic **blade**.

borer A small lithic **flake** or **blade** pointed using deliberate retouch to form a tool for boring through soft materials.

BP Before present.

burin A chisel-edged lithic flake or blade used for scoring and engraving of soft and hard materials.

calibration The method by which uncalibrated radiocarbon dates are converted into real (calendar) dates through comparing them with radiocarbon dates on samples for which the true age is known by independent means. The most commonly used calibration curve was constructed using tree rings (dendrochronology), which can be counted annually to provide a real timescale and dated by radiocarbon to examine dating offsets. These offsets can then be used to 'correct' radiocarbon dates. All other dating methods essentially produce real (calendrical) ages. *See* box on p 89.

Cheddar point A backed blade or bladelet with two **oblique truncations**, one at each end of the piece.

Clactonian notch A simple notch created on the edge of a stone tool by one removal. Named after the Lower Palaeolithic 'Clactonian' assemblage type characterised by a lack of bifaces (handaxes) and in which these implements first appear. Experiments have confirmed the usefulness of notches for whittling and 'spokeshaving' wood.

core The volume of lithic material from which products (**flakes**, **blades**, **bladelets**) have been removed by **knapping**.

Creswell point A backed blade or bladelet with one **oblique truncation** on the functional end of the piece. *See* **Cheddar point**.

Creswellian A term previously used to refer to British examples of the Late Upper Palaeolithic **Magdalenian**.

cross-laminae Primary sedimentary structures less than 1cm thick in which stratification is formed at an angle (ie inclined) to bedding. They are commonly formed by the migration of features such as dunes and ripples and constitute cross-beds.

denticulate A stone tool that has two or more notches consecutively along an edge, forming a 'denticulate' or saw-toothed edge. Modern experiments and microscopic wear patterns on denticulates show they were useful for

woodworking, eg spokeshaving, though they were probably used for a variety of tasks.

Dryas One of a series of cold stadials in the Lateglacial period, the Younger Dryas, the Older Dryas and the Oldest Dryas, from the most recent to oldest. The name is taken from *Dryas octopetalia* (mountain avens), a cold-climate shrub and favoured food of reindeer.

ecotonal Referring to an area of the landscape in which two or more distinct ecosystems meet. At Creswell this is the upland plateau and river valley. The mix of resources from each creates a uniquely rich environment, to which Upper Palaeolithic hunter-gatherers were preferentially drawn.

electron spin resonance (ESR) dating An **absolute dating technique**. Most such techniques rely on the decay of radioactive isotopes within them. These clocks, assuming the decay rate is known (ie the rate and regularity of the clock's ticking), can be used to ascertain the age at which a sample lived (radiocarbon) or was deposited. Accumulation of radiation is at the heart of ESR dating, whereby electrons accumulate in crystal lattices (traps) in samples such as teeth. When the samples are bombarded with radiation the traps open, releasing the accumulated electrons, which can be measured and from which a date can be obtained.

end-scraper A lithic **blade** with its functional end regularised by **retouch** to form a discrete, distal working edge. End-scrapers were relatively common in the Upper Palaeolithic.

Federmessergruppen Literally 'penknife-point groups'. Late Upper Palaeolithic groups centred on Germany, the Netherlands and Belgium, characterised by small, curved-backed points with proximal (basal) retouch reminiscent of the blades of penknives. Chronologically they are restricted to the Allerød (*see* **Lateglacial**), and form the north-west European expression of a wider European reliance upon curved-backed points, the smallest of which were probably arrowheads.

ferruginous Iron-rich.

flake Lithic chip removed from a **core** by **knapping**. Flakes may come in a variety of shapes and sizes depending upon the knapping methods used.

flowstone Formation of precipitated calcium carbonate hanging from cave ceilings (**stalactites**), growing up from cave floors (**stalagmites**) and flowing down cave walls (**flowstones**).

Font Robert point A point with a tang used as a weapon tip and knife, characteristic of the early part of the Gravettian period of the Mid Upper Palaeolithic, around 28,000 BP.

Gravettian Of the Mid Upper Palaeolithic period in Europe (29,000–21,000 BP). After La Gravette (Dordogne).

interstadial A brief period of climatic warming not of sufficient length to allow the establishment of full interglacial forests.

knapping Removing **flakes** and **blades** from **cores** of stone through hitting with a hammer. Hammers may be hard (of stone) or soft (of wood, antler, and other soft materials).

Late Upper Palaeolithic *See* **Palaeolithic**.

Lateglacial Referring to the last 10,000 years of the Pleistocene, including the Lateglacial Interstadial and Younger Dryas. The Lateglacial Interstadial (13,000–11,000 ^{14}C years BP) was a relatively warm interstadial during which mean summer temperatures were only 1 or 2 °C cooler than today. It is traditionally divided into an earlier phase, the Bölling (13,000–12,200 BP), in which environments were still open grassland, and a latter phase, the Allerød (11,800–11,000), in which boreal woodland had become established. The two were separated by a cold stadial, the Older Dryas, approximately between 12,200 and 11,800 BP. *See also* **Dryas**.

lithic Stone. At Creswell, Neanderthals worked quartzites and some flint, whereas Upper Palaeolithic *Homo sapiens* worked flint.

leaf point A specific leaf-shaped weapon tip characteristic of the Northern European Plain and Hungarian Basin from around 45,000 to 35,000 BP. Leaf points were shaped by minimal modification (**retouch**) of the tip(s) by flaking across either one surface or more extensively across both surfaces (bifacially). Most specialists agree that these were produced by late Neanderthals.

Magdalenian Relating to the Late Upper Palaeolithic period in western and central Europe between 17,000 and 12,000 BP, named after the rock shelter of La Madeleine (Dordogne). In Britain the archaeology of the period has historically been referred to as Creswellian.

Middle Palaeolithic Second of three subdivisions of the **Palaeolithic**. In Europe it was characterised by the Neanderthals (*Homo neanderthalensis*).

oblique truncation In lithic technology the presence of a truncation (edge) formed by retouch, running oblique to the main axis of the **flake**, **blade** or **bladelet**. *See* **backed**, **Cheddar point**, **Creswell point**.

Palaeolithic Literally 'Old Stone Age'. The term was first used in 1865 by Sir John Lubbock to describe the earliest part of the Stone Age. Specialists divide the Palaeolithic into three broad periods, initially defined stratigraphically. The lowermost and oldest in Europe (the Lower Palaeolithic), lasted from before 1,000,000 BP to around 300,000 BP; the Middle Palaeolithic, from 300,000 to 30,000 BP; and the youngest and uppermost, the Upper Palaeolithic, from 40,000 to 10,000 BP. (Radiocarbon dates are imprecise in this period but indicate an overlap of up to 10,000 years between the Middle and Upper Palaeolithic in some areas of Europe; this could be significantly less in real, ie calendrical, years.) Subdivisions of these exist, such as the division of the Upper Palaeolithic into Early (EUP: 40,000–30,000 BP), Mid (MUP: 30,000–20,000 BP) and Late (20,000–10,000 BP) phases.

piercer A lithic form brought to a point for piercing soft materials. Similar to a **borer**.

Pleistocene The geological epoch approximately 1.8 million to 10,000 years ago, characterised by an unstable and often cold climate and informally known as the 'Ice Age'. It is divided into Lower (1,800,000 to 800,000 BP), Middle (800,000 to 130,000 BP) and Upper (130,000 to 10,000 BP) periods.

radiocarbon dating An **absolute dating technique** used to date samples from once-living organisms such as bone, antler, teeth and plant remains (including charcoal) by means of the radioactive decay of ^{14}C. *See* box on p 89.

retouch Small, often delicate, knapping along the edge of flakes, blades and bladelets. Used to modify (eg regularise) the shape of the edge, or blunt (back) the edge to facilitate safe prehension or hafting.

sagaie French term for a spear/javelin point. In the Upper Palaeolithic these were made from antler, bone and mammoth ivory.

solutional fissure A crevice formed by the erosion of bedrock by acids carried in a solution (usually water) percolating through the rock.

stadial A brief period of cold climatic conditions not long enough to see the establishment of full glacial conditions. *See*, for example, **Dryas**.

stalactite *See* **flowstone**.

stalagmite *See* **flowstone**.

tang Symmetrical 'foot' on a stone tool, thinner than the width of the main body of the tool and created for the purposes of hafting. Can be distinguished from a *shoulder*, which is located asymmetrically on the tool.

terminus post quem Latin, literally 'date after which'. Term used in archaeological dating to denote a maximum age. Compare *terminus ante quem*: Latin, literally 'date before which', used in archaeological dating to denote a minimum age. The uranium-series dates on flowstones overlying engravings discussed in Chapter 5 have provided *termini ante quem* for three Creswell images.

thermoluminescence (TL) dating An **absolute dating technique**. As with other dating techniques using radioactive decay as a 'clock' that can be used to ascertain their age (*see* **electron spin resonance** and **uranium-series dating**), TL dating measures the amount of radioactivity that has accumulated in materials over time. When heated, samples release radioactivity that has naturally accumulated within them. Deliberate or accidental burning of stone tools in a hearth will have this effect of 'zeroing' the TL signature; thereafter radioactivity will begin to accumulate once more. Bombarding samples with radioactivity in the laboratory (the scientific equivalent of heating them) will release the radioactivity that has accumulated since the last zeroing. A more sensitive technique, optically stimulated luminescence (OSL), can be used to release radioactivity accumulated in sediments since they formed.

Upper Palaeolithic Third of three divisions of the **Palaeolithic**, corresponding to the time of *Homo sapiens*. The European Upper Palaeolithic dates from around 40,000 BP to the end of the Pleistocene around 10,000 years ago.

uranium-series dating An absolute dating technique. Like other dating methods relying on unstable (ie radioactive) isotopes (*see* **electron spin resonance dating**), the accumulation and complex decay of uranium in bone and stalactite can be used to ascertain when these samples came to lie in their sedimentary context. These materials take up uranium from the surrounding environment, which decays through a complex chain of daughter isotopes of uranium and thorium. The position of a sample in the decay chain can be used to ascertain its age.

REFERENCES

Abramova, Z A 1962 *Palaeolithic Art on the Territory of the USSR* (in Russian). Moscow and Leningrad: Akademia Nauk

Aldhouse-Green, S (ed) 2000 *Paviland Cave and the 'Red Lady': A Definitive Report*. Bristol: Western Academic and Specialist

Armstrong, A L 1922a 'Flint-crust engravings, and associated implements, from Grime's Graves, Norfolk'. *Proc Prehist Soc East Anglia* **3**, 434–43

Armstrong, A L 1922b 'Further discoveries of engraved flint-crust and associated implements at Grime's Graves'. *Proc Prehist Soc East Anglia* **3**, 548–58

Armstrong, A L 1925 'Excavations at Mother Grundy's Parlour, Creswell Crags, Derbyshire, 1924'. *J R Anthropol Inst* **55**, 146–78

Armstrong, A L 1926 'Excavations at Creswell Crags, Derbyshire, 1924–6'. *Trans Hunter Archaeol Soc* **3** (2), 116–22

Armstrong, A L 1927 'Notes on four examples of Palaeolithic art from Creswell Caves, Derbyshire'. *IPEK (Jahr Prähist Ethnogr Kunst)*, 10–12, 1 pl

Armstrong, A L 1928 'Pin Hole Cave excavations, Creswell Crags, Derbyshire: Discovery of an engraved drawing of a masked human figure'. *Proc Prehist Soc East Anglia* **6**, 27–9, 1 pl

Armstrong, A L 1929 'Excavations at Creswell Crags, Derbyshire, 1926–28: The Pin Hole Cave'. *Trans Hunter Archaeol Soc* **3** (4), 332–4

Armstrong, A L 1949 'Exploration of prehistoric sites in east Derbyshire'. *Derbys Archaeol J* **69**, 69–73

Armstrong, A L 1956a 'The Creswell finds'. *Derbys Countrys* **21** (6), October/November, 26–7, 33

Armstrong, A L 1956b 'Report on the excavation of Ash Tree Cave, near Whitwell, Derbyshire, 1949 to 1957'. *Derbys Archaeol J* **76**, 57–64

Ashton, N and Lewis, S 2002 'Deserted Britain: Declining populations in the British Late Middle Pleistocene'. *Antiquity* **76**, 388–96

Baffier, D and Girard, M 1998 *Les Cavernes d'Arcy-sur-Cure*. Paris: La Maison des Roches

Bahn, P 2003 'Art of the hunters'. *Br Archaeol* **72**, 8–13

Bahn, P G and Vertut, J 1997 *Journey through the Ice Age*. London: Weidenfeld & Nicolson; Berkeley: University of California Press

Bahn, P, Pettitt, P and Ripoll, S 2003 'Discovery of Palaeolithic cave art in Britain'. *Antiquity* **77**, no. 296, June, 227–31

Bahn, P (with S Ripoll, P Pettitt and F Muñoz) 2005 'Creswell Crags: Discovering cave art in Britain'. *Curr Archaeol* **197**, May/June, 217–26

Barton, R N E 1992 *Hengistbury Head, Dorset, Vol II: The Late Upper Palaeolithic and Early Mesolithic Sites*. Monograph 34. Oxford: Oxford University Committee for Archaeology

Barton, R N E, Jacobi, R M, Stapert, D and Street, M J 2003 'The Late-glacial reoccupation of the British Isles and the Creswellian'. *J Quat Sci* **18** (7), 631–43

Bischoff, J, González Morales, M R, Garcia Diez, M and Sharp, W 1999 'Aplicación del método de series de Uranio al grafismo rupestre de estilo paleolítico: el caso de la cavidad de Covalanas (Ramales de la Victoria, Cantabria)'. *Veleia* **20**, 143–50

Bonsall, C and Tolan-Smith, C (eds) 1997 *The Human Use of Caves*. British Archaeological Reports International Series 667. Oxford: Archaeopress

Breuil, H 1952 *Four Hundred Centuries of Cave Art*. Montignac: Centre d'Etudes et de Documentation Préhistoriques

Breuil, H 1957 'Une deuxième pierre gravée de figures féminines stylisées de la grotte de la Roche (Dordogne)'. *L'Anthropologie* **61**, 574–5

Breuil, H and Obermaier, H 1913 'Institut de Paléontologie Humaine: Travaux exécutés en 1912'. *L'Anthropologie* **24**, 1–16

Burkitt, M C 1963 'A brief account of the life and work of Albert Leslie Armstrong', *in* J W Kitching, *Bone, Tooth & Horn Tools of Palaeolithic Man: An Account of the Osteodontokeratic Discoveries in Pin Hole Cave, Derbyshire*. Manchester: Manchester University Press, xi–xiv

Campbell, J B 1969 'Excavations at Creswell Crags: preliminary report'. *Derbys Archaeol J* **89**, 47–58

Campbell, J B 1977 *The Upper Palaeolithic of Britain*, 2 vols. Oxford: Clarendon

Chamberlain, A T 1996 'More dating evidence for human remains in British caves'. *Antiquity* **70**, 950–3

Charles, R and Jacobi, R M 1994 'The Lateglacial fauna from the Robin Hood Cave, Creswell Crags: A re-assessment'. *Oxf J Archaeol* **13** (1), 1–32

Cheng, H, Edwards, R L, Hoff, J, Gallup, C D, Richards, D A and Asmerom, Y 2000 'The half lives of uranium-234 and thorium-230'. *Chem Geol* **169**, 17–33

Coles, B J 1998 'Doggerland: a speculative survey'. *Proc Prehist Soc* **64**, 45–81

Coope, G R 1977 'Fossil coleopteran assemblages as sensitive indicators of climatic changes during the Devensian (Last) cold stage'. *Philos Trans R Soc Lond* **B280**, 313–40

Currant, A and Jacobi, R 2001 'A formal mammalian biostratigraphy for the Late Pleistocene of Britain'. *Quat Sci Rev* **20** (16–17), 1707–16

Currant, A P and Jacobi, R M 2002 'Human presence and absence in Britain during the early part of the Late Pleistocene', in Tuffreau, A and Roebroeks, W (eds) *Le Dernier Interglaciaire et les occupations humaines du Paléolithique moyen*. Publications du CERP 8. Lille: Centre d'Études et de Recherches Préhistoriques, Université des Sciences et Technologies de Lille, 105–13

Daniel, G 1961 'Editorial'. *Antiquity* **35**, 257–62

Daniel, G 1981 'Editorial'. *Antiquity* **55**, 81–9

Davies, G, Badcock, A, Mills, N and Smith, B 2004 'The Creswell Crags Limestone Heritage Area Management Action Plan'. Unpublished report, ARCUS, University of Sheffield

Dawkins, W B 1869 'On the distribution of the British postglacial mammals'. *Q J Geol Soc Lond* **25**, 192–217

Dawkins, W B 1874 *Cave Hunting: Researches on the Evidence of Caves Respecting the Early Inhabitants of Europe*. London: Macmillan

Dawkins, W B 1876 'On the mammalia and traces of man found in the Robin-Hood Cave'. *Q J Geol Soc London* **32** (3), 245–58

Dawkins, W B 1877 'On the mammal-fauna of the caves of Creswell Crags'. *Q J Geol Soc Lond* **33** (3), 589–612

Dawkins, W 1880 *Early Man in Britain*. London: Macmillan

Dawkins, W 1925 'Late Palaeolithic art in the Cresswell caves'. *Man* **25**, March, no. 28

Dawkins, W B and Mello, J M 1879 'Further discoveries in the Cresswell caves'. *Q J Geol Soc Lond* **35** (4), 724–35

Eden, R A, Stevenson, I P and Edwards, W 1957 *Geology of the Country around Sheffield: Explanation of One-inch Geological Sheet 100, New Series*. Memoir of the Geological Survey of Great Britain. London: HMSO

Edwards, R L, Chen, J H and Wasserburg, G J 1987 '^{238}U-^{234}U-^{230}Th-^{232}Th systematics and the precise measurement of time over the last 500,000 years'. *Earth Planet Sci Lett* **81**, 175–92

Ford, D C and Williams, P W 1989 *Karst Geomorphology and Hydrology*. London: Unwin Hyman

Gamble, C, Davies, W, Pettitt, P, Richards, M and Hazelwood, L 2005 'The archaeological and genetic foundations of the European population during the Lateglacial: Implications for "agricultural thinking"'. *Camb Archaeol J* **15** (2), 193–223

Garrod, D A E 1926 *The Upper Palaeolithic Age in Britain*. Oxford: Clarendon

Gaussen, J 1984 'L'Utilisation du relief à Gabillou'. *L'Anthropologie* **88** (4), 105–15

Grigson, G 1955 'Caves, crags, and coal mines'. *The Listener* **54**, no. 1399, 22 December, 1083–4 (also in *Derbys Countrys* **21** (3), May/June 1956, 22–3)

Grigson, G 1957 *The Painted Caves*. London: Phoenix House

Heath, T 1880 *Creswell Caves v Professor Boyd Dawkins*, 2 edn. Derby: Clulow

Hedges, R E M, Housley, R A, Bronk Ramsey, C and Van Klinken, G J 1994 'Radiocarbon dates from the Oxford AMS system: *Archaeometry* datelist 18'. *Archaeometry* **36** (2), 337–74

Hedges, R E M, Pettitt, P B, Bronk Ramsey, C and Van Klinken, G J 1996 'Radiocarbon dates from the Oxford AMS system: *Archaeometry* datelist 22'. *Archaeometry* **38** (2), 391–415

Hetherington, D A, Lord, T C and Jacobi, R M 2005 'New evidence for the occurrence of Eurasian lynx (*Lynx lynx*) in medieval Britain'. *J Quat Sci* **21** (1), 3–8

Houlder, C 1974 *Wales: An Archaeological Guide*. London: Faber and Faber

Housley, R A, Gamble, C S, Street, M and Pettitt, P 1997 'Radiocarbon evidence for the Lateglacial human recolonisation of northern Europe'. *Proc Prehist Soc* **63**, 25–54

Jackson, J W 1925 'Report on the animal remains found at the cave known as Mother Grundy's Parlour, Creswell'. *J R Anthropol Inst* **55**, 176–8

Jacobi, R M 2004 'The Late Upper Palaeolithic lithic collection from Gough's Cave, Cheddar, Somerset, and human use of the cave'. *Proc Prehist Soc* **70**, 1–92

Jacobi, R M 2006 'Creswell Crags and the sabre-toothed cat'. *Stud Spelaeol* **14**, 33–8

Jacobi, R M 2007 'The Stone Age archaeology of

Church Hole, Creswell Crags, Nottinghamshire', *in* Pettitt, P, Bahn, P and Ripoll, S (eds) *Palaeolithic Cave Art at Creswell Crags in European Context*. Oxford: Oxford University Press, 71–111

Jacobi, R M and Higham, T F G 2008 'The "Red Lady" ages gracefully: New ultrafiltration AMS determinations from Paviland'. *J Hum Evol* **55**, 898–907.

Jacobi, R M, Rowe, P J, Gilmour, M A, Grün, R and Atkinson, T C 1998 'Radiometric dating of the Middle Palaeolithic tool industry and associated fauna of Pin Hole Cave, Creswell Crags, England'. *J Quat Sci* **13** (1), 29–42

Jacobi, R M, Higham, T F G, and Bronk Ramsey, C 2006 'AMS radiocarbon dating of Middle and Upper Palaeolithic bone in the British Isles: Improved reliability using ultrafiltration'. *J Quat Sci* **21** (5), 557–73

Jenkinson, R D S 1984 *Creswell Crags: Late Pleistocene Sites in the East Midlands*. BAR, British series 122. Oxford: British Archaeological Reports

Jenkinson, R D S and Gilbertson, D D (eds) 1984 *In the Shadow of Extinction: A Quaternary Archaeology and Palaeoecology of the Late Pleistocene Sites and Caves at Creswell Crags SSSI*. Sheffield: University of Sheffield

Kaldi, J 1986 'Sedimentology of sandwaves in an oolite shoal complex in the Cadeby (Magnesian Limestone) Formation (Upper Permian) of eastern England', *in* Harwood, G M and Smith, D B (eds) *The English Zechstein and Related Topics*. Geological Society of London Special Publication 22. Oxford: published for Geological Society by Blackwell Scientific, 63–74

Lambeck, K 1995 'Late Devensian and Holocene shorelines of the British Isles and North Sea from models of glacio-hydro-isostatic rebound'. *J Geol Soc Lond* **152** (3), 437–48

Liger, J-C 1995 'Concrétionnement et archéologie aux grottes d'Arcy-sur-Cure (Yonne)'. *Bull Soc Préhist Fr* **92** (4), 445–9

Lorblanchet, M 2007 'The horse in the Palaeolithic parietal art of the Quercy: Outline of a stylistic study', *in* Pettitt, P, Bahn P and Ripoll, S (eds) *Palaeolithic Cave Art at Creswell Crags in European Context*. Oxford: Oxford University Press, 207–28

Ludwig, K R 2003 'Mathematical-statistical treatment of data and errors for ^{230}Th/U geochronology'. *Rev Mineral Geochem* **52**, 631–56

Marshack, A 1975 'Exploring the mind of Ice Age man'. *Natl Geogr* **147** (1), 64–89

Mellars, P A 1969 'Radiocarbon dates for a new Creswellian site'. *Antiquity* **43**, 308–10

Mello, J M 1875 'On some bone-caves in Creswell Crags'. *Q J Geol Soc Lond* **31** (4), 679–91

Mello, J M 1876 'The bone-caves of Creswell Crags: 2nd paper'. *Q J Geol Soc Lond* **32** (3), 240–4

Mello, J M 1877 'The bone-caves of Creswell Crags: 3rd paper'. *Q J Geol Soc Lond* **33** (3), 579–88

Morgan, W L 1913 'Bacon Hole, Gower'. *Archaeol Cambrensis*, 6th ser, **13**, 173–8

Mullan, G J, Wilson, L J, Farrant, A R and Devlin, K 2006 'A possible engraving of a mammoth in Gough's Cave, Cheddar, Somerset'. *Proc Univ Bristol Spelaeol Soc* **24** (1), 37–47

Mullins, E H 1913 'The ossiferous cave at Langwith'. *Derbys Archaeol J* **35**, 137–58

Nobbs, M F and R I Dorn 1988 'Age determinations for rock varnish formation within petroglyphs: Cation-ratio dating of 24 motifs from the Olary region'. *S Aust Rock Art Res* **5** (2), 108–46

Oakley, K P 1969 'Analytical methods of dating bones', *in* Brothwell, D and Higgs, E (eds) *Science in Archaeology*, 2 edn. London: Thames & Hudson, 35–45

Pettitt, P B 2004 'Is it the infancy of art? Or the art of an infant? A possible Neanderthal face from La Roche-Cotard, France'. *Before Farming* (2003–4), 1–3. Available online at http://www.waspress. co.uk/journals/beforefarming/

Pettitt, P 2007 'Cultural context and form of some of the Creswell images: an interpretative model', *in* Pettitt P *et al* (eds) *Palaeolithic Cave Art at Creswell Crags in European Context*. Oxford: Oxford University Press, 112–39

Pettitt, P and Bahn, P 2003 'Current problems in dating Palaeolithic cave art: Candamo and Chauvet'. *Antiquity* **77** (295), 134–41

Pettitt, P B and Pike, A W G 2007 'Dating European Palaeolithic cave art: Progress, prospects, problems'. *J Archaeol Method Theory* **14** (1), 27–47

Pettitt, P, Bahn, P and Ripoll, S (eds) 2007 *Palaeolithic Cave Art at Creswell Crags in European Context*. Oxford: Oxford University Press

Peyrony, D 1930 'Sur quelques pièces intéressantes de la grotte de la Roche près de Lalinde (Dordogne)'. *L'Anthropologie* **40**, 19–29

Pike, A W G, Gilmour, M, Pettitt, P, Jacobi, R, Ripoll, S, and Muñoz, F 2005 'Verification of the age of the Palaeolithic cave art at Creswell Crags, UK'. *J Archaeol Sci* **32**, 1649–55

Richards, D A and Dorale, J A 2003 'U-series chronology and environmental applications of speleothems'. *Rev Mineral Geochem* **52**, 407–60

Ripoll, S and Muñoz, F 2006 'El Tardiglaciar en el Reino Unido', *in* Maillo, J M and Baquedano, E (eds) *Miscelánea en Homenaje a Victoria Cabrera*.

Zona Arq. 7, vol. 1. Alcalá de Henares: Museo Arqueológico Regional, 562–77

Ripoll, S and Muñoz, F 2007 'The Palaeolithic rock art of Creswell Crags: Prelude to a systematic study', in Pettitt, P et al (eds) *Palaeolithic Cave Art at Creswell Crags in European Context*. Oxford: Oxford University Press, 14–33

Ripoll, S, Muñoz, F, Bahn, P and Pettitt, P 2004a 'Palaeolithic cave engravings at Creswell Crags, England'. *Proc Prehist Soc* **70**, 93–105

Ripoll, S, Muñoz, F, Pettitt, P and Bahn, P 2004b 'New discoveries of cave art in Church Hole (Creswell Crags, England)'. *Int Newsl Rock Art* **40**, 1–6

Ripoll, S, Muñoz, F J and Avezuela, B 2007 'Sobre la experimentación del bajorrelieve ligero en el arte rupestre: el caso de Church Hole en Creswell Crags (Reino Unido)', in *Arqueología experimental en la Península Ibérica: Investigación, didáctica y patrimonio*. Santander: Asociación Española de Arqueología Experimental, 165–71

Rockman, M H 2003 'Landscape learning in the Late Glacial recolonisation of Britain'. Unpublished PhD dissertation, University of Arizona

Rogers, T 1981 'Palaeolithic cave art in the Wye Valley'. *Curr Anthropol* **22** (5), 601–2

Rogers, T, Pinder, A and Russell, R C 1981 'Cave art discovery in Britain'. *Illustr Lond News*, **269**, no. 6990, January, 31–4

Roussot, A 1984 'Abri du Cap Blanc', in *Atlas des Grottes Ornées*. Paris: Ministère de la Culture, 157–63

Russell, M 2000 *Flint Mines in Neolithic Britain*. Stroud: Tempus

Sauvet, G 2004 'L'Art mobilier non classique de la grotte magdalénienne de Bédeilhac (Ariège)', in Lejeune, M and Welté, A-C (eds) *L'Art du Paleolithique Supérieur*. Liège: ERAUL 107, 167–76

Sauvet, G and Tosello, G 1999 'Le Mythe paléolithique de la caverne', in Sacco, F and Sauvet, G (eds) *Le Propre de l'homme, psychanalyse et préhistoire*. Lausanne: Delachaux et Niestlé, 55–90

Schmid, E 1964 'Remarques au sujet d'une représentation de bouquetin à Niaux'. *Bull Soc Préhist l'Ariège* **19**, 33–9

Schwarcz, H P and Latham, A G 1989 'Dirty calcites. 1. Uranium-series dating of contaminated calcite using leachates alone'. *Chem Geol* **80**, 35–43

Sieveking, A 1987 *A Catalogue of Palaeolithic Art in the British Museum*. London: British Museum

Sieveking, A 1992 'The continental affiliations of two Palaeolithic engraved bones found in England'. *Antiq J* **72**, 1–17

Sieveking, G 1972 'Art mobilier in Britain', in *Santander Symposium*. Santander: Patronato de las cuevas de la provincia de Sander, Dirección General de Bellas Artes, 385–8

Sieveking, G 1982 'Palaeolithic art and natural rock formations'. *Curr Anthropol* **23** (5), 567–9

Sieveking, G and Sieveking, A 1981 'A visit to Symond's Yat 1981'. *Antiquity* **55**, 123–5

Smith, D B 1989 'The late Permian palaeogeography of north-east England'. *Proc Yorks Geol Soc* **47**, 285–312

Smith, D B 1995 *Marine Permian of England*. Geological Conservation Review Series no. 8. London: Chapman & Hall

Sollas, W J 1924 *Ancient Hunters and Their Modern Representatives*, 3 edn, revised. New York: Macmillan

Sollas, W J 1925 'Late Palaeolithic art in the Cresswell caves'. *Man* **25**, April, no. 35, 63–4

Stuart, A J 1976 'The history of the mammal fauna during the Ipswichian/Last Interglacial in England'. *Philos Trans R Soc Lond* **B276**, 221–50

Taylor, S R and McLennan, S M 1995 'The geochemical evolution of the continental crust'. *Rev Geophys* **33**, 241–65

Tucker, M E 2001 *Sedimentary Petrology: An Introduction to the Origin of Sedimentary Rocks*, 3 edn. Oxford: Blackwell Science

Tucker, M E 2003 *Sedimentary Rocks in the Field*, 3 edn. Chichester: Wiley

Tucker, M E and Wright, V P 1990 *Carbonate Sedimentology*. Oxford: Blackwell Science

Tymula, S 2002 *L'Art solutréen du Roc de Sers (Charente)*. Documents d'archéologie française no. 91. Paris: Maison des Sciences de l'Homme

Utrilla, P, Mazo, C, Sopena, M C, Domingo, R and Nagore, O 2004 'L'Art mobilier sur pierre du versant sud des Pyrénées: les blocs gravés de la grotte d'Abauntz', in Lejeune, M and Welté, A-C (eds) *L'Art du Paléolithique Supérieur*. Liège: ERAUL 107, 199–218

Varndell, G 2004 'Seeing things: A. L. Armstrong's flint crust engravings from Grimes Graves', in Topping, P and Lynott, M (eds) *The Cultural Landscape of Prehistoric Mines*. Oxford: Oxbow Books, 51–62

Wedepohl, K H 1995 'The composition of the continental crust'. *Geochim Cosmochim Acta* **59**, 1217–39

Zilhão, J 1995 'The age of the Côa valley (Portugal) rock-art: validation of archaeological dating to the Palaeolithic and refutation of "scientific" dating to historic or proto-historic times'. *Antiquity* **69**, 883–90

INDEX